The
AMOROUS HEART

The

AMOROUS HEART

An Unconventional History of Love

Marilyn Yalom

BASIC BOOKS
New York

Hachette Book Group supports the right to free expression and the value of copyright. The purpose of copyright is to encourage writers and artists to produce the creative works that enrich our culture.

The scanning, uploading, and distribution of this book without permission is a theft of the author's intellectual property. If you would like permission to use material from the book (other than for review purposes), please contact permissions@hbgusa.com. Thank you for your support of the author's rights.

Basic Books
Hachette Book Group
1290 Avenue of the Americas, New York, NY 10104
www.basicbooks.com
Printed in the United States of America

First Edition: January 2018

Published by Basic Books, an imprint of Perseus Books, LLC, a subsidiary of Hachette Book Group, Inc. The Basic Books name and logo is a trademark of the Hachette Book Group.

The publisher is not responsible for websites (or their content) that are not owned by the publisher.

Library of Congress Cataloging-in-Publication Data

Names: Yalom, Marilyn
Title: The amorous heart : an unconventional history of love / Marilyn Yalom.
Description: First edition. | New York : Basic Books, 2018. | Includes
 bibliographical references and index.
Identifiers: LCCN 2017037772| ISBN 9780465094707 (hardback) | ISBN
 978046509471-4 (ebook)
Subjects: LCSH: Heart--Symbolic aspects. | Love symbols. | BISAC:
HISTORY /
 Europe / General. | ART / History / General. | LITERARY CRITICISM /
 European / General.
Classification: LCC GT498.H45 Y35 2018 | DDC 611/.12--dc23
LC record available at https://lccn.loc.gov/2017037772

ISBNs: 978-0-465-09470-7 (hardcover), 978-0-465-09471-4 (electronic book)

LSC-C

10 9 8 7 6 5 4 3 2 1

For my big-hearted husband

Contents

Introduction

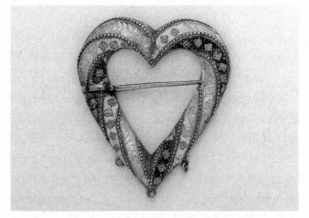

FIGURE 1. Artist unknown, Brooch from the Fishpool
Hoard, 1400–1464. British Museum, London, England.

A EUREKA MOMENT AT THE BRITISH MUSEUM IN 2011 GAVE
birth to this book. I was attending an exhibition of medieval
artifacts, including gold coins and pieces of jewelry that were
part of the Fishpool treasure hoard discovered in Notting-
hamshire in 1966. Many of the items had been made in
France and carried French inscriptions—for example, a small
gold padlock with the words *de tout* (with all) on one side and
mon cuer (my heart) on the other.

1

Suddenly an exquisite heart-shaped brooch seized my attention: I noticed the heart's two lobes at the top and its V-shaped point at the bottom as if I were seeing them for the first time. Then, for a brief moment, all the hearts I had grown up with—on valentine cards and candy boxes, posters and balloons, bracelets and perfume ads—flashed into my mind. It quickly dawned on me that the perfectly bi-lobed symmetrical "heart" is a far cry from the ungainly lumpish organ we carry inside us. How had the human heart become transformed into such a whimsical icon?

From then on, that mystery has pursued me, and inevitably it drew me back into the subject of love, an inexhaustible domain for which the heart has served as a kind of compass.

It is not surprising that the heart is associated with love. Anyone who has ever been in love knows that your heart beats faster when you catch a glimpse of the person who stars in your romantic imagination. And if you have the misfortune of losing that person, you feel an ache in your chest. "I have a heavy heart" or "My heart is broken" are the words we use when love turns against us.

How long has the heart been coupled with love? When was the heart icon created? How did it spread across the globe? What does it tell us about the meaning of love in different eras and places? How have various religions dealt with the amorous heart? These are some of the questions I grapple with in this book.

ANCIENT EGYPTIANS BELIEVED THE HEART WAS THE SEAT of the soul, to be weighed on a scale at the time of one's death (Figure 2). According to the Egyptian *Book of the Dead*, if the heart was pure enough and weighed less than the feather of truth called *Maat*, the deceased would gain entry into the

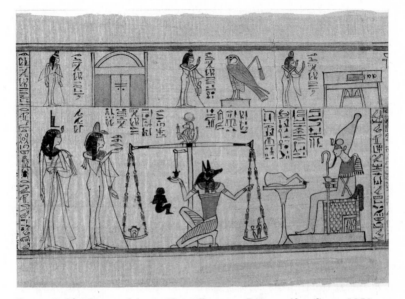

FIGURE 2. The Singer of Amun Nany, Funerary Papyrus (detail), ca. 1050 BC. Papyrus, paint. The Metropolitan Museum of Art, New York, Rogers Fund, 1930.

afterlife. However, if the heart was impure and heavy with evil deeds, it would sink lower on the scale than the feather and cause the dead man or woman to be devoured by a grotesque beast. Obviously this scenario of the heart on trial prefigured the Christian Last Judgment.

But ancient Egyptians also saw the heart as the home of a person's amorous feelings. One Egyptian poet visualized his heart as a "slave" to the woman he desired, and another poet felt his heart surge with love as he went about his daily tasks: "How wonderful to go to the fields when one's heart is consumed by love!" Despite the distance of more than three thousand years, we immediately recognize these sentiments as identical with our own.

In general the religions that subsequently arose in the Middle East—Judaism, Christianity, and Islam—have been wary of the amorous heart. Aside from the *Song of Songs* and a few stories in the Hebrew Bible, the sacred books of these religions do not extol sensual love between human beings. Indeed, the birth of monotheism ushered in a rivalry between secular and religious claims to the heart—a rivalry that took different forms during the first millennium and became overtly contentious during the Middle Ages.

WHEN TWELFTH-CENTURY TROUBADOURS FROM THE SOUTH of France took up their lyres to sing of love, they believed their songs would have little value unless they sprang from an amorous heart. Then, following the lead of Occitane troubadours, northern French minstrels and storytellers pledged their hearts to an idealized woman and aspired to "exchange" their hearts as tokens of fidelity. It is true that this lofty mode of behavior was intended primarily for members of the nobility and that even they could not live up to such high standards. And yet this doctrine of refined love issuing from regional courts in France, Germany, and Italy proved to be remarkably persistent: over the centuries it evolved into the small and large courtesies that Western men and women expect of each other, and it created a romantic ethos that has endured to this day.

At the same time Christianity contributed, though in different ways, to the renewed prominence of the heart. Starting with the Bible, the heart was understood to be the chief organ for receiving and storing the word of God. Among the Church fathers, the one most associated with the heart was Saint Augustine (354–430), who mentioned it more than two hundred times in his *Confessions*, frequently as a term for his

innermost self. As Augustine put it in an oft-quoted affirmation of his faith: "Thou hast made us for thyself, O Lord, and our heart is restless until it finds its rest in thee." Perhaps more than any other Church figure, Saint Augustine was responsible for claiming the chaste heart for Christianity and for discrediting the lustful heart associated with secular love.

During the twelfth and thirteenth centuries the revival of religious life in monasteries and convents presided over by such towering figures as Bernard of Clairvaux (1090–1153), Hildegard of Bingen (1098–1179), and Saint Francis (1181–1226) placed a new emphasis on one's inner life, represented by the pure heart dedicated to Jesus. The Church promoted the love of God and all His creatures, conceptualized in the virtue of *caritas*, as a superior rival to erotic love.

Yet despite the Church's official opposition to earthly love, Eros found its way into cloistered retreats, where some men and women of the cloth adopted the language of lovers for conversations with each other and with God. Mystical thinkers, such as Gertrude the Great of Helfta, had visions of intimate bodily encounters with Jesus that sound as if they could have come off the pages of French and German romances.

The heart icon (♥) as a symbol of love first appeared during this medieval period of cultural renewal. It was created simultaneously for secular and religious works of art and flourished most notably in courtly circles. Once born, the amorous heart motif found its way into thousands of items—such as jewelry, tapestries, ivory carvings, and wooden chests—all produced for the enjoyment of the upper classes. This symbol of love, at first known only to elite members of society, has by now become the property of everyone who can see.

The appeal of the heart icon lends itself to aesthetic, philosophical, and psychological interpretations. Its perfect

symmetry and bold color speak to our sense of beauty. Its two equal halves merged into one convey the philosophical idea, dear to Plato, that each person seeks to be joined with his or her soulmate. And on an unconscious level the round lobes evoke sexual images of breasts and buttocks. For all these reasons and more, this medieval symbol has embodied different ideas about love meaningful to different groups of people in different times and places.

Although this book focuses on Western culture, I shall also consider the Arabic world from the period between classical antiquity and the Middle Ages and, to a lesser extent, some examples from contemporary Asia. These forays outside the Western sphere suggest that the association between heart and love is prevalent in certain other parts of the world as well. For example, I was not surprised to discover that the Japanese character for love contains within it the character for heart.

heart → 心
love → 愛

Tracing the connection between the heart and love has led me into trails I would never have anticipated in advance: how philosophers and physicians disputed the functions of the heart, how the heart was sometimes buried separately from the body, and how both Catholics and Protestants utilized the heart for religious ends. The way the heart has been discussed and portrayed by authors and artists in myriad cultures is obviously more than one person can explore in a lifetime. Yet even a selection of these topics brings us closer to that mysterious, multifaceted phenomenon we encapsulate within the word "love."

Chapter 1

The Amorous Heart in Antiquity

LONG BEFORE THE AMOROUS HEART FIRST APPEARED VISU-
ally, a connection between the heart and love had been firmly
established in speech and writing. As far back as the ancient
Greeks, lyric poetry already identified the heart with love in
verbal conceits that would not find their visual equivalents for
almost two thousand years. Among the earliest known Greek
examples the poet Sappho agonized over her own "mad heart"
quaking with love. Sappho lived during the seventh century
BCE on the island of Lesbos surrounded by female disciples
for whom she wrote passionate poems, now known only in
fragments, like the following:

> *Love shook my heart,*
> *Like the wind on the mountain*
> *Troubling the oak-trees.*

Sappho's heart was never still. It was constantly agi-
tated against her will by Aphrodite, the goddess of love. She

pleaded with Aphrodite: "Don't shatter my heart with fierce pain." Yet in old age Sappho bemoaned her "heavy heart," no longer vulnerable to the transports caused by youthful love.

Sappho's voice echoes down through the ages, as generation upon generation of men and women experienced love as a sort of divine madness invading their hearts. The Greek biographer Plutarch, some six hundred years after Sappho, recognized this malady in the person of King Antiochus. When Antiochus fell in love with his stepmother, Stratonice, he manifested "all Sappho's famous symptoms—his voice faltered, his face flushed up, his eyes glanced stealthily, a sudden sweat broke out on his skin, the beatings of his heart were irregular and violent." Love was understood to be a bodily experience lodged primarily in the heart and affecting the entire soma. It was often portrayed as a painful affliction, visited upon mortals by capricious gods.

THE STORY OF JASON AND MEDEA, AS TOLD BY APOLLONIUS of Rhodes around 250 BCE in his *Voyage of the Argo*, gives a good example of how the Greek gods imposed love upon humans. Prompted by the goddesses Hera and Athena, Aphrodite prevailed upon her young son Eros to make Medea fall in love with Jason so as to enable him to capture the Golden Fleece.

> . . . *drawing wide*
> *apart with both hands he [Eros] shot at Medea;* . . .
> *And the bolt burnt deep*
> *down in the maiden's heart, like a flame.*

Eros with his bow and arrow was hardly a benign figure as he would become much later in the cuddly form of Cupid.

Here he is clearly a dangerous, inhuman force, inflicting sexual desire upon an innocent maid and filling her heart with fierce passion that will ultimately prove destructive.

Ancient Greek philosophers agreed, more or less, that the heart was somehow linked to our strongest emotions, including love. Plato argued not only for the dominant role of the chest in the experience of love but also for the negative emotions of fear, anger, rage, and pain. In his *Timaeus* he established the reign of the heart over the body's entire emotional life.

Aristotle expanded the role of the heart even further and granted it supremacy in all human processes. Not only was it the source of pleasure and pain, but it was also the central location for the immortal soul, the *psuchê*, or psyche. Aristotle's differences with Plato and, afterward, with the Greek physician Galen (130 CE–circa 200) would be debated endlessly by successive philosophers and scientists into the seventeenth century.

BY THE TIME OF THE ROMANS THE ASSOCIATION BETWEEN the heart and love was already commonplace. Venus, the goddess of love, was credited—or blamed—for setting hearts on fire with the aid of her son Cupid, whose love darts aimed at the human heart were always overpowering. Hearts enflamed by Venus or pierced by Cupid's arrows regularly appeared in the works of such poets as Catullus (87–54 BCE), Horace (65–8 BCE), Propertius (circa 50–15 BCE), and Ovid (43–17/18 BCE).

These poets commonly employed a pseudonym for the loved one—"Lesbia" for Catullus, "Cynthia" for Propertius, "Corinna" for Ovid—but we cannot be sure there was always a living counterpart behind the name. Still, they wrote convincingly of their love experiences centered on the figure of

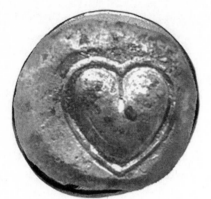

FIGURE 3. Artist unknown, Drachm depicting a silphium seed pod, ca. 510–490 BC. Sanctuary of Demeter and Persephone, Cyrene, catalogue number 14.

the *domina*—the woman who had taken hold of their hearts, obsessed their thoughts, and forced them into emotional servitude.

In Catullus's case, at least, Lesbia is known to have been a pseudonym for Clodia, the wife of a Roman politician. The other poets' mistresses were probably either married women or *demimondaines*—free women (as opposed to slaves) who attended private dinners in mixed company and circulated in public venues like the circus and races. It was to a woman of this sort that the poet dedicated his heart, despite her reputed unfaithfulness.

Catullus also has a curious connection to the visual image of the heart shape on the ancient coin pictured in Figure 3. This coin, stamped with the outline of the seed from the silphium plant, a now-extinct species of giant fennel, looks exactly like our present-day heart icon (♥), which has symbolized love since the Middle Ages. In one of his poems Catullus specifically mentioned Cyrene in ancient Libya as the city producing silphium—a city that had, in fact, grown so rich from the export of silphium that Cyrenians put it on their coins.

You ask, Lesbia, how many kisses should
You give to satisfy me . . .
Greater than the number of African sands that
Lie in silphium–bearing Cyrene.

Why would Catullus mention silphium in a love poem? The most common explanation today is that silphium was highly prized in the ancient world as a form of contraception. Another Cyrenian coin even carried the image of a woman touching a silphium plant with one hand and pointing to her genitals with the other. The second-century Greek physician Soranus suggested that taking a small dose of silphium once a month would not only prevent conception but also, when necessary, induce abortion.

It is unlikely that the shape of the silphium seed had anything to do with the heart icon created in Europe more than a millennium later. Still, Catullus's reference to silphium in a love poem does remind us that women have always had to worry about the possible consequences of their sexual relationships; pregnancy was *not* something to be wished for by Catullus or his mistress. He ends the poem deriding the evil-tongued "busybodies" who are outraged by Lesbia's kisses, more numerous than the sands from silphium-bearing Africa.

Whatever the significance of silphium for Catullus, the fact remains that its seed pod, as pictured in Figure 3, is the oldest known image of the shape that will become, in time, the world's most ubiquitous symbol of love.

OVID, THE BEST KNOWN OF THE ROMAN LOVE POETS, PRE-sents *amor* as a kind of game that anyone can play as long as you know the rules. And he set out—somewhat tongue in

cheek—to teach those rules in his *Art of Love* (*Ars amatoria*), which gained instant popularity in his day, became fashionable once again during the Middle Ages, and even today has a worldwide following through numerous translations—at least ten in English alone listed on Amazon.com.

For Ovid love is a curious mixture of sex and sentiment, with an emphasis on the former. In fact, whenever he uses the word "heart" for a man, the reader should equate it with eros—sexual desire. Ovid's heroes (himself, first of all) are warriors committed to "winning" and bedding a designated woman:

> *Love is a warfare: sluggards be dismissed.*
> *No faint-heart 'neath this banner may enlist.*

Eros, according to Ovid, had no law outside itself, no greater morality binding the heart than its own passion. The poet had nothing but applause for the bold man who "shows a lover's heart," by which he meant a man willing to overcome daunting obstacles in pursuit of an irresistible woman. While he assumed that men will be the seducers and women the seduced, the women he knew were by no means passive players in the game of love.

And what, then, of woman's heart? Hers, too, was the home of Eros, but according to Ovid, it was girded by numerous other desires such as money, flattery, secrecy, and reputation. Ovid did not offer an attractive portrait of the women he lusted after. There was one area, however, where he gave woman her due, and that was the bedroom. Here he expected that she would be his match, that she too would enjoy sex as much as he. As he put it: "I hate a union that exhausts not

both." Somehow Ovid managed to describe the intimacies of lovemaking without sounding pornographic. Any woman, then or now, would appreciate his understanding of how erotic enjoyment can be shared equally, as expressed in the following lines:

> *Love's climax never should be rushed, I say,*
> *But worked up softly, lingering all the way.*
> *The parts a woman loves to have caressed*
> *Once found, caress. . . .*
> *But ne'er must you with fuller sail outpace*
> *Your consort, nor she beat you in the race:*
> *Together reach the goal; it's rapture's height*
> *When man and woman in collapse unite.*

This, then, is Ovid's vision of a sated "heart." Taking his cues from the love trysts of Venus, Mars, and other Greco-Roman gods, he pictured love in the form of two bodies wrapped together in mutual delight. There is nothing ethereal in this vision, none of the metaphysical idealism that Plato had espoused four centuries earlier, nor the religious connotations Dante would invest in love thirteen hundred years later, nor the overwrought emotional states of nineteenth-century Romantics. Ovidian love is embedded in the flesh, with the "heart" a lofty euphemism for the genitals.

AMONG FREE ROMANS MARRIAGE HAD LESS TO DO WITH erotic love than with family ties, social position, property, and progeny. Yet the heart was still supposed to inspire tender feelings between husbands and wives. In fact, the wedding ring given to the bride to wear on her fourth finger was believed

to have a special connection to the heart, as explained by the second-century Latin author and grammarian Aulus Gellius:

> When the human body is cut open as the Egyptians do . . . a very delicate nerve is found which starts from the [ring] finger and travels to the heart. It is, therefore, thought seemly to give to this finger in preference to all others the honor of the ring, on account of the loose connection which links it with the principal organ.

What a fanciful notion! Although it has no basis whatsoever in our current knowledge of anatomy, the Roman belief that a small vein called the *vena amoris* (vein of love) ran from the fourth finger to the heart endured for centuries. It was still current in the fifth century CE, as evidenced by the Latin playwright Macrobius in his *Saturnalia*, and even appeared regularly in the Middle Ages as part of marriage ceremonies. In medieval Salisbury, England, the liturgy for the marriage service stated emphatically that the groom should place a ring on the bride's fourth finger "because in that finger there is a certain vein, which runs from thence as far as the heart, and inward affection." Thus the Romans established the practice of placing a ring on the bride's finger to seal the wedding ceremony and strengthen the bride's affection.

The Roman wife who lived up to expectations would sometimes be honored at her death with a nostalgic reference to her loving heart. In this vein an epitaph from the second century BCE reads, "Here is the unlovely grave of a lovely woman. . . . She loved her husband with her heart. She bore two sons. . . . She was graceful in her speech and elegant in her step. She kept the home." These words praise the deceased

wife as a mother, homemaker, graceful speaker, and possessor of a faithful heart.

Men, too, were expected to harbor sweet feelings in their hearts for their wives. The great statesman Cicero began a letter to his first wife, Terentia, in 58 BCE: "Light of my life, my heart's desire. To think that you, darling Terentia, are so tormented." Cicero's marriage to his "heart's desire" lasted for more than thirty years, but the couple were frequently separated during that time, often by his choice. Eventually they divorced, which permitted him to marry Publilia, his very young ward, who came with a substantial dowry. The true love of Cicero's life was his daughter, Tullia, who died only a month or so after his second marriage. Unable to stop crying, he experienced what we today would recognize as deep depression. Because the Romans disapproved of public displays of grief, especially regarding a woman, Cicero had to conceal his emotions, and shortly afterward he ended his short-lived marriage to Publilia.

Catullus, when he was not writing about Lesbia, described the kind of heart considered appropriate for each half of a Roman couple. The husband: "Within his inmost heart a fire / Is flaming up of sweet desire." The wife: "Submissive to her lord's control / Around her heart love's tendrils bind." Would today's young Americans find such hearts suitable, with the wife's heart submissive to her husband's? I don't think so.

And yet compared to many other countries yesterday and today, Roman women were often fairly independent. They were not confined to a woman's section in their homes, and they could circulate with relative freedom outside the house. They probably had little say about the husbands their families selected for them, but in contrast to polygamous societies, the

bride did not have to share her husband with other wives, as Roman law allowed a man only one spouse (at a time). If the dictates of her heart drove her beyond the marital bed into the arms of a lover, her husband had the right to divorce her but not to kill her, as he might have done with impunity in earlier times.

Emperor Augustus, wishing to rein in married women's sexual liberties, introduced the *Lex Julia de adulteris* in 18–17 BCE, which made adultery a serious crime. Ten years later he suddenly sent Ovid into exile and offered two causes for this radical judgment: a poem (presumably *The Art of Love*) and an unspecified "indiscretion." In his battle against marital infidelity (which didn't affect his personal behavior), Augustus did not spare members of his own family: both his daughter Julia and his granddaughter, the younger Julia, were banished for the same offense. Though Ovid was obliged to spend the last years of his life in exile on the distant shores of the Black Sea, he was not forgotten in Rome, where his works continued to be immensely popular.

DID GREEKS AND ROMANS BELIEVE THAT ALL-POWERFUL gods on Mount Olympus initiated love between humans? Let's leave the last word to Ovid: "Gods have their uses, let's believe they're there." Many of Ovid's contemporaries shared his skepticism. Some Greeks and Romans were probably fervent believers, whereas others—certainly as far back as Plato—understood the gods as allegorical figures, character types, or divine essences. In Greek and Roman myths the gods acted just like human beings: they made love and war, experienced jealousy and rage, committed adultery, lied, cheated, seduced male youths and female maids, and sometimes even stole babes. They had no compunctions using their

supernatural powers to conquer a love object for themselves or to cause a mortal to fall disastrously in love.

Their powers, like forces of nature, were fundamentally amoral, and the sexual love they promoted in humans was frequently destructive. For example, Medea, who helped Jason acquire the Golden Fleece, ended up murdering their children in a fit of rage when he abandoned her for another woman. Phaedra, who fell in love with her stepson, Hyppolitus, ultimately caused his death as well as her own. Helen, joined to Paris by the machinations of Aphrodite, subsequently became responsible for the Trojan War—the playwright Aeschylus aptly called her "a heart-eating flower of love." In these and other instances ancient male writers endowed mythological females with hearts capable of the most horrendous deeds. Rarely was the heart united harmoniously with another heart; instead, it was often "eaten," pierced, conquered, invaded, ripped apart, destroyed.

Still, Greeks and Romans looked to marriage as a possible incubator for tender, mutually loving hearts. Starting with Penelope and Odysseus in the *Odyssey*, Greek literature offered the picture of man and wife bound together by affection, family ties, and loyalty to one another. Whatever the daily life of Greek and Roman couples might have been— contentious, miserable, sweet, peaceful, or a mosaic of many possible emotional states—they at least paid lip service to an ideal vision of conjugal love. Flaming romantic love, such as we know it today, was to be feared rather than embraced.

While the heart was the part of the body most frequently associated with love, the classical world did not ignore the genitalia: Greek vases featured scenes of copulation in every possible position, and ancient Athenians even erected large-scale monuments to the phallus. Nude statues of Roman gods

and goddesses did not cover up the penis or female breasts, and Ovid made daring verbal allusions to "the parts a woman loves to have caressed." Still, only the most cynical Greek or Roman would have argued that love resided solely between one's legs.

Chapter 2

Arabic Songs from the Heart

AFTER THE FALL OF THE WESTERN ROMAN EMPIRE (in 476 CE) secular love left few written traces in Europe but found oral and written expression across the Mediterranean in North Africa. There, as in ancient Greece and Rome, language linked the heart to love. Arabic bards known as *rawis* memorized and recited heartfelt love poems, which ranged from risky heterosexual trysts within nomadic tents and "male-male passion" to the chaste adoration of a well-born married lady. Collected in writing during the eighth and ninth centuries, these poems give us a glimpse of love among nomadic Bedouins before the death of Muhammed in 632. Afterward religion supplanted amorous love as the dominant subject of Arabic poetry.

The pre-Islamic lover's heart was often sad and filled with longing for a specific woman. Among nomads meetings were often temporary and partings an occasion for sorrow. Thus, one poet, Ka'b Bin Zuhair, cried out, "Su'ad is gone, and

today my heart is love-sick." Another poet, Umar Ibn Abi Rabi'ah, asked his comrades to sympathize with his one-sided love for Zaynab, who had gained total possession of his heart. A third, al-Aswad Bin Yafur, bemoaned his wasted state as an older man and wistfully looked back to a time when he had savored the pleasures of women who could "shoot the hearts of men (with their eyes)."

If some of these themes sound familiar, that's because the lovesick poet wounded in his heart is by now such a stereotype. We have already seen him in antiquity, and we'll see him again both in the Middle Ages and the nineteenth century. But what is different about these early Arabic lovers was the truly perilous world they inhabited and the bravado they demonstrated in carrying out their adventures. The lover was constantly on the move, surrounded by vast expanses of desert, battered by winds, beholden to his camel, and relieved by the sight of tents in the distance. The women they loved, with their flowing robes and smell of musk, represented a kind of paradise, though poets often depicted them as capricious, like water in the desert. Many desired women had families or husbands or guardians to be avoided. It took reckless courage to carry out the amorous exploits described by these pre-Islamic Bedouins.

Still, there were always a few audacious women who did not let their husbands and children put an end to their love trysts. Imru' al-Qays, once a lover of many women, remembered those he had visited at night and one in particular whom he had "diverted from the care of her yearling." He explicitly described how the mother managed to attend to her infant without putting an end to making love. "When the suckling behind her cried, she turned round to him with half her body, but half of it, pressed beneath my embrace, was not turned from me."

Whew! These lines are "among the most licentious in classical Arabic poetry," according to a knowledgeable scholar. Imru' al-Qays evoked several such conquests as examples of his youthful swagger and ability to please the ladies.

But at the time of writing this poem he was in the midst of an all-encompassing love affair and bemoaned the state of his heart under the sway of one Fatima. No longer free to roam from woman to woman, he complained that his heart had been "wounded" by her eyes, broken to pieces, and could never be restored.

Imru' al-Qays was one of roughly a hundred poets from the pre-Islamic period whose passionate and vivid love poems allow us to enter into the hearts and minds of Bedouin men living in nomadic tribes, where lovers took pride in their daring exploits, sometimes catching love on the run, sometimes—like any other would-be lover in any era—gripped by melancholy for the one person they could not have.

EVERY CIVILIZATION HAS ITS LEGENDARY LOVERS: ANTHONY and Cleopatra for the Romans, Abélard and Héloïse for the French, Tristan and Isolde for the French and Germans, Lancelot and Guinevere for the English and French, Romeo and Juliet for the English. Whether based on real people or totally fictional, they offer an indelible portrayal of fervent love. Each of these couples experienced the joys of erotic passion rendered more intense by obstacles coming from their families, countries, the Church, husbands, and the like. Most had sad or tragic ends.

Arab culture has its legendary lovers in the figures of Jamil and Buthayna, Majnun and Layla, Kuthayyir and Azza. Created by three different poets, these couples interest us not only because they demonstrate fidelity to an amatory ideal but

also because they have been recognized as sowing the seeds for "courtly love"—the kind of love that would assert its sway in Europe during the Middle Ages.

Consider the case of the poet Jamil (circa 660–701), who offered a new archetype for the Bedouin lover—one who was gallant, faithful, and, unlike his predecessors, chaste. Reflecting the values of Islam, which established itself during Jamil's lifetime, this new ideal allowed a lover to adore an Arab woman from afar and remain faithful to her in his heart, even though their emotional bond would never be physically consummated.

Jamil's story follows his infatuation with a young woman from his tribe named Buthayna. At first she responded to his overtures and they managed to meet occasionally, far from the eyes of guardians and gossips. But Buthayna was careful to keep Jamil's attentions limited to conversation and an occasional kiss; any other indiscretion, if discovered, could prove fatal to a Bedouin woman.

It did not take long for Jamil to ask for Buthayna's hand in marriage. When it was denied him because her family had found a more advantageous match for their daughter, Jamil was despondent. Still, he continued to adore her, even in her married state. As he put it: "I loved single women when Buthayna was single / and when she married, she made me love wives." Unlike pre-Islamic poets, Jamil held fast to his one, exclusive love, taking comfort from the thought that he would meet her in the afterlife. In this respect Jamil's vision of love reflected Muslim beliefs: the love denied him on earth would ultimately be attained in paradise. Buthayna became something of a holy figure, the object of Jamil's daily prayers. He and his fellow poets came to regard love like a religion, with the beloved installed as its reigning deity.

IN THE ELEVENTH CENTURY IBN HAZM, AN ARAB THEOLO-
gian, jurist, and philosopher living in southern Spain, wrote a
treatise on love that would become influential not only in the
Arabic world but also in France during the following century.
In *On Love and Lovers* Ibn Hazm set out to "describe love,
its diverse meanings, its causes, accidents, vicissitudes, and
the favorable circumstances that surround it." He promised
to base his work on his personal experiences and on those re-
counted by trustworthy parties. He started out by invoking
religion and law: "Love is not condemned by religion, nor
prohibited by law, because hearts are in the hand of Allah."
Hearts, then, are intimately linked to Allah, who insists on "a
heart devoted to Him" (Quran 26:89).

For all his adherence to the Quran, Ibn Hazm was no
less a Platonist. Like Plato he agreed that love originated in
an appreciation of physical beauty but that true love had to
involve the soul. He recalled the words of an earlier poet:
"When my eyes see a person dressed in red [like his beloved],
my heart breaks and bursts with anxiety." Eye, soul, and, of
course, heart are words that reappear in Ibn Hazm's treatise,
like the refrain in a love song.

Sometimes, during only a brief encounter "love attaches
itself to the heart with a simple look." Love at first sight, go-
ing straight to the heart, seems to be a stock trope in many
cultures. But true love, Ibn Hazm insists, can occur only with
time. He himself had never known love in his heart except
after a long period of time. Many European writers after him
would disagree and stick with the love-at-first-sight moment,
which makes for better drama.

But they would follow his lead in insisting that one can-
not love two people at the same time. As he put it: "In the
heart, there is no place for two loved ones . . . the heart is one

[a unit] and can become enamored of only one person. . . . Any heart that acts differently is suspect in regard to the laws of love." The belief that one's heart can contain only one true love would become a pillar of Western romance.

For the most part, in the world of Ibn Hazm the beloved and the lover were of unequal status. Differences of age, in feeling, in social rank were common. Often a man fell in love with his slave or someone else of a lower class and even ended up marrying her. This situation would be reversed in the European annals of courtly love. There, the minstrel or knight will become enthralled by a woman of higher status, the wife of a king or lord. The husband would allow the young man's attentions to his spouse as long as they remained noncarnal.

In the end Ibn Hazm came down on the side of noncarnal relations. After relating numerous stories about erotic love, mainly heterosexual but also a few homosexual, he excoriated the sins of sex, especially fornication, adultery, and sodomy. Passion itself was ultimately seen as "the key to the door of perdition." His counsel was to abstain from sin and, if possible, follow the path of continence. "He whose heart is led astray, whose spirit is monopolized by love" will end up in Hell. Only the man who comes to Allah "with a pure heart" will be granted an eternal home in Paradise. The heart, as understood by Ibn Hazm, was simultaneously the home of earthly passion—which he condemned—*and* of religious conscience. Whatever his personal experience of passion in the past, Ibn Hazm made his peace with Allah by promoting the spiritual over the physical and by renouncing mortal love for the love of God.

Chapter 3

The Heart Icon's First Ancestors

THROUGHOUT MY RESEARCH INTO ANCIENT GREEK, ROMAN, Arabic, and early medieval civilizations, I was on the lookout for visual representations of the heart, hoping to discover the very first appearance of our familiar heart icon. It is one thing to find associations between the heart and love spelled out in poetry and prose and quite another to discover pictures of the two-lobed symmetrical heart symbolizing love. For many months a stubborn question pursued me: Did the heart icon exist before the high Middle Ages? The answer to that question is both yes and no. Yes, insofar as the shape of the heart icon could be found in the Mediterranean world as far back as the sixth century BCE on the Cyrenian coin shown in Figure 3. No, since that shape did not represent the human heart per se and was not equated with love.

In time I discovered several other "heart" figures on artifacts from the Mediterranean region. For example, a magnificent silver drinking vessel created in Persia (present-day

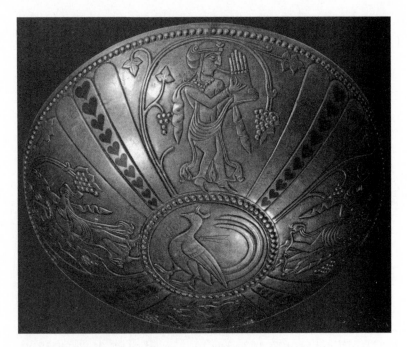

FIGURE 4. Artist unknown, Drinking bowl decorated with female musicians, sixth century AD. Silver, Tehran Museum, Tehran, Iran.

Iran) during the sixth century CE carries motifs shaped exactly like our familiar, scalloped heart. At that time in Persia, before the Muslim conquest and the adoption of Islam, the Sassanian Empire was at the height of its power, with mighty kings and a luxurious court culture. The vessel pictured in Figure 4 is a highly sophisticated work embossed with four female figures—three musicians and one dancer—each encircled by vines and grapes and separated from the others by a row of "heart" decorations. But it is unlikely that these motifs were intended to represent human hearts and even less likely that they were connected to love. Perhaps they were related to

wine, as this is a drinking vessel on which grapes, leaves, and vines are prominently displayed.

Another sixth-century "heart" motif, this time of European origin, made its appearance in Paris in the fall of 2016 as part of an exhibition titled "What's New in the Middle Ages?" (*Quoi de neuf au Moyen Age?*) On a clasp that once belonged to a Catholic chaplain and somehow ended up in the tomb of a sixth-century nobleman, a small object resembling a heart icon had been placed dead center. Was this small "heart" merely a fanciful shape, or did it have a specific meaning?

The late Dutch neurosurgeon and publisher Pierre Vinken argued that such motifs from the early medieval period were not intended to represent the heart; rather, he saw them as merely decorative, more often than not inspired by ivy-like leaves. The examples pictured in his book *The Shape of the Heart* support that thesis. But other early artifacts not included by Vinken suggest that the bi-lobed shape may sometimes have had symbolic meanings, even if we don't know what that meaning was. Some of the most intriguing can be found in the twenty-six Spanish manuscripts of a text known as *The Commentary on the Apocalypse*, dating from the late ninth through the early thirteenth centuries.

The Commentary on the Apocalypse was originally written in Spain by the eighth-century monk Beatus of Liébana, who believed that the world was about to come to an end. This belief was based on the last book of the New Testament—the Apocalypse, or Book of Revelation—which describes in surreal detail the final destruction of the world when the righteous will be swept up into Heaven and all evildoers destroyed by horrendous calamities. Beatus and his

contemporaries had fixed the date of the Apocalypse at the year 800, but even when that date had passed, his *Commentary* continued to be reproduced in numerous monasteries in northern Spain, where Mozarabs had settled. Mozarabs were Christians who had held onto their faith without converting to Islam after the Muslim conquest of Spain in 711.

One of the Beatus manuscripts, from the mid-tenth century and now in the Morgan Library in New York, was made by a Spanish scribe and illuminator named Maius (Ms 644). Of particular interest are the rows of little "hearts" outlined in red so as to mark a separation in the text. According to the medieval manuscript expert Christopher de Hamel, they resemble "those in a love-sick teenage girl's exercise book," but they probably had nothing to do with love.

Moreover, elsewhere in the Morgan Beatus, an illustration of the Lamb of Christ is decorated with two small stylized "hearts" stamped on its body. Perhaps the illuminator of the Morgan Beatus had seen the "heart" motif, already employed among sixth-century Persians and Visigoth Christians, and thought it would make a useful embellishment to his work.

ANOTHER BEATUS MANUSCRIPT, THE GIRONA CODEX completed in 975, contains "hearts" that may have had symbolic implications. In a full-page miniature featuring the Four Horsemen of the Apocalypse, the white horse is decorated from head to tail with what we today instinctively see as little red hearts. Why should this horse bear such decorations while the others do not? If we look into the Book of Revelation for the passage that inspired this illustration, we find a description of the four horses, each with its specific color and attributes:

"a white horse and he that sat on him had a bow."

"another horse that was red: . . . and there was given unto him [the rider] a great sword."

"a black horse; and he that sat on him had a pair of balances in his hand."

"a pale horse: and his name that sat on him was Death."

(Revelation 6:1–8)

FIGURE 5. Artist unknown, "The Opening of the First Four Seals" (detail), from the *Girona Beatus* (folio 126r), tenth century AD. Illuminations decorated with gold and silver, 400 x 260 mm, Museum of the Cathedral of Girona, Girona, Spain. Copyright moleiro.com.

The meaning of these four horses has been bedeviling theologians for centuries. The horses are clearly harbingers of doom, with the reddish one in the upper right symbolizing war, the black one in the lower left symbolizing famine, and the pale one in the lower right symbolizing death. The rider of the white horse is often identified with Christ, but some interpretations have presented him, instead, as the Antichrist.

In the Girona Beatus the rider on the white horse is clearly different from the others (Figure 5). Not only does his horse carry upbeat-looking "hearts," but the rider himself faces backward, toward the other horsemen, perhaps aiming his bow at them. The "hearts" on the white horse may be marking its rider as a counterforce to war, famine, and death, a visual statement consistent with the view that he is a representative of Christ.

ANOTHER MANUSCRIPT FURTHER CONFOUNDS THE ISSUE. Known as the Facundus Beatus from the name of its scribe, it was commissioned by King Ferdinand I and Queen Sancha and dated 1047. It uses the "heart" decoration in several highly imaginative illustrations.

In the "Four Horsemen of the Apocalypse" two of the horses—the one in the upper right and the one in the lower left—are branded with a single heart on their haunches. Why should these two horses be stamped with hearts, whereas the white horse in the upper left is covered with small circles and the horse in the lower right has no decorative imprints whatsoever on its body? This question is unanswerable, at least by me.

Another miniature from the Facundus Beatus, this one titled "Rider Called Faithful and True" shows six horses on three registers. The two horses at the top of the page are branded with a "heart" on their haunches, like a military

insignia, whereas the four horses in the lower registers are not distinguished in this manner. Facundus placed "hearts" on animals in a few other illustrations, as well as in a picture of a palm tree trunk constructed from "heart" shapes lined up one atop the other.

All these Mozarabic "hearts" created in northern Spain during the tenth and eleventh centuries do not appear in later versions of the Beatus manuscripts from the twelfth and thirteenth centuries. Why they disappeared is a mystery, and whether they had a direct connection to subsequent French and Italian illustrations of the heart—both religious and non-religious—remains another mystery. Barring further discoveries, we have to conclude that the "heart" decorations from ancient Persia and early medieval Europe are probably not related to the heart or love. What we see is a pleasing form in search of a meaning or whose meaning has simply been lost or forgotten.

Stop for a moment to consider what might have happened to this shape. If it had become strongly associated with the silphium seed pod pictured on the coin from ancient Libya in Figure 3, it might have become the sign for contraception or abortifacients. Or, five or six hundred years later, when rows of "hearts" appeared on the ancient Persian drinking vessel shown in Figure 4, it may have become the sign of wine and winemakers. Or, in tenth-century Spain, given the evidence of the Beatus manuscript in Figure 5, it might have become a brand for horses. Why not? The double lobes do suggest haunches. But none of these meanings stuck to the scalloped figure we call a heart. It had to await the right set of circumstances to become a symbol of love, and those circumstances would first emerge in the high Middle Ages.

Chapter 4

French and German Songs from the Heart

FIGURE 6. Artist unknown, "Herr Alram von Gresten: Minne Gespräch," from the *Codex Manesse* (COD. Pal. 848, Bl. 311r), 1300–1340. Parchment, cover color miniatures, 35 x 25 cm, Heidelberg University Library, Heidelberg, Germany.

DURING THE TWELFTH AND THIRTEENTH CENTURIES THE amorous heart found a home in the feudal courts of northern Spain, Provence, France, Germany, and Italy. Minstrels called *troubadours* in the South of France (where people spoke Occitane) and *trouvères* in the North (where they spoke old French) celebrated a new form of love that came to be known as *fin' amor*. Fin' amor is impossible to translate: today we call it courtly love, but its original meaning was closer to "extreme love," "refined love," or "perfect love."

Courtly love required the troubadour to pledge his heart—his whole heart—to only one woman, with the promise that he would be true to her forever. Accompanied by his lyre or harp, he would sing his heart out in the presence of his lady and members of the court to which she belonged. Wherever he wandered, he proclaimed his undying love for the one who had aroused his "yearning heart." These words, from the twelfth-century troubadour Bernart de Ventadorn, were reputedly inspired by Eleanor of Aquitaine, whom he visited after she had relocated in England. Eleanor was the granddaughter of William IX, Duke of Aquitaine, credited with having created the first troubadour love lyrics, and she brought with her an entourage of gifted troubadours in her first marriage to Louis VII of France and in her second marriage to Henry II of England.

Bernart began one of his song-poems with the assertion that "Singing has little value / If the song cannot come from the heart. / And the song cannot come from the heart / If it does not have fin' amor within it." Bernart claimed he sang better than any other troubadour because his heart—along with his mouth, eyes, and spirit—was consumed with love and his commitment to his lady was nothing less than global: "She has taken my heart, she has taken everything, / Myself and the entire world."

Fin' amor was supposed to have a positive influence on the lover who strove to prove himself worthy of his beloved. Another troubadour, Arnaud Daniel, maintained that the love within his heart was a force that would make him "improve and grow better." He insisted that such an extreme love had never entered into anyone else's heart or soul. Troubadours were not shy about praising their personal prowess, be it in the domain of song, love, or moral valor.

Neither were they shy about expressing erotic desire. Even the celebrated woman troubadour, the Countess de Die, spoke of the love she felt for her chevalier in terms that were frankly physical. When she wrote, "I grant him my heart and my love," she added boldly that she hoped to hold him in her arms in the place of her husband. This rare woman among male troubadours lauded the joys of the bedchamber, just like the men.

In the South of France, with its sunshine, warmth, and verdant vines, the religious asceticism that gained a greater foothold in the North never seriously challenged sensual life. In the latter region, with its various shades of gray, trouvères were, generally speaking, less focused on the physical. They too pledged their hearts to a chosen lady and willingly submitted to the dictates of fin' amor, however hopeless their quest. Thus, Gace Brulé, a prolific minstrel active around the turn of the thirteenth century, sang frequently of his "true heart," his "honest heart," and his "loyal heart" given to his lady "with no hope of release." The compulsion to love, to sing, and to suffer were all embedded within Brulé's heart, which he called upon as a witness to his lovelorn state: "Heart, how can I help it." He swore to his lady a pledge of permanent submission: "I grant you all my heart and body." Brulé was the consummate poet of unconditional love, as he affirmed in a characteristic refrain: "For my heart wishes to have no one / but her." Even

if she did not share his sentiments, he professed to be grateful for the one-sided love in his heart.

A generation later the Count Thibaut de Champagne, the great-grandson of Eleanor of Aquitaine, also sang of the suffering planted deep within his heart. Following the conventions of fin' amor, he vowed to serve his lady faithfully, just as a vassal served his lord, and to welcome the pleasurable pains induced by love. He wrote, "He who has put all his heart and all his will into loving / Should suffer good and evil, and be grateful." Yet sometimes Thibaut was less resigned and cried out, "If only God would grant me the favor of embracing her beautiful body."

A thirteenth-century minstrel known as Sordello visualized the literal impression his lady had made upon his heart:

> *Love engraved*
> *Your features in an image*
> *Cut deeply into my heart,*
> *And so I've handed myself over,*
> *To do whatever pleases you,*
> *Finely and firmly through all my life.*

The idea of carrying the picture of one's beloved within one's heart became a commonplace among poets, as in the verse of Folquet de Marseille, who declared, "I carry your image deep in my heart, / And it urges me never to change my feelings." When this poem was anthologized in a thirteenth-century collection of troubadour poetry, it was accompanied by an illustration of Folquet wearing the lady's image on the part of his tunic that covered his heart.

Troubadours and trouvères listened to their hearts as guides for the tone and mood of their songs. An anonymous

trouvère was happy to offer his joyful heart to the woman who had inspired him to sing. Another, contemplating the form of his beloved, felt his heart expand and burst into flame "while singing gaily." But more often than not the minstrel's song was wistful and melancholic, as in the case of Blondel de Nesle, who complained that an unfeeling woman had caused his heart to become "black and gray." Sad or happy, sensual or platonic, the poems sung by troubadours and trouvères all celebrated an idealized love that honored women and granted them absolute power in matters of the heart. Of course, in real life most medieval women had practically no power at all, with the exception of those queens, duchesses, and countesses who promoted this new model of love at their courts.

The explosion of song and poetry that started in France spread to surrounding countries, each of which added and created its own variations. Occitane song and poetry infiltrated northern Spain, Portugal, and northern Italy, while northern French poems and stories made their way to Germany, Hungary, and eventually Scandinavia. And in each region love staked out its place not only as a literary concept but also as an important social value and an intrinsic part of being human. Instead of viewing erotic love as a punishment inflicted by capricious Greco-Roman gods or as a sinful experience to be avoided by Christians, secular civilization embraced love as never before. A yearning for amorous love seeped into the Western consciousness and has remained there ever since.

THE MEDIEVAL GERMAN COUNTERPARTS TO FRENCH MINstrels were known as Minnesingers (*Minnesänger*), taking their name from Frau Minne, the personification of love that developed after 1100 in Middle High German. Like their forerunners in France, Minnesingers usually composed both

the words and music for their love songs. Many were members of the minor nobility or were high-ranking commoners who depended for their livelihood on court patronage. In writing and singing about love they adhered to the courtly ideal that had developed in France while adding their own regional and personal flavors.

One of the best-known poems from this period, written by an anonymous Minnesinger, offers a charming picture of mutual love that cannot be destroyed because the beloved person is locked within the speaker's heart.

> *You are mine, I am yours,*
> *Of that you can be certain.*
> *You are locked*
> *Within my heart*
> *The little key is lost:*
> *You must dwell there forever.*

Locking love into one's heart quickly became a common literary trope—one that would find visual representation two centuries later in illuminated scripts.

Another anonymous German poem from the twelfth century also presents a guileless swain with a heart full of love and longing.

> *Come, come, my heart's loved one,*
> *Full of longing I await you! . . .*
> *Sweet, rose-colored mouth,*
> *Come and restore me to health.*

Soon, however, these naïve expressions of love would be superseded by the works of more sophisticated Minnesingers,

such as Wolfram von Eschenbach, Walther von der Vogel-
weide, Heinrich von Ofterdingen, Hartmann von Aue, and
Gottfried von Strassburg. German civilization is lucky to have
preserved two outstanding medieval codices of Minnesinger
verse, *Carmina Burana* (circa 1230) and the *Codex Manesse*
(1300–1340). The earlier one contains both Latin and German
texts, including drinking songs popular with itinerant stu-
dents. The later contains 137 full-page illustrations as well as a
large selection of German poems. These songbooks and oth-
ers written in French, Italian, and Spanish constituted a new
genre during the Middle Ages, one that would have influence
for centuries to come.

The songs preserved in these manuscripts bear testi-
mony to the new vision of love that began to flourish at sec-
ular courts in Germany in the twelfth century. Replacing
the scholarly Latin of the Church, they were intended for
German-speaking audiences thirsty for knowledge of how
they should behave according to the new etiquette for lovers.
Poets like Walther von der Vogelweide (circa 1170–1230) were
eager to instruct them.

"Saget mir ieman, waz ist minne?" (Can anyone tell me
what love is?) Walther asked rhetorically. It was no longer suf-
ficient for a knight to possess a lady physically; he was obliged
to conquer her heart. Walther's poems were miniguides to
this high-minded approach.

Walther began his poetic career by addressing an unat-
tainable high-born lady and sometimes Frau Minne herself,
following the conventions of courtly love, but in his mature
years he developed a less stilted style and a vision of reciprocal
love appealing to people from all stations of life. In one of his
most famous poems, "Unter der Linden," Walther allows a
simple country girl to be the speaker. She meets her lover in

the woods, where flowers are blooming and the nightingale sings. He has already prepared a "little resting place" for the two of them, and there he kisses and embraces her. In German the verb *herzen* literally means "to press to one's heart." And what happened next is known only to the girl, her lover, and the nightingale. The last line of the poem tells us it is best to pass over all of this in silence.

Indeed, Walter's later works, with their rustic ambience, promote a vision of man and woman in harmony with each other and with nature. Walther was foremost among the early German poets in making nature the requisite setting for love. Germans often blended their amorous hearts with flowers, plants, trees, and birds, bringing nature into songs of love as never before. To this day song—perhaps even more than poetry—has become the essential medium for lovers. Think of the countless lyrics from the twentieth and twenty-first centuries that evoke love, from folk and blues to rock and rap. What would the music industry do without the theme of love? And what would love do without love songs?

THOUGH ALMOST ALL THESE HEARTFELT PAEANS WERE written by men, women were not portrayed as helpless or subordinate. According to the ideals of fin' amor, if a man hoped to "win" the heart of a chosen lady, he was expected to demonstrate the nobility of his own heart through numerous trials, a willingness to suffer, and unswerving fidelity. Ultimate power in matters of the heart, however, resided with the woman. As the primary object of the male quest, she was the one for whom the minstrel sang, and she was the one who decided whether his efforts merited her love.

This vision of love ran counter to real-life relationships between the sexes. In reality men—fathers, grandfathers,

brothers, uncles—had control over girls, and husbands had control over their wives. Male dominance in marriage was reinforced by a notable difference in age between spouses, with a woman of seventeen or eighteen usually marrying a man ten years her senior. Yet the ideal relationship promoted by fin' amor reversed each gender's role, with women commanding superior power. Why this reversal occurred in the ethos of twelfth-century feudal courts has intrigued generations of scholars. Some have pointed to the influence of Arabic poetry, which treated the inaccessible lady like a semireligious deity. Some have pointed to the cult of the Virgin Mary as a refining influence upon both men and women. Others have looked to the Crusades, when women assumed greater power at home while the men were away waging war. Certainly the rise of queenship during the eleventh and twelfth centuries, with formidable female figures appearing in Christian Spain, Aquitaine, France, England, Tuscany, Sicily, and the parts of Germany under the Holy Roman Empire, suggested that at least some women were meant to be obeyed.

What, we may ask, made prominent women worthy of such treatment? The man was expected to earn his reward through demonstrating his worth, whereas it was sufficient for her to be beautiful, of high rank, and reasonably articulate. There are few, if any, medieval heroines in literature who can act as role models for women today. And yet in one important respect the Middle Ages provided a lesson in love that is still with us: women, like men, were both encouraged to heed the messages of their amorous hearts—messages they have been struggling to accommodate ever since.

Chapter 5

Romances of the Heart

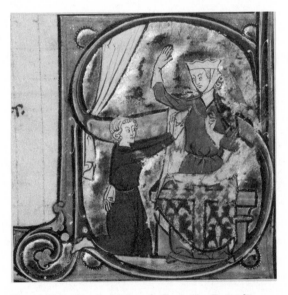

FIGURE 7. Atelier du Maître de Bari, "La Dame livre
son cœur à Doux Regard," folio 41v, illuminated detail
from *Le Roman de La Poire* (fr. 2186), ca. 1250. Bib-
liothèque nationale de France, Paris, France.

MEDIEVAL MINSTRELS SPREAD THE CULT OF THE HEART TO all who would listen. Their songs and stories were sung and recited to rapt audiences from the château to the townhouse and even the barn, where French peasants gathered for after-work evenings known as *veillées*. In these diverse settings romance overshadowed all other subjects.

The very word *romance* comes from the word *roman*—that is, a narrative written in one of the Romance languages derived from Latin (Italian, French, Spanish, Portuguese, Romanian). These tales often followed the adventures of a knight, whose aim was to prove himself in battle and in the bedroom. Over time the French word *roman* has come to stand for the genre of fiction known in English as the novel. Amorous love, in the Middle Ages and even today, was so bound up in the literature of love that it is difficult to know what came first: Did French medieval stories (romans) create the vision of love we now call romantic, or did romantic love exist prior to the storytellers?

Certainly the history of Abélard and Héloïse, from the first half of the twelfth century, indicates that the troubadours were not the first medieval Europeans to obsess over passionate love. The story of the cleric Abélard's seduction of his gifted pupil Héloïse, her pregnancy, their child named Astrolabe, their secret wedding, and Abélard's subsequent castration at the hands of Héloïse's vengeful uncle was already widespread during the couple's lifetime.

Although Héloïse became a nun at Abélard's insistence and eventually rose to the position of abbess, she never denied that her first allegiance was to him—not to God. In her words, "I can expect no reward from God, as I have done nothing for love of Him. . . . My heart was not within me, but with you, and even today, if it is not with you, it is nowhere. It

cannot truly exist without you." Héloïse's letters are the most extraordinary outpourings of the amorous heart to be found anywhere in the Middle Ages and perhaps any age. When she wrote about the heart she had given to her beloved she was not relying on a literary trope but an expression of her lasting ardor and commitment to the man who had been her lover before he was castrated and then devoted his heart exclusively to God.

It was common for medieval minstrels and storytellers to glorify the man or woman who gave his or her heart away at first sight or who had the good fortune of exchanging his or her heart with the beloved. Take, for example, the twelfth-century poet Chrétien de Troyes (1130–1191) when he was under the patronage of Marie de Champagne, the daughter of Eleanor of Aquitaine and Louis VII of France. At Marie's court in the bustling little city of Troyes, where love was elevated into an idealized code of conduct, Chrétien became Marie's resident spokesman for the amorous heart.

In *Cligès*, one of Chrétien's verse romances, a young Greek prince named Alexander, while residing at the court of King Arthur in Britain, falls for Sordamour but is too shy to say so. In a long monologue he takes up an old theory of love's origin: love has wounded him with its arrow, passing into his heart through the eyes without affecting them but causing his heart to burst into flames.

> *It's not the eye that was hurt*
> *But the heart . . .*
> *. . . the eye*
> *Is the heart's mirror, so the arrow*
> *Reaches the heart through its mirror,*
> *Doing no damage to the eye. . . .*

The heart sits in the body
Like a candle set inside
A lantern.

In medieval literature love experienced by men invariably begins with the sight of a beautiful woman. She enters the heart by route of the eyes in countless songs and poems and even in a few illustrations.

Sordamour too falls for Alexander at first sight: "Love's aim was perfect: its arrow / Struck her right in the heart." And like Alexander, she is intent upon keeping her feelings hidden. It's only when Queen Guinevere notices their silent love for each other that their reciprocal sentiments are exposed. In the words of the queen,

I know quite well, from watching
Both your faces, that here
Are two hearts beating as one.

So Alexander and Sordamour allow the Queen to be their matchmaker and King Arthur to seal their love in marriage.

Yet such is the importance of the heart as the locus of love that the writer feels free to digress for thirty-seven lines to *disprove* the idea, presented earlier, that two hearts can beat as one. The author explains that when we say, "two hearts become one— / That's false and impossible; a single / Body can't have two hearts." Two people become one when each feels what the other feels and they both share the same passion: "two hearts / Can share a single desire, / Much as many different / Voices can sing the very / Same song." The total merging that lovers experience because they share the same

feelings is offered as the true meaning of the consecrated expression "two hearts beating as one."

Would such a tangent bore the listener or reader? Not at all. Such was the interest in the amorous heart that the audience was expected to be willing to patiently follow the author's convoluted argument. Suffice it to say that the idea of hearts merging did not disappear. We find it throughout medieval and Renaissance writing as well as in our own times. There is currently a billboard in San Francisco advertising "Two Hearts One Love, Inc.," a dating service. Or, if you already have a sweetheart, you can buy her a "two hearts in one" necklace for $119 online.

ALL FIVE OF CHRÉTIEN'S ARTHURIAN ROMANCES MAKE AMple use of the word "heart" (*cuer* in Old French). References to the heart of his heroes, whether Cligès, Lancelot, Erec, Yvain, or Perceval, are frequent throughout their many fabulous adventures. More often than not their hearts are sad, suffering, regretful, and pained by their distance from the beloved. These negative sentiments lodged in the heart spurred the hero to action with the hope that by overcoming a perceived obstacle, the heart would ultimately find joy.

The heart extolled by twelfth-century storytellers was always faithful to its one true love. As Chrétien de Troyes wrote in his masterful *Lancelot*, "Love, which rules / All hearts / allows them only / One home." Similarly the chaplain Andreas Capellanus, who also enjoyed the patronage of Marie de Champagne, wrote in his Latin treatise *On Love* (*De arte honeste amandi*), "True love joins the hearts of two people with so great a feeling of love that they cannot long for the embraces of others." Here and elsewhere Capellanus echoed some of the

ideas already expressed by the Muslim philosopher Ibn Hazm a century earlier. Fidelity to the beloved was a given in medieval literature, whatever the truth might be outside the text in the lives of real people.

The belief in faithfulness applied whether the sought-after woman was a virginal maid or already married. Obviously, when the desired woman was someone else's wife, love was, to say the least, problematic. The stories of Tristan and Isolde, Lancelot and Guinevere, and other adulterous couples spoke for the appeal of forbidden fruit. Though we can never know the extent to which adultery existed in real life, medieval society seems to have been obsessed with the subject of the adulteress, as reflected in numerous high-culture verse narratives and popular satirical tales known as *fabliaux*. Given the fear that women would produce bastard offspring, feudal practices made it difficult for them ever to be alone. Women of noble birth were constantly surrounded by other women—relatives and servants commanded by the male head of the house to keep careful watch over his wife or daughters.

One of the reasons for the popularity of adulterous stories lay in the belief, fashionable at the court of Marie de Champagne, that true love could not thrive within marriage. Indeed, when asked her opinion, she answered unequivocally, "We state and affirm unambiguously that love cannot extend its sway over a married couple." She reasoned that lovers are free to grant or withhold their love, whereas married people are duty bound to satisfy each other and thus not susceptible to the spontaneous transports of lovers. Echoing his patroness, Capellanus at first defended the view that love can have no place between husband and wife. Yet by the end of *On Love* he had changed his mind. Reverting to a Christian stance, he claimed that the first rule (of thirty-one) for lovers

was, "Marriage does not constitute a proper excuse for not loving." It is likely that Capellanus—a cleric—was ultimately uncomfortable with the negative stance on marital love taken by Marie de Champagne and others of her rank.

Chrétien also attempted to reconcile marriage and love. In *Cligès* he had told the story of two young people whose love led to a happy marriage. In *Erec et Enide* and *Yvain* he went even further and portrayed true love within marriage. Yet his most popular romance, then and now, was *Lancelot: The Knight of the Cart*, a story of adulterous lovers. In this masterly verse narrative Lancelot risks his life in order to free King Arthur's wife, Guinevere, from captivity, and when she is at last assured of her release, Guinevere receives him in her bed, where both of their hearts find ultimate joy.

> *Holding him tight against*
> *Her breast, making the knight*
> *As welcome in her bed, and as happy,*
> *As she possibly could, impelled*
> *By the power of Love, and her own*
> *Heart . . .*
> *. . . he*
> *Loved her a hundred thousand*
> *Times more, for if other hearts*
> *Had escaped Love, his*
> *Had not. His heart was so*
> *Completely captured that the image*
> *Of Love in all other hearts*
> *Was a pale one.*

Lancelot is depicted as the consummate hero not only because he has been victorious in battle and rescued the queen,

but because his heart, too, is heroic and filled with more love than any other heart. By the late twelfth century the amorous heart had risen to the top of the list of masculine virtues, alongside physical courage—in French *coeur* and *courage* are linguistic relatives. Perhaps the most famous heart-identified male of the age was Richard I of England, better known as Richard the Lionheart, who gained fame during the Third Crusade and his armed struggle against the sultan Saladin. Not incidentally, he also wrote songs and poems while he was a prisoner.

THOUGH THE FRENCH INVENTED THE FORM, THE GERMANS quickly took to it. Consider Tristan and Isolde, whose story is best known to us today from the version written by Gottfried von Strassburg (circa 1180–1210) and, six centuries later, Wagner's world-famous opera. In the course of adventures worthy of a superhero, Tristan proves himself to be a perfect knight, but when he is sent from Cornwall to Ireland to woo Isolde for his uncle, King Mark, his fate is sealed. On the return trip Tristan and Isolde mistakenly drink from a magic potion intended for Mark and Isolde on their wedding night. Henceforth, nothing can weaken the mutual passion that invades the bodies of Tristan and Isolde. Having consummated their love on the boat that brought them back to Cornwall, they will keep their erotic relationship hidden after Isolde is duly wed to Mark.

One of the most famous scenes in the tale takes place in a grotto within a forest. It is a setting where sexual love reigns naturally among plants and animals, without the artificial constraints of society and religion. Lovemaking within this grotto is elevated to a form of devotion that unites body, heart, and spirit. To quote only a few lines from this paean

to love: "They fed in their grotto on nothing but love and desire . . . pure devotion, love made sweet as balm that consoles body and sense so tenderly, and sustain the heart and spirit . . . they never considered any food but that from which heart drew desire, the eyes delight, and which body, too, found agreeable."

Gottfried exalts eros and does not try to answer the moral questions raised by adultery. He places the heart at the center of the universe and assumes that it should direct human affairs, whatever the obstacles encountered. One modern critic, in commenting on *Tristan*, concluded that "everything is permitted for those who love."

By 1200, in both French and German high culture, erotic love rivaled and even surpassed the value it had in Greek and Roman antiquity. Love might still be conceived of as madness, but a madness worth living and dying for. Tristan and Isolde will die for love; German even has a word for their act: *liebestod* (from *liebe*, meaning "love," and *tod*, meaning "death"). Centuries later this tragic-cum-erotic destiny inspired Wagner's glorious operatic version of *Tristan and Isolde*.

Though the story of Tristan and Isolde was written for members of the nobility, like many other tales it found its way to audiences beyond aristocratic courts. One indication of their popular appeal appears in the names given to French children at the time of baptism: 120 examples of the name "Tristan," 79 of "Lancelot," 72 of "Arthur," 46 of "Gauvain," 44 of "Perceval," and 12 of "Galehaut" (Gallahad) have been found on church registries dating from the medieval years before 1500. Lovers in the form of knights and high-status ladies seem to have filtered into the imagination of ordinary folk—bourgeois proprietors, middling artisans and shopkeepers, and perhaps even peasants. The fact that illiteracy was the

norm does not seem to have stopped some common folk from imbibing the romance-oriented culture of their "betters."

ONE OF THE MAJOR FORMS OF ROMANCE THAT EMERGED IN the thirteenth century was allegory. Like all allegories, whether secular or religious, these presented abstract ideas as characters in a narrative. Many, if not most, were love stories.

One allegory from the mid-thirteenth century, *The Romance of the Pear* written by a certain Tibaud, left behind a now-famous manuscript with the first-known illustrations of the amorous heart. Although the text itself does not constitute great literature, the colorful miniatures created in the Parisian workshop of the Master of Bari (Maître de Bari) are minor masterpieces. Eighteen oversized decorative letters signal new sections in the text, and all eighteen show a male lover or his emissary. Two include images of the amorous heart.

If you look closely at the picture reproduced at the beginning of this chapter in Figure 7, you will see a pinecone-shaped object intended to represent a human heart. Taken from an illuminated manuscript, this miniature presents two figures encased within the swirling letter S. One figure is a kneeling youth who extends his arms upward with a heart clutched in his hands. The other is a standing lady who raises her right hand in a gesture of surprise and places her left hand on her breast, as if she doesn't quite know what to do with the offering. His simply drawn face expresses humility, hers proud disdain. Her head is encased in a crown-like wimple, her hands in very long gloves, and her body in elegant attire, while he is simply clad in a blue tunic, with a pair of gloves dangling at his waist. Everything fits into the conventional story of a youthful suitor offering his heart to a noble lady.

The object in his hands does not look much like a heart to us. It is obviously not anatomically correct; rather, it has the shape of a pinecone, eggplant, or pear. Yet medieval viewers would have immediately recognized it as a heart offering, such as they had already encountered in song and story.

If we had only this image, we would assume that the young man is offering his own heart to the lady. But the text of the allegory tells us otherwise. The kneeling figure called Doux Regard (Sweet Looks) is carrying *another man's* heart; the gloves at his waist indicate that Sweet Looks is a messenger. This appealing youth has been sent to convey the author/lover's heart for safekeeping to the woman in the image—who is not the lady for whom it is ultimately intended.

Following the courtly conventions of the twelfth and thirteenth centuries, in the *Romance of the Pear* the author/lover is condemned to suffer since the day he found himself in a garden with a highborn lady who offered him a pear from which she had already peeled part of the skin and taken a bite. Once he too had bitten into the pear, he was hooked; the pear's perfume penetrated into his heart and never left. In spite of the obvious connection with the biblical tale of Adam, Eve, and the apple, this story has no moral or religious implications. Instead of the Old Testament God, the reigning deity is the God of Love, who is a character in the story and directs what little action there is. He will test the lover with a series of trials while holding the lover's heart hostage.

It's at this point that Sweet Looks appears. The God of Love chooses him to carry the lover's heart to the woman pictured above. Meanwhile the lover suffers many a trial as he tries to prove himself worthy of the other lady, the one who had offered him the pear, the one he desires. Reason advises him to renounce such an impossible quest and to court a lady

closer to his station. Of course, the author/lover refuses and continues to pursue the lady of his dreams. Finally the God of Love decides that the lover has suffered enough; he shoots an arrow into the highborn lady's heart, causing *her* to suffer the pangs of love. Eventually she is persuaded to send her own heart to the author/lover, and all ends well, as readers at the time would have come to expect.

Surprisingly the second heart illustration in *The Romance of the Pear*, which is enclosed within the capital letter M, is held by a woman—a lady dressed in pink who is shown extending a heart to a young man. The hearts in both miniatures are more or less identical, yet the first is that of a man and the second that of a woman. The male and female heart look alike!

Medieval texts and images gave us men and women who were not so different in their heart of hearts. Like men, women had hearts that expanded to encompass love, that experienced desire and longing, and could be riddled with jealousy and despair. Despite the differences and inequalities that clearly existed between medieval men and women, the heart was considered a realm of equal opportunity.

THE HEART OFFERINGS PICTURED IN THE MASTER OF BARI'S miniatures for *The Romance of the Pear* would proliferate as artistic and literary emblems for several centuries. The heart was shaped like a pinecone because that is the way medical authorities had described it since the time of the Greek physician Galen in the second century CE. Medieval authorities, including the Persian philosopher Avicenna around 1000, the German Dominican friar Albertus Magnus in the thirteenth century, the French surgeon Henri de Mondeville around 1300, and the Italian anatomist Mundinus in the early

Figure 8. Artist unknown, *A Lady Crowning Her Lover*, ca. 1300. Carved elephant ivory mirror case, Victoria and Albert Museum, London, England.

fourteenth century, continued to use the word *pinecone* to describe the human heart.

One of the most famous examples of the pinecone-shaped heart was carved in ivory on the back of a French mirror from around 1300, now in the Victoria and Albert Museum in London (Figure 8). Here the man kneels before his lady and offers up his heart while she raises a large hoop above his head with one hand and touches his draped arm with the other. The

smiles on each of their faces and the curved slant of her head toward his contribute to an aura of gracious affection.

Because this heart bears only a distant resemblance to the anatomical heart, viewers today would not necessarily recognize it as such unless they were already familiar with the theme of the heart offering. We in a post-Freudian era have little difficulty seeing it as a phallic symbol, especially in relation to the circular hoop held in the woman's hand above the man's head. Medieval artisans, without the benefit of Freud, knew exactly what they were doing.

THE ROMANCE OF THE PEAR WAS PART OF A GROWING BODY OF allegory that dominated literature during the high and late Middle Ages. *The Pear* was probably not very popular in its own time, as only three manuscripts of it have survived. By contrast, the extremely popular allegory known as *The Romance of the Rose* left behind over two hundred manuscripts. Begun around 1225 by one Guillaume de Lorris but left unfinished after 4,000 lines, *The Romance of the Rose* was so much in demand that, later in the century, a writer named Jean de Meun added another 21,780 lines.

This elaborate allegory told in the first person starts with a dream supposedly experienced by the narrator four or five years earlier. He had fallen asleep in the month of May, traditionally when love blooms along with the flowers. In his dream he sees himself walking along a riverbank and coming upon a high garden wall with paintings of horrible creatures on it: Envy, Avarice, and Old Age. Despite their forbidding faces, a lady named Idleness helps the young man gain entry into the garden. There, welcomed by Pleasure and Courtesy, he dances with a band of young people and explores an idyllic, flower-garden setting.

At one point he finds a superb rose garden where the sight and fragrance of "roses in profusion, the most beautiful in all the world," overwhelm him. One rose in particular captures the essence of that peerless flower, commonly associated with girls and women. In the words of the text, "From among these buds I chose one so beautiful that when I had observed it carefully, all the others seemed worthless in comparison." This is the moment the God of Love chooses to direct his arrow into the young man's heart. Once again an arrow enters a lover's eyes and penetrates his heart, leaving him permanently wounded. The text does not spare us the painful physical details, meant to be understood allegorically: "I took hold of the arrow with both hands and began to pull hard, sighing a great deal as I pulled. I pulled so hard that I drew out the flighted shaft, but the barbed point, which was named Beauty was so fixed in my heart that it could not be torn out; it remains there still."

As in *The Romance of the Pear* when the hero bites into the pear, the lover in *The Romance of the Rose* is irrevocably hooked. Henceforth, he will submit to the God of Love and pursue the lady of his dreams, whatever the obstacles and consequences.

Characters named Courtesy, Reason, Jealousy, Wealth, and the trio of Rebuff, Fear, and Shame either abet or oppose the Lover's suit. Of course, he eventually overcomes all obstacles and enjoys the rewards of love. From this simplistic summary you would never guess that such a story could have been a medieval best-seller. It was more than that, in fact, for it provided a vision of love shared by an untold number of men and women—not only the French but also Germans, Italians, and other Europeans who read it in translation.

The Rose even inspired a major controversy more than a hundred years later at the very beginning of the fifteenth

century, pitting the learned poet Christine de Pizan and the chancellor of the University of Paris, Jean Gerson, who jointly condemned the book, against others who lauded it. Christine argued that *The Rose* was written by a man who knew little about women: Jean de Meun had been a cleric. She fumed against its nasty, misogynistic passages—the book contains several—as well as obscene words used for various parts of the body. In short, Christine denounced *The Rose* as essentially immoral. Whatever one thinks of it, it's hard to imagine any book today that would attract a devoted following for two centuries and inspire a heated debate at the highest levels of society.

Chapter 6

Exchanging Hearts with Jesus

FIGURE 9. Henri Van Severen, *The Sacred Heart of Jesus*, ca. 1900. Embroidery, Saint Nicholas's Church, Ghent, Belgium.

FASCINATION WITH THE LOVING HEART WAS BY NO MEANS limited to the secular world. During the eleventh, twelfth, and thirteenth centuries voices from within the Catholic Church discovered new ways of expressing love for God by focusing on the heart of Jesus. Christians believed that Jesus, the son of God, had a heart that was human as well as divine. Like all human hearts, his heart ached and suffered, and God-like, it sympathized and loved. Visions of his sacred heart, both wounded and compassionate, found their way into monasteries and convents, where monks and nuns addressed their prayers directly to the heart of their savior.

The religious heart was explicitly hostile to the amorous heart because erotic love was seen as a powerful rival to the love of God. From Saint Paul onward and especially after Saint Augustine, the Church promoted the idea that the sex act was meant solely for the purpose of procreation and should not be accompanied by passionate manifestations of sensual love. Marriage was better than extramarital fornication, but it was still considered a lesser state of grace than virginity and celibacy. But if we look closely at what was said and written by certain monks, friars, nuns, and theologians, it becomes clear that human love and the love of God were often intertwined. Such was the influence of the amorous heart that it penetrated the reclusive confines of monasteries and convents. And such was the force of the religious heart that it brought a spiritual element into the ideals of courtly love.

Jesus's wounded heart became the ultimate object of Christian veneration during the Middle Ages. Pious individuals meditated upon the crucifix showing the bloody gash in Jesus's side and were moved to feel his pain in their own hearts. After Saint Francis suffered the stigmata—wounds on his body replicating those endured by Jesus on the cross—such

wounds were seen as marks of divine favor. Other stigmatics, predominantly women, subsequently experienced marks on their hands, feet, chests, wrists, foreheads, or backs, and the Church subsequently honored many of them as saints.

Consider the Sacred Heart of Jesus, a familiar symbol today throughout the Christian world. Bursting into flame, encircled with a crown of thorns, Jesus's wounded heart has its roots in the mystical practices of such revered Church figures as Saint Anselm of Canterbury (1033–1109), who employed a language that was often heart centered. When he was abbot of the French priory of Bec, he wrote to his beloved fellow monk Gudulf, "Everything I feel about you is sweet and joyful to my heart." In his prayers he begged Jesus to take him into the magnanimous mercy of his divine heart. Saint Anselm set the tone for later monks, including Saint Bernard of Clairvaux (1090–1153) and Saint Bonaventure (1221–1274), who explicitly advised Christians to find their way to Jesus's heart through meditating upon the wound in his side.

Readers may be familiar with the names of Saint Anselm and Saint Bernard and possibly even Saint Bonaventure, but who has heard of Saint Gertrude the Great of Helfta (1256–1302)? I hadn't before I started to research a history of female friendship and found Gertrude hidden away in the fortress-like stacks of the Stanford University library. She is of interest to us here because her spiritual writings contain some of the most intimate visions of Jesus's heart.

Gertrude entered the monastery of Helfta in northern Saxony at the age of five and remained there for the rest of her life. Helfta was already a renowned center of culture and mysticism, under the direction of its abbess Gertrude of Hackeborn, and another remarkable nun, Mechtilde of Hackeborn,

who was to become Gertrude the Great's spiritual mentor and closest friend.

Unlike many other members of the monastery, Gertrude did not come from a noble family. In fact, little is known about her family of origin. What we do know is that she distinguished herself early by her intelligence, love of learning, ability to write in both German and Latin, and competence as a copyist of ancient manuscripts. With her older friend, Mechtild of Hackeborn, she chanted the liturgy, studied scripture, and performed daily tasks like spinning, embroidering, and caring for the sick. In 1291 Mechtild revealed to Gertrude her longstanding revelations and eventually allowed Gertrude to record them in what is now known as *The Book of Special Grace* (*Liber specialis gratiae*).

In time Gertrude had her own visions, which she recorded in the works that have survived under the titles *The Herald of Divine Loving-Kindness* (*Legatus divinae pietatis*) and *Spiritual Exercises* (*Exercita spiritualia*), both composed in medieval Latin prose. Most of her visions concerned her meetings with Jesus and a few with his mother, Mary, and all are studded with captivating images of the heart. Her intimate encounters with Jesus often sound remarkably like those in medieval romances.

In Book II of her *Herald*, the section most assuredly of her own hand, she tells us that when she was in her twenty-sixth year she met an adolescent Jesus at twilight. He stretched out his hand toward her and said, "Come to me and I shall make you drunk with the torrent of my divine voluptuousness." From that point on, she was imbued with a spiritual joy that made it possible to accept previously unbearable burdens. Gertrude's language, like that of so many other mystics, is not only spiritual but vividly sensual in her expression of love.

Seven years later Gertrude engaged an unnamed person to recite for her a daily prayer in front of a hanging image of the crucifixion. This person implored Jesus, on behalf of Gertrude, to "pierce her heart with the stroke of your love." Inspired by this prayer, Gertrude added an impromptu supplication at Sunday mass: "I beg your Loving-kindness to pierce my heart with the arrow of your love." Immediately she felt that her words had reached Jesus's divine heart.

Returning to her pew after taking communion, she had a second vision, this one inspired by a picture of the crucifixion within her book of worship: "It seemed to me that from the right side of the Crucifix painted on the page, that is to say, from the wound on that side, there issued a ray of light, with the sharp point of an arrow, and, miraculously, this ray spurted out and then withdrew, only to spurt out again, and the effect of this prolonged activity was to tenderly excite my love." What a strange mixture of scriptural reference and sexual imagery! The blood and water that flowed out from the side of Jesus after he had been pierced by a soldier's lance, according to the Gospel of Saint John, has been reimagined as a ray of light. And yet it is the spurting and withdrawal and respurting that excite her love. It's hard for a modern reader not to see erotic longing leaking from the unconscious.

Over and over again in the *Herald*, whether a given passage was written by Gertrude herself or reported by those who knew her, she expressed her love for Jesus through images of their two hearts joined together as one. Some of her dialogues with Jesus sound as if they would have been at home in a French romance like *Lancelot* or *Cligès*. We hear Jesus speaking about Gertrude: "The beating of her heart is mixed with the beating of my love." And again: "Under the ardent love that her heart brings me, my entrails melt . . . as

fat melts in the fire, and the sweetness of my divine heart dissolves next to the warmth of her own heart."

How are we to understand these amorous words placed on the tongue of the Christian Lord? Certainly Saint Gertrude was shaped by her times, when love was on the lips of anyone who could read and many more who could not. The letters of Saint Anselm to his brother monks are filled with comparable expressions, which in his case could be interpreted as homoerotic. But love as experienced and expressed by medieval mystics should not be reduced to sublimated sexuality; they loved God in a style that was in keeping with the religious culture of their times.

How did Gertrude understand her own heart? At another point in the *Herald*, when speaking to Jesus, she turns to a traditional Christian interpretation: "I knew that, thanks to you, my heart is the home of my soul." Since biblical times both Jews and Christians have conceptualized the heart as the dwelling place of the soul, and in that tradition Gertrude, like other mystics, understood her rapturous experiences as spiritual encounters with Jesus and God.

In Gertrude's other prayers, meditations, litanies, and hymns, collected under the title *Spiritual Exercises*, she called repeatedly upon the heart of Jesus to receive the burning love she felt in her own heart: "Stamp my heart with the seal of your heart." "From my heart I long for you." "Open to me the innermost recesses of your heart." "May your love carry my heart into you so that I may cling inseparably to you as if by glue." "My soul loves you, my heart desires you, my virtue cherishes you." "You are what my heart thirsts for." "My heart already burns for the kiss of your love." "Show me the agreement of the nuptial contract that my heart now has entered into with you." "Blessed the heart that senses the kiss of your heart."

In many instances Gertrude's appeals to Jesus's heart have a distinctly female tone. She sees herself as the bride of Christ, as his spouse, his lover, his daughter, his prisoner. Sometimes she articulates her love in a manner that recalls the outspoken female speaker in the biblical *Song of Songs* or certain lustful women found in medieval love stories. How could she have come to know those romances if she had entered the monastery at age five? What texts might she have discovered in the scriptorium, and what tales did she hear from other nuns who had entered the convent as adults? She was comfortable mentioning Venus several times in her writings, and she was familiar with the exchange of hearts as a literary conceit, which she appropriated as her own.

Imbued with erotic significance from several sources—biblical, classical, and courtly—the heart became the object through which Gertrude established a love relationship with Jesus. Along with her sister nun Mechtild of Hackeborn, Gertrude helped sow the seeds for the cult of the Sacred Heart of Jesus that would grow during the following centuries largely through the efforts of women.

Saint Catherine of Siena (1347–1380) was another female saint recognized for her devotion to the Sacred Heart. After a mystical experience when she was about twenty-one, she thought of herself as married to Jesus and even believed she wore an invisible marriage ring to symbolize their union. Catherine's religious thoughts recorded in a work called her *Dialogue* and the many letters she dictated to persons as diverse as monks, popes, queens, and prostitutes attest to a fixation on the wounded side and blood of Jesus. Once in a vision, when she asked Jesus why he had wanted his side to be opened and pour out such a torrent of blood, he replied, "First of all, I wanted this because by having my side opened

I showed you the secret of my heart. For my heart held more love for humankind than any eternal physical act could show." Surrounded by devoted disciples, Catherine was highly influential in Catholic circles during her short lifetime, which led to her canonization in 1471.

A SIMILAR DEVOTION KNOWN AS THE IMMACULATE HEART of Mary can also be traced back to Gertrude the Great and Mechtild of Hackeborn as well as to Saint Bridget of Sweden (1303–1373). Praying directly to Mary's heart, these women revered it as the symbol of her love for God the Father, her maternal love for Jesus, and her overflowing love for all humankind. Devotees of the Immaculate Heart can point to the Gospel of Luke, in which a prophet named Simeon said to Mary that she, like her son, had great sorrows ahead of her, and that her heart would be pierced with a sword (Luke: 2:35). To this day many devotees of the Virgin Mary honor her daily by reciting the following Novena Prayer to the Immaculate Heart of Mary.

> O Most Blessed Mother, heart of love, heart of mercy, ever listening, caring, consoling, hear our prayer. As your children, we implore your intercession with Jesus your Son. . . .
>
> We are comforted in knowing your heart is ever open to those who ask for your prayer. We trust to your gentle care and intercession, those whom we love and who are sick or lonely or hurting. Help all of us, Holy Mother, to bear our burdens in this life until we may share eternal life and peace with God forever.
> Amen.

FIGURE 10. LEOPOLD KUPELWIESER, *The Immaculate Heart of Mary*, ca. 1836. Oil on panel with gold leaf, Peterskirche, Vienna, Austria. Photograph by Diana Ringo.

The two devotions—the Sacred Heart and the Immaculate Heart—arose around the same time and share some similarities but also differ in important ways. Devotion to the heart of Jesus is intended to produce an intimate encounter with Jesus through his divine heart. Devotion to Mary's heart serves the function, as Mary often does, of mediating between the Christian believer and Jesus or God.

Visual representations of the Sacred Heart of Jesus and the Immaculate Heart of Mary began to appear from around 1400 onward. One of the most beautiful Sacred Hearts was painted circa 1452–1460 by the celebrated French painter Jean Fouquet for a Book of Hours that is now in the Louvre. Fouquet's miniature shows Jesus's heart with flames rising from it. Another striking Sacred Heart from a Book of Hours produced around 1490, now housed in the Pierpont Morgan Library in New York, shows the heart affixed to the cross, pierced by four heavy spikes and encircled by a crown of thorns. The Immaculate Heart of Mary is often pictured pierced with a sword or with seven swords for her seven dolors and encircled with roses or lilies. Long before the present day, images of the Sacred and the Immaculate Hearts had become familiar symbols throughout the Catholic world.

Chapter 7

Caritas, or the Italianized Heart

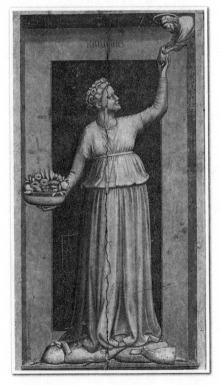

FIGURE 11. Giotto di Bondone, *Caritas* (detail), 1305. Fresco, Scrovegni Chapel, Padua, Italy.

IN NORTHERN ITALY AROUND 1300 THE AMOROUS HEART WAS everywhere, a fashionable theme in literature and the visual arts. It could be found in the poetry of the *dolce stil nuovo* (the new sweet style), whose most famous exemplar was Dante; in the frescoes of the master painter Giotto; and in the texts and illustrations of a little-known jurist named Francesco da Barberino.

The "new sweet style" was inaugurated by the poet Guido Guinizelli. His poem "Al cor gentil rempaira sempre amore" ("Within the Gentle Heart Love Always Dwells") magnified the spiritual dimension of love and lauded the women who inspired it. Only the "gentle" or "noble" heart could feel true love, an experience Guinizelli interpreted as a kind of religious devotion. He suggested that by adoring God's most perfect specimen—the angelic lady—the lover was simultaneously worshipping God. In the balance between sensual love (*amor profano*) and spiritual love (*amor sacro*) Guinizelli tilted the scale in favor of the latter.

Following Guinizelli's lead, Dante (circa 1265–1321) wrote a sonnet that captured the oneness of love and the heart as never before:

> *Love and the gentle heart are one thing,*
> *As the sage [Guinizelli] declares in his poem,*
> *and one cannot be without the other.*

Dante decreed that the world is ruled by the lord of love and that the heart is love's dwelling place once it is activated by the appearance of the right person.

> *Then beauty appears in a virtuous woman,*
> *Pleasing the eyes so much that, within the heart,*
> *a desire for the delightful thing is born.*

And it dwells there [in the heart]
until the spirit of love is woken.
And a worthy man does the same in a woman.

Dante's lady embodies a form of sublime beauty that is both physical and spiritual. Of course, she enters into the heart through the eyes, following a trajectory that had been around since Plato, but she must also be *saggia*—wise or virtuous—if she is to reach the poet's heart.

Dante found this ideal woman in the person of Beatrice, a figure familiar to any student of literature. According to Dante, he saw her for the first time when she was almost nine and he barely a year older. Her image remained persistently in his mind even though he saw her only a few more times before her early death at the age of twenty-four. After her death Dante composed the work in her honor that eventually became *La Vita Nuova* (*The New Life*). In it he sought his personal happiness by writing words of praise for Beatrice and by elevating her to semidivine status:

She is the best that nature can produce;
she is the very exemplum of beauty.

In another sonnet found in the *Vita Nuova* the effect of Beatrice's miraculous presence is felt by all who look upon her:

So gentle and so honest appears
my lady when she greets others,
that every tongue, trembling, becomes mute.

The sonnet ends with lines that follow the route of love to two different destinations within the lover's person: "She

sends a sweetness to the heart" and "a soft spirit full of love / that goes straight to the soul saying: Sigh." This new concept of love is directed to both heart and soul, both matter and spirit, and produces a form of beatific contentment. As the Italianist Robert Harrison eloquently puts it, "the sigh that ends the poem . . . brings its subject to rest in aesthetic stasis. Here Beatrice no longer incites desire but placates it."

There is one very strange scene in *La Vita Nuova* that cannot be avoided in any discussion of Dante and the heart. In a dream Dante sees a frightening, high-ranking man who announces in Latin "I am thy master." This man is holding in his arms the sleeping figure of Beatrice, naked but wrapped in a crimson cloth. What follows next is shocking: "In one hand he seemed to be holding something that was all in flames, and it seemed to me that he said these words: *Vide cor tuum* [*Behold your heart*]. And after some time had passed, he seemed to awaken the one who slept, and he forced her cunningly to eat of that burning object in his hand; she ate of it timidly."

In short, Dante portrays Beatrice eating his heart! Even softened by the Latin words suggestive of Catholic ritual, the vision is cannibalistic. The act of eating human flesh, however "timidly," has savage overtones inconsistent with the sublime Beatrice. The scene ends suddenly with Beatrice carried away in the arms of the unknown man, "and together they seemed to ascend toward the heavens."

Dante's vision of the "eaten heart" is surely related to other medieval tales in which an adulterous wife is served the heart of her lover and eats it unknowingly—all due to the machinations of her jealous husband. But this oneiric scene is more enigmatic and has confounded interpreters for seven centuries. The least one can say is that by eating Dante's heart

and then ascending to heaven, Beatrice prepares for their own reunion in Dante's *Divine Comedy*, where she will ultimately appear as his guide to Paradise.

DANTE AND THE *STIL NUOVISTI* POETS, ALTHOUGH DIRECT successors of the troubadours from Provence, diverged significantly from their view of love. The Italian poets rejected eroticism for its own sake and, in its place, embraced a love that does not aspire to sexual consummation. The figure of Beatrice carries us into the realm of the angels.

Secular love, whether called *amore* in Italian, *amor* in Latin, *amour* in French, or *Minne* in German, continued to be viewed with suspicion in official Catholic circles. *Caritas*, the replacement offered by the Church, had a dedicated following among monks and nuns and others able to renounce pleasures of the flesh. For a layman Dante went as far as he could to subdue sexual desire and spiritualize love. Along with other Italian poets, he attempted to imbue *amor* with enough *caritas* to tone down its overt sexuality and effect a truce between those two rival visions of love.

But in his literary imagination it was impossible for Dante to ignore eros. In *The Divine Comedy* he gave us the figure of Francesca da Rimini, placed in the flames of hell and destined for all eternity to remember the adulterous passion that had led to damnation. Francesca recounts how she and Paolo fell in love while reading the story of Lancelot and Guinevere. This example of what René Girard has called "mimetic desire" speaks to the role of literature as an agent that incites passion. For hundreds of years, long before the advent of film and television, readers like Paolo and Francesca first learned about love from legends, romance, poetry, and drama. Dante suggested that such tales can have a pernicious effect on one's

soul. And yet he gave us the captivating figure of Francesca, whom women can identify with to this day, even if they don't follow her adulteress path. It's hard to say the same about the saintly figure of Beatrice.

IN ITALY LITERATURE AND ART ENHANCED ONE ANOTHER. When we look at the visual arts from around 1300 we find an explosion of heart imagery related to the theological virtue of *caritas*, sometimes translated from Latin into English as "charity," and sometimes as "love." Caritas is mentioned in the Bible in a well-known passage from Saint Paul: "And now abideth faith, hope, charity, these three; but the greatest of these is charity" (I Corinthians 13:13). By "charity" Paul did not mean giving alms to the needy, as we use the term today, but rather love of one's fellow man and kindness in general.

This passage was singled out by the thirteenth-century religious philosopher Saint Thomas Aquinas in his encyclopedic *Summa Theologica*. In that text he devoted a section to the theological virtues of faith, hope, and charity, with a decided preference for charity, which he understood as the love of God and other human beings. His interpretation of charity encompassed *misericordia*, the virtue that calls for empathy with others and actions that alleviate suffering. What we would today call compassion was for Aquinas a consequence of loving God.

What does the theological virtue of charity have to do with the amorous heart? Around 1305, when Giotto painted the figure of Caritas among the panels of Virtues that adorn one side of the Scrovegni Chapel in Padua, he was probably inspired by secular images of the "heart offering" made in France. The monumental figure of Charity lifts her heart to a haloed, bearded figure, who is presumed to be Christ (Figure

11). This scene clearly recalls the amorous heart offering found in *The Romance of the Pear*, at least in style. Once again the heart is pinecone shaped, with its narrow end pointed upward and its wider, lower part held within a human hand. From a distance one would mistake it for a piece of fruit or a vegetable, perhaps a pear or eggplant, but on closer inspection the aorta can be seen issuing from the bottom of the upside-down heart. In her other hand Charity holds a basket of fruit to give to the poor.

Giotto's *Caritas* influenced subsequent Italian painters and sculptors, whose works still grace the churches and museums of northern Italian cities. These include the relief sculpture made by Andrea Pisano around 1337 for the bronze door of the Baptistery next to the Florence Duomo, with Charity holding a heart in one hand and a torch in the other. Siena, too, boasts a Caritas fresco painted by Ambrogio Lorenzetti around 1340 for its Palazzo Publico.

Caritas is always represented as a woman. Undoubtedly the veneration of the Virgin Mary, which reached new heights in the thirteenth and fourteenth centuries, was at work here. Mary's image, carved into stone on the facades of gothic churches, shining through gigantic rose windows and even graciously portrayed in miniature ivory pieces, imbues Caritas with the female ideal of maternal love.

One rare work placed the Virgin Mary and Caritas together. In *Madonna with Caritas*, painted by the master of the Stefaneschi Altar during the early fourteenth century and now in Florence's Bargello Museum, a seated Mary holds the baby Jesus in her lap while a standing Caritas stretches out an elongated arm to offer him her heart.

All these Italian works, following the example of Giotto's *Caritas*, show the heart in its pinecone shape. The

symmetrical, bi-lobed heart icon, which would become our familiar "valentine" heart, had not yet appeared on the scene.

THE ARTISTIC HISTORY OF THE AMOROUS HEART, LIKE THE evolution of animal species, has its strange mutants, unique creations that arise suddenly and subsequently disappear or persist as more permanent species. We come upon such a creation around 1300 in Italy on the pages of a text written and illustrated by one of Giotto and Dante's contemporaries who called himself Francesco da Barberino.

Whereas Giotto was already famous in his lifetime for his paintings and Dante for his poetry, only a very small number of Italians living around 1300 would have recognized the name Francesco da Barberino. Even today he is known only to specialized scholars. And yet in a roundabout way he contributed significantly to the heart icon now enjoyed globally by hundreds of millions if not billions of people.

Francesco di Neri di Ranuccio was born in the Tuscan town of Barberino in 1264, one year before Dante. As an adult he would take on the name of his birthplace and present himself as Francesco da Barberino. He studied the seven liberal arts (grammar, logic, rhetoric, arithmetic, geometry, music, and astronomy) in Florence and pursued judicial studies at the prestigious University of Bologna, obtaining the title of notary in 1294. Between 1297 and 1304 he lived in Florence and exercised the function of Church notary for two bishops. He also came into contact with the chief Florentine poets of his age, among them Dante, before that great poet was forced into exile in 1301. Like the other poets of his age, Barberino took up the pen to praise a lady, in his case a woman named Constanza (Constance). Along with poetry he also took up drawing, possibly under the tutelage of Giotto or a member

of Giotto's workshop. Barberino was clearly familiar with the works of the early Renaissance's most revered painters, namely Cimabue and Giotto.

He spent the four years between 1309 and 1313 in France, where he made connections with the highest authorities, ranging from those at the pontifical court in Avignon to the royal court in Paris presided over by King Philippe le Bel. He stayed for the longest period in Provence, familiarizing himself with troubadours and the Occitane language. His residence there did not prevent him from traveling extensively throughout France, from the south and the center as far north as Picardy. His French connections obviously served him well because when he returned to his own country, he obtained a papal bull that allowed him to practice both civil and canonical law. Somehow, with all that traveling and a wife who bore him five children, he managed to complete the major part of two substantial literary works, *Documenti d'Amore* and *Reggimento e costume di donna* (*Precepts on Love* and *Rules for Women's Conduct and Clothing*).

Barberino's *Documenti*, written in an unwieldy combination of Italian and Latin, presented a semireligious vision of love in praise of a lady, whose role was to elevate the lover's soul. The more he loves, the more he deifies her, and the more he strives to be worthy of her perfection. Through his writing Barberino brought the songs of Occitane troubadours and the allegories of French storytellers back to his native soil, adding a strong dose of Italian erudition and Catholic morality. His love precepts do not spring from the heart but from a highly cerebral head.

And yet his drawings in the *Documenti* manuscripts, specifically those showing the figure of Cupid, are surprisingly original (Figure 12). Cupid appears in full triumph standing on a galloping horse. He has his traditional wings, a quiver

full of darts in one hand, a branch of roses in the other, and a leafy bandolier strung across his chest. And as in other fourteenth-century versions of Cupid, he also has talons, which Barberino saw as symbols of love's firm grasp. Nothing particularly original so far. But look again: What do we see across the neck of the horse? A string of hearts! Red hearts painted in one manuscript, black and white hearts sketched in the other. It is true that these hearts appear from a distance more like triangles, but even without the aid of a magnifying glass, an indentation between two rudimentary lobes can be seen in each of the hearts. Cupid races off victorious with the hearts he has pierced, leaving behind a row of love-struck individuals, who appear beneath him.

In a short treatise on love (*Tractatus Amoris*) at the end of the book the author tells us that Cupid's horse does not need a saddle, a bridle, or spurs because "for Love, the absence of a bridle presents no inconvenience. . . . Love doesn't risk falling off." The text zeroes in on the darts, which are described as "little, numerous and evil like savage animals." And if we still have any doubts about the items strung around the horse's neck, we are told that the animal is obliged "to carry many hearts" ("site quor molti gli faccio portare"). I am by no means the first person to have discovered those amorous hearts carried off in triumph by Cupid. The great art historian, Erwin Panofsky, called attention to them as early as 1939, and other more recent observers have added their own insightful commentaries.

Panofsky was also the first to link Barberino's illustrations to another Cupid bearing a string of hearts, painted by Giotto and his associates around 1323. These later hearts are not hidden away in a difficult-to-access library but are found in a church fresco that can be viewed to this day: the "Allegory of

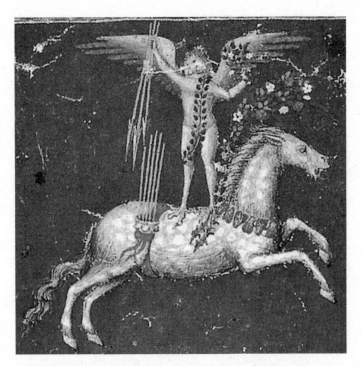

FIGURE 12. Francesco da Barberino, "The Triumph of Love" (detail), from *Documenti d'Amore*, ca. 1315. Illuminated manuscript illustration, MS Barb. Lat. 4076, Vatican Library, Rome, Italy.

Chastity" in the lower church of San Francesco at Assisi (Figure 13). In the fresco, although the motif of hearts strung on a rope is similar to Barberino's, almost everything else is different. To begin, the hearts are worn by Cupid himself and not by his horse. They are slung across Cupid's nude body as a replacement for the leafy bandolier in the Barberino version. But the hearts themselves do not show the indentations and rudimentary scallops of the Barberino hearts and look more like pieces of fruit hanging by their stems. Moreover, the adolescent Cupid with wings and darts, unambiguously

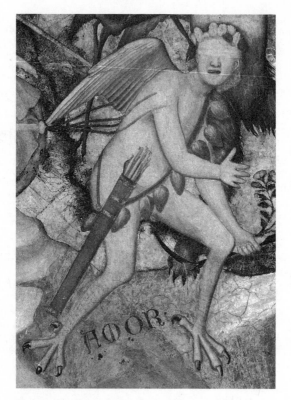

FIGURE 13. Giotto di Bondone, *Allegory of Chastity* (detail), ca. 1320. Fresco, Lower Church, San Francesco, Assisi, Italy. Image credit: Scala/Art Resource, New York.

identified by the word *AMOR* between his clawed feet, has the added feature of being blindfolded. This new development in the iconography of Cupid is meant to convey the idea that love is blind—that is, irrational and foolish.

The overall point of the Assisi fresco is different: whereas Barberino's illustrations had celebrated the triumph of love, the fresco vilifies it. We see Cupid (Amor) and his similarly

nude companion (Ardor) being chased away from the Tower of Chastity by a black skeleton with a scythe who represents death (Mors). Panofsky likened the bandolier across Cupid's body to the string of a quiver "on which are threaded the hearts of his victims like scalps on the belt of an Indian." In the Assisi church Amor is banished from the company of righteous-minded men and women and relegated to extinction among the damned.

The rudimentary hearts drawn around 1300 by Francesco da Barberino and by Giotto around 1323 were followed in the 1330s by figures closer to our own familiar heart icon. Witness, for example, a miniature of the Virgin of the Assumption surrounded by a bevy of angels, now hidden away in a register of public documents belonging to the city of Siena (Figure 14). This colorful painting, circa 1334–1336, is signed Niccolò di Ser Sozzo, but no other works by him are known to exist. In the lower portion of the miniature a kneeling woman in flowing robes struggles to lift a huge golden barely indented heart—it is almost as big as she is—up toward the Virgin sitting placidly above. This extraordinary image is proof that the Italianized version had almost completely evolved into the heart's ultimate iconic form by the fourth decade of the fourteenth century.

Yet to equate Ser Sozzo's heart with our own typical heart icon would be only partially correct. His heart image and the others that emerged in Florence, Siena, Padua, Pisa, and Assisi during the early fourteenth century were all religious in nature—hearts offered to God, Jesus, or the Virgin Mary. What we do not find in Italian paintings of this period are positive images of the amorous heart offered by one human being to another. For that we need to travel north into France and Flanders.

Figure 14. Niccolò di Ser Sozzo Tegliacci, *Assumption of the Virgin* (detail), ca. 1334–1336. Illuminated manuscript illustration, Archivio di Stato, Siena, Italy. Image credit: Scala/Art Resource, New York.

Chapter 8

Birth of an Icon

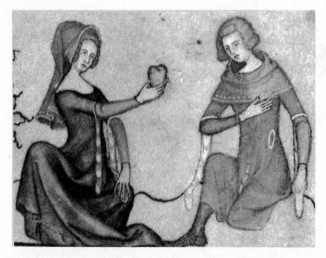

FIGURE 15. Jehan de Grise and his workshop, "The Heart Offering," 1338–1344. Illuminated manuscript illustration, from *The Romance of Alexander*, MS. Bodl. 264, folio 59r, Bodleian Library, Oxford, England.

THE BODLEIAN LIBRARY IN OXFORD POSSESSES A PRICELESS manuscript titled *The Romance of Alexander*, written in the French dialect of Picardy by Lambert le Tor and, after him, finished by Alexandre de Bernay. The scribe, Jean de Bruges, signed off with a flourish on December 18, 1338, and the illuminator, Jean de Grise, in 1344. With hundreds of exquisitely ornamented pages, *The Romance of Alexander* is truly one of the great medieval picture books. One of its illustrations has the distinction of being the first indubitable heart icon symbolizing secular love.

Unlike the illustrations in *The Romance of the Pear*, those in *The Romance of Alexander* are not generally linked to the text. The scene containing the heart image appears in the lower border of a page decorated with sprays of foliage, perched birds, and other motifs characteristic of French and Flemish illumination (Figure 15). On the left-hand side a woman raises a heart that she has presumably received from the man facing her. She accepts the gift of his heart while he touches his breast to indicate the place from which it has come.

On the right-hand side there is a very different scene: a lady turns away from a suitor who offers her a purse. The two couples present a graphic vision of how men and women should and should not relate to each other: one is pure and inspired by feelings from the heart, the other is venal and based on material rewards.

The *Alexander* manuscript is filled with pictures of young people flirting, kissing, playing chess, listening to various instruments. It's practically a compendium of activities that took place at court and in towns throughout France and Flanders. In addition, there are phantasmagorical images of monkeys and exotic animals as well as a few earthy scenes where males show their bare asses in a spirit of defiance. Most of

these scenes have absolutely nothing to do with the highly fanciful narrative concocted around the historical figure of Alexander the Great.

STARTING IN THE 1340S, WHEN THESE ILLUSTRATIONS WERE created, the stylized heart quickly became ubiquitous. Love, amour, amore, liebe was the subject of innumerable poems, songs, and narratives in English, French, Italian, and German, among other languages. It was also the subject of innumerable Catholic prayers, hymns, and devotions in which caritas offered a religious alternative or supplement to amor. By the end of the fourteenth century there was even a special day for love, Saint Valentine's Day, celebrated in both England and France. The culture of courtly love knew exactly what to do with a pleasing form that had once served merely as decoration.

The heart icon became visible not only on the pages of manuscripts but also on numerous luxury items like brooches and pendants. Artisans in Parisian workshops carved ivory heart offerings for scenes on women's jewelry cases and the backs of mirrors, which were subsequently copied in neighboring countries.

A mirror case made in northern Italy around 1390–1400, now in the Smithsonian Institution in Washington, DC, is a beautiful example. A gentleman offers a perfectly shaped, clearly indented heart to his lady, which she reaches up to receive with an arm draped in elegant cloth. The two figures stand surrounded by hummocks, in front of towers and trees, and all of this within a frame only three and three-eighths inches across.

The heart also found its way into weavings and tapestries that not only had decorative value but also offered protection

from the cold. A gorgeous French tapestry circa 1400, now in the Louvre, shows a lover holding his little heart between his thumb and forefinger, as if it were a piece of chocolate. He boldly steps forward, extending a well-shaped leg, while she remains seated and demurely casts her eyes downward toward a dog, the symbol of loyalty. Situated in a garden of love, where every other animal has symbolic meaning (the falcon represents nobility; rabbits stand for fecundity), the sumptuously dressed man and woman look less like lovers than actors in a fashion plate—yet his heart, however tiny, conveys his pledge of love.

A large German tapestry in the Stadtmuseum of Regensburg offers an interesting contrast. Known as the Medallion Tapestry and dated 1390, it consists of six rows of medallions, with four medallions to a row and each one encircled with a German phrase. The pictures and phrases speak for love in its various guises: love's entreaties, love's joys, love's torments. Though the craftsmanship is somewhat crude, the ensemble is impressive, and individually many of the medallions have great originality and charm. For our purposes the medallions with hearts are of special interest.

In row four, devoted to love's torments, there are two medallions that show *Minnekönigin*, the German goddess of love, who is shooting darts into the lover's chest. In the first medallion Minnekönigin with enormous wings and a regal crown holds a bow from which an arrow has already reached its mark. The poor lad with an arrow in his chest lies, as though dying, in the lap of his beloved.

The next medallion in the same row (Figure 16) shows Minnekönigin still wearing her crown, but her wings are now attached to the heart itself, which commands center stage. The winged heart seems to float in midair but is in fact held up, on

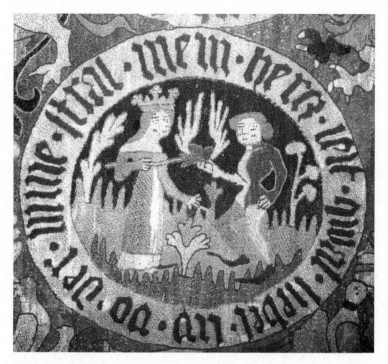

FIGURE 16. Artist unknown, Regensburg "Medallion Tapestry" (detail), ca. 1390. Tapestry, Regensburg Stadtmuseum, Regensburg, Germany.

one side, by the arrow extending from Minnekönigin's hand and, on the other, by the lover's fingers. To head off any confusion in interpreting this scene, the text around the medallion says, "My heart suffers . . . from love's beam" ("Mein Herz leit Qual . . . vo(n) der liebe Stral"). The idea that love strikes you with the deadliness of an arrow aimed by a goddess can obviously be traced back to Venus and Cupid, though in this reincarnation Venus has acquired the hallmarks of courtly love and specifically German attributes, including her name.

Compared to the French tapestry the German one is something of a country cousin, though it may have been created to

celebrate the marriage of Kaiser Wenzel I with Sophie von Bayern in 1389. If so, perhaps they and their descendants and those who owned it in subsequent centuries enjoyed both the warmth it provided and its lessons in love.

THE HEART BECAME ESPECIALLY POPULAR AS A LOVE MOTIF in jewelry. During the fourteenth and fifteenth centuries the French jewelry industry produced numerous heart-shaped brooches and pendants inscribed with French inscriptions, including "de tout cuer" (with all my heart) or "mon cuer avez" (you have my heart). One beautiful gold pendant now in the British Museum is encrusted with tears on one side and the words "tristes en plaisir" (sadness in pleasure) on the other, in recognition of the fact that love is often bittersweet.

A common inscription on jewelry made in England, France, and Italy was the Latin motto "Amor vincit omnia" (Love conquers all), words from Virgil that turn up on the brooch worn by the Prioress in Chaucer's *Canterbury Tales*, written around 1390. Also, in Chaucer's *Troilus and Cressida* the two lovers exchange a brooch described as containing a ruby in the shape of a heart.

Rings, too, were sometimes made with heart-shaped stones or settings and carried similar inscriptions. One from fourteenth-century Italy bears a heart-shaped ruby in a golden frame engraved with clinging ivy—the symbol of fidelity—and the inscription "Corte Porta Amor" (Courtship Brings Love). Another, in the collection of the Victoria and Albert Museum in London, has a heart-shaped wolf's tooth, which may have been intended to ward off danger. I well remember a silver ring with two dangling little hearts, given to me by a boy in my class when I was all of thirteen.

DURING THE FIFTEENTH CENTURY THE HEART ICON CONtinued to proliferate in a variety of unexpected ways. It turned up in coats of arms, playing cards, combs, rings, jewelry cases, ivory carvings, wooden chests, sword handles, burial sites, woodcuts, engravings, and printer's marks. The heart icon was adapted to practical and whimsical uses, with most—but not all—related to amorous love.

One of the most imaginative items was a heart-shaped songbook made in 1475 for Jean de Montchenu, who would become Bishop of Agen two years later. The book, consisting of seventy-two parchment folios within a leather binding, opens out to form two hearts united at the seam. It contains fifteen French and thirteen Italian love songs by well-known composers of the time. Two Italian heart-shaped manuscripts have also been preserved from the sixteenth century as well as a Danish collection of eighty-three love ballads made for the court of King Christian III (Figure 17).

A Frenchman named Pierre Sala contributed to the history of the amorous heart with a little book titled *Emblèmes et Devises d'amour* (*Love Emblems and Mottos*), prepared in Lyon around 1500. His collection of twelve love poems and illustrations was intended for Marguerite Bullioud, the love of his life, although she was already married to another man. She eventually wed Sala after her husband's death.

Sala's tiny book was meant to be held in the palm of one's hand—it is only four-by-three inches—and contains two miniatures with remarkable hearts. One of the miniatures shows Monsieur Sala dropping his strawberry-like heart into the cup of a daisy, called a *marguerite* in French. When capitalized, both marguerite and daisy can be used as names for girls, as in the case of Marguerite Bullioud. The first line of

FIGURE 17. Artist unknown, *The Heart Book*, ca. 1550.
Thott 1510 kvart. Ballad manuscript with leather cover.
Published with the permission of the Royal Danish Library,
Copenhagen, Denmark.

the text reads, "My heart wants to be inside this *marguerite*."
It is unlikely that medieval readers would have ignored the
sexual implications.

Another fanciful illustration shows two women attempt-
ing to catch a bevy of flying hearts in a net stretched out be-
tween two trees (Figure 18). The winged heart, borrowing the
appendages of angels, had already appeared in the fourteenth
century as the sign of soaring love. In our own time it is,
among other things, the symbol of the Sufi Order, a mystic
branch of Islam founded in the early twentieth century, as
well as a favorite tattoo for free-spirited lovers.

A number of Pierre Sala's contemporaries, more inter-
ested in love's torments than its pleasures, devised novel ways
of expressing inner turmoil. Fifteenth-century Italians de-
veloped the theme of "cruel love," showing mutilated hearts

FIGURE 18. Master of the Chronique scandaleuse, "Miniature of Two Women Trying to Catch Flying Hearts in a Net" (detail), ca. 1500. From Pierre Sala, *Petit Livre d'Amour*, MS 955 folio 13r, British Library, London, England.

either inside or outside the body. In an engraving by Baccio Baldini, an elegantly clad lady has plucked the heart from the chest of a slender youth tied to a tree; she holds it up to his face, while he leans stoically back like a sacrificial victim resigned to love's torture. This same theme was reproduced in colorful maiolica plates made in the town of Deruta, which produces world-famed ceramics to this day. One shows a woman in court dress drawing her bow to aim an arrow at

a young man bound naked to a column; between them his heart, pierced by two arrows, stands upright on a pedestal. Another dish shows a well-dressed woman holding a trophy containing a heart pierced by two arrows with an inscription behind her that reads, "El mio core e ferito p[er] voe" (My heart is wounded by you).

Even more macabre, a wooden casket made in Basel around 1430 depicts a lady grating her lover's heart into a mortar. The most horrific example is certainly the woodcut made by Casper von Regensburg around 1480. It shows the hearts of nineteen victims of Frau Minne, squeezed, pierced, broken, burned, sliced in half, and sadistically tortured. If this gruesome picture doesn't frighten away the would-be lover, nothing will.

We are now in a position to answer some of the questions posed in the introduction to this book. When the bi-lobed figure we now call a heart first appeared some twenty-five hundred years ago, it was merely a decorative item with no meaning at all. Indeed, it probably evolved from the shapes found in nature, such as leaves and flowers, and acted as pure embellishment. Certainly the examples found in ancient Persian art and even those in the Spanish Beatus manuscripts do not claim to represent love.

Yet during the thirteenth and fourteenth centuries this decorative shape acquired a meaning: it came to signify love. The first hearts symbolizing love were shaped like pinecones, eggplants, or pears. These "heart offerings," intended for another person in *The Romance of the Pear*, circa 1250, and for God in Giotto's *Caritas*, circa 1300, expressed the *meaning* of the heart as love but did not yet contain its iconic *form*. That form evolved in the first decades of the fourteenth century from images in Barberino's *Documenti*, Giotto's *Chastity*

fresco, and Niccolò di Ser Sozzo's *Assumption of the Virgin* before assuming its definitive shape during the 1340s in *The Romance of Alexander*. Italian, French, and Flemish painters can all take credit for the invention of the bi-lobed, symmetrical heart.

Symbols were so common to the medieval mentality that people were expected to recognize their meaning without explanation or definition. For lay people the heart simply meant love. It represented the overwrought feelings that lovers experience—feelings that can be satisfied only when two hearts merge as one, metaphorically speaking. For members of the clergy, the heart was understood as a meeting place between God and man. God sent His message of love directly into a person's heart, where it might—or might not—be fully embraced.

But symbols have a way of slipping out of their envelopes and assuming meanings and uses that were never anticipated. In the fifteenth century the heart showed up in a number of unusual places, such as the facade of a townhouse in Bourges built by the ultra-rich French minister of finance, Jacques Coeur (1395–1456). The pictogram that spoke his name—*Coeur* (heart)—was also incorporated into his personal coat of arms, following a European practice that had been around since 1194, when King Knut (Canute) VI placed nine hearts and three lions on the Danish seal.

When playing cards first appeared in the fifteenth century the heart icon was assigned to represent one of the suits. Initially, as there was no uniform pan-European system, the number and type of suits varied from country to country. The Anglophone world got its four suits—spades, hearts, diamonds, and clubs—from the French. Later in the century the Germans also settled on four suits, one of which was hearts; the others were acorns, leaves, and bells. The red heart carries

undertones of love, whereas the black spade, derived from the Italian word *spada*, meaning "sword," suggests tragedy and death. For most of us such cultural associations linger long in the psyche.

And surely the English nursery rhyme known as "The Queen of Hearts" is about love, though in such coded form that a child of four wouldn't understand its meaning.

> *The Queen of Hearts,*
> *She made some tarts,*
> *All on a summer's day;*
> *The Knave of Hearts,*
> *He stole the tarts,*
> *And took them clean away.*
> *The King of Hearts*
> *Called for the tarts,*
> *And beat the Knave full sore;*
> *The Knave of Hearts*
> *Brought back the tarts,*
> *And vowed he'd steal no more.*

I suspect that the rhyme originated in tales of adultery inspired by such legendary characters as Lancelot, Guinevere, and King Arthur. The husband, his attractive wife, and her lover have formed an archetypal trio in the Western world for a very long time, beginning with the Greco-Roman gods— Mars, Venus, and Vulcan.

Once launched in the Middle Ages as love's representative, the heart has maintained its iconic shape and status as the preeminent symbol of amorous love, despite other meanings and uses that have glommed on to it since then.

Chapter 9

A Separate Burial for the Heart

MANY YEARS AGO I VISITED THE FRENCH ABBEY OF FON-
tevraud near Angers to see the burial site of Eleanor of Aqui-
taine. A recumbent statue of the queen, with an open book
in her hands, is stretched out on top of her tomb. Next to
her there is another tomb containing the bodies of her second
husband, Henry II of England, and their son, Richard I, bet-
ter known as Richard the Lionheart. It was a moving experi-
ence to see the resting place of those three famed personages,
sorely divided in life and brought together in death, but I was
surprised to learn that Richard's heart is not with the rest of
his body at Fontevraud. When he died in France in 1199 his
heart was embalmed with herbs and spices, wrapped in linen,
placed in a leaden box, and given a separate burial inside the
Cathedral of Rouen, 300 kilometers away.

The cities of Rouen in Normandy and Angers in Anjou
had special meaning for the English. Richard I was officially
the Duke of Normandy and the Count of Anjou as well as

the King of England. After his childhood in England he spent most of his adult life either in his mother's homeland, Aquitaine in southern France, or on crusades to the Holy Land. The placement of Richard's heart in Normandy and his body in Anjou suggested not only an emotional attachment to French civilization but also English claims to these territories that would not be resolved until the end of the Hundred Years' War in the fifteenth century.

The discovery that Richard's heart had been buried apart from his body led me into a fascinating investigation of this practice. Why was the heart considered so special as to merit separate burial? Why not the brain or the liver? Had there been precedents for this procedure before the Middle Ages?

Indeed, there had been, stretching back four thousand years to the ancient Egyptians. While they preserved the deceased person's viscera in four canopic jars—one each for the stomach, intestines, lungs, and liver—the heart was treated with a reverence not accorded the other organs. It was removed from the body, mummified, and then returned to the chest so as to be present at the time of judgment and bear witness for the deceased.

During the lifetime of Richard the Lionheart the procedure of extracting the heart and giving it a separate burial was rare, though a precedent for interring his heart at the Cathedral of Rouen had been set by his royal ancestor, Henry I, in 1135. Henry's heart, along with his eyes, bowels, and tongue, were left behind in Rouen when most of his body was carried back to England for burial at Reading Abbey.

It is not surprising that the practice of burying the heart separately became more frequent during the Crusades; if a crusader died far from home, his body would deteriorate

during the long voyage back to Europe, whereas an embalmed heart could be returned intact to the ancestral vault.

During the thirteenth century such split burials for both Englishmen and Frenchmen of the highest ranks became common. The first woman to be so honored was Blanche de Castille, the mother of King Louis IX, better known as Saint Louis. Her heart was in interred in the Abbaye du Lys (Abbey of the Lily) in 1252, and her body in the Maubuisson Abbey, a Cistercian nunnery she had founded in the suburbs of Paris.

Three decades later the heart of Blanche's younger son, Charles d'Anjou, was placed in the Dominican convent on the rue Saint-Jacques in Paris, while the rest of his body was interred in the Cathedral of Saint Denis, the traditional resting place for French royalty. A recumbent statue of Charles was laid out on top of the heart sepulcher, with Charles portrayed holding his heart in his left hand over his chest.

In that same year, 1285, the heart of King Philippe III ("the Bold") was extracted from his body and buried at the same Dominican convent in Paris chosen for the heart of his uncle, Charles d'Anjou. Philippe III was the first French king whose heart was placed all alone in a separate sepulcher. But not the last. In December 1314 the heart of his son, Philippe IV, called "the Fair," was buried separately in the church of Saint-Louis de Poissy.

From this period to the seventeenth century, French kings and queens were routinely given two burial sites, one for the heart and another, usually Saint Denis, for the rest of the body. King Charles V prepared well in advance for the day in 1380 when his heart would be lifted out of his body and placed in the Cathedral of Rouen. He commissioned a sepulcher for his heart from the sculptor Jean de Liège, who

began to work on it years before the king's death. Though the tomb has since disappeared, drawings show that the sculpture of the king on top of the tomb portrayed him with a scepter in one hand and his heart in the other.

Some notable royal figures resisted the practice. Queen Isabeau de Bavière (d. 1435) stated explicitly in her testament of 1431 that she did not want her heart removed from her body. Neither King Charles VII (d. 1461) nor King Louis XII (d. 1515) had two burial sites. Louis XII wished to make it quite clear that his full body was interred at Saint Denis, heart and all. His epitaph read, "Here lies the body with the heart of the very high, very excellent, very powerful prince Louis XII King of France."

Those who continued the practice sometimes went to great expense and ceremony to ensure that their hearts would become objects of special veneration, like the relics of saints. Thus, René d'Anjou (d. 1480), the cousin of King Charles VII, insisted in his testament that the funeral ceremony for his heart should be as elaborate as the one for his body. His heart was carried to the Franciscan church of the Minor Brothers in Angers by a large procession drawn from both the religious and lay population as well as fifty poor men dressed in black, whose presence had been stipulated in René's will. His heart was enclosed in a silver box and carried by four distinguished men with university degrees. Once they were all inside the church a mass was held in honor of the deceased, and the heart was placed in a niche carved into one of the chapel walls. (We will encounter René's unique contributions to the literature of the heart in the following chapter.)

Heart tombs became more and more elaborate. The heart sepulcher for King Charles VIII (d. 1498) in the church of

Notre-Dame de Cléry was itself shaped in the form of the by-then common heart symbol. And to make certain that viewers understood who and what was inside, the lid on the top of the leaden box containing his heart carried the inscription: "This is the heart of King Charles the Eighth."

His wife, Anne de Bretagne (d. 1514), also had a magnificent heart sepulcher. Her story demonstrates why royalty perpetuated the practice of housing the heart in a separate site. Through her marriage to Charles VIII Anne had united the independent duchy of Brittany with the crown of France. She remained duchess of Brittany as well as queen of France during her marriage to Charles VIII and then, after his death in 1498, held on to those positions through her second marriage to Louis XII. By placing her heart in the tomb of her parents at the convent of the Carmelites in Nantes, Anne signaled her emotional attachment to her progenitors as well as her great geographical gift to France. It was an eminently political act, affirming Anne's rule over her Breton subjects, which would presumably be passed on to her descendants.

Though the body of Anne de Bretagne was eventually interred with that of her second husband, Louis XII, in the most grandiose tomb ever built in Saint Denis, her heart belonged to Brittany. The epitaph on top of her heart sepulcher exalted her personal virtues and her significant place in French history: "In this little vessel / of pure gold reposes a great heart . . . Anne was her name. In France two times the queen. Duchess of the Bretons, royal and sovereign."

Here and elsewhere both political and affective reasons entered into the decision to honor the royal heart with a separate tomb. Buried apart, the semimystical heart inspired reverence and commanded loyalty to one's deceased sovereign.

THE POPULAR KING OF FRANCE HENRY IV WAS KILLED BY A Catholic fanatic on May 14, 1610. He had expressed the desire for his heart to be brought to the Jesuit *collège* of La Flèche and kept there, along with that of his wife, when she died. One of the students at La Flèche was none other than the future philosopher René Descartes, who spent several days in prayer with the other students after they heard the tragic news and before the king's heart was laid to rest. One wonders whether this dramatic event had some influence on the attention Descartes gave to the heart in his philosophical work (to be discussed in Chapter 14).

The treatment of the heart and body of the mighty King Louis XIV makes for macabre history. Immediately after his death in 1715 doctors from the Faculty of Medicine began an autopsy with the removal of his heart and entrails. The heart was embalmed and sent in a golden reliquary to be hung in the Jesuit Church of Paris, while the entrails were dispatched to the Cathedral of Notre Dame. A few nights later the rest of his body was transported in a torch-lit procession to the Cathedral of Saint Denis.

Unfortunately Louis XIV's heart, entrails, and body all suffered ignominious fates during the French Revolution. In 1793 his body and those of other French kings were disinterred from Saint Denis and thrown into a common grave. His entrails were also gotten rid of. And the heart? That was sold to an artist, to be ground up and used as *mumia* for paint.

PERHAPS THE MOST BIZARRE TREATMENT OF A ROYAL BODY involved King James II of England. After he was deposed during the Glorious Revolution of 1688, he fled to France, where he lived as Louis XIV's honored guest. When he died in 1701 James's son brought his father's heart to the convent of

the Visitandine nuns on the Chaillot hill in Paris. The convent had been founded in 1651 by James II's mother, Queen Henrietta Maria, who had also lived in exile in France and whose heart had already been placed in the convent. Today the Palais de Chaillot stands on the site.

Other parts of James's body were distributed elsewhere: his brain in a lead casket was sent to the Scots College in Paris, his entrails were placed in two gilt urns and sent to the parish church of Saint-Germain-en-Laye and the English Jesuit college at Saint-Omer, and the flesh from his right arm was given to the English Augustinian nuns of Paris. What was left of his body was buried in the chapel of the English Benedictines on the rue Saint-Jacques. All of James's remains were destroyed during the French Revolution except parts of his bowel, rediscovered during the nineteenth century in the church of Saint-Germain-en-Laye.

WHILE THE FRENCH AND ENGLISH LED THE WAY IN BURYing royal hearts separately from the body, the House of Habsburg in Austria followed suit in the seventeenth century, beginning with the heart of Archduke Ferdinand IV in 1654 and ending with the heart of Archduke Franz Karl in 1878. There are fifty-four Habsburg hearts enclosed within copper urns and housed in Vienna's Augustiner Church, which is situated inside the palace courtyard. Visible through a window in an iron door, these royal hearts have made lasting impressions upon generations of Viennese children brought there to honor the monarchy. In recent years they have become a tourist destination.

In 2011 Otto von Habsburg, the last heir to the Austro-Hungarian Empire, had his heart buried separately from his body. He chose the Benedictine Abbey in Pannonhalma,

Hungary, as a gesture of affection for the country that was once a major part of the Austro-Hungarian Empire. One hundred members of the House of Habsburg, representatives of the Hungarian government, and various clergymen from the Catholic, Lutheran, and Jewish religions attended the ceremony, with vespers in Latin and ecumenical prayers. The rest of Otto von Habsburg was buried in Vienna.

ALTHOUGH THE PRACTICE OF SEPARATE BURIALS FOR THE heart is best known in conjunction with royalty and nobility, it was practiced, though much less frequently, among clergymen. When Lawrence O'Toole, the second archbishop of Dublin, died in 1180, his heart was sent to Dublin's Christ Church Cathedral. It remained there in a heart-shaped wooden box within an iron cage until 2012, when it disappeared. No one has yet recovered the heart of this Irish saint, and the theft remains a mystery.

From the late Middle Ages onward the prince-bishops of Würzburg in Germany were buried in three parts: their corpses in the Würzburg Cathedral, their intestines in the Marienberg castle church, and their hearts in what is now Ebrach Abbey.

Popes, too, followed the practice, from Sixtus V in 1590 to Leo XIII in 1903. Twenty-two papal hearts are buried in marble urns at Santi Vincenzo e Anastasio a Trevi in Rome, a baroque church directly across from the considerably more famous Trevi Fountain.

UNDER THE OTTOMAN EMPIRE SOME MULTIPLE BURIALS for high-status individuals may also have taken place. Recently investigators descended on a small city in southern

Hungary called Szigetvar, where the heart of Suleiman the Magnificent is believed to have been buried.

According to legend Suleiman died at this site while fifty thousand of his Ottoman soldiers sacked a nearby fortress defended by twenty-five hundred Croatian-Hungarian Christians. Suleiman's death was kept secret until after the battle. Then his heart and other vital organs were buried in Hungary, and his body was carried back to Istanbul. Excavations have uncovered a sixteenth-century memorial in the form of a brick mosque, a dervish cloister, and the *turbe*, or tomb, where the sultan's heart and entrails are thought to have been interred. Those structures stood until 1692, when the Hapsburgs conquered the region and carried anything of value back to Vienna. It is believed that some artifacts left behind, including Suleiman's heart, were then reburied by local farmers.

Regardless of whether the sultan's heart still remains at this site, an invitation has been extended from the city of Szigetvar to the presidents of Turkey, Croatia, and Hungary to help further the search for it.

In all these cases the heart was understood as a partial substitute for the person whose body was buried elsewhere. But in the fifteenth century the heart sometimes superseded its status as a partial representative. It wanted to be more independent. It wanted to *be* the whole person. And so in literature the heart became an individual in its own right.

Chapter 10

The Independent Heart

FIGURE 19. Barthélemy van Eyck, "Cœur et Désir arrivant chez Espérance" (detail), ca. 1458–1460. Illumination on parchment, from René d'Anjou, *Livre du cœur d'amour épris*, Austrian National Library, Vienna, Austria.

WE HAVE ALREADY ENCOUNTERED RENÉ D'ANJOU, WHOSE heart was given such an elaborate burial in Angers in 1480. Now we will get to know him better as well as his cousin, Charles d'Orléans. Both were high-ranking members of royalty, and both composed verse in which the amorous heart acted like a person, with its own voice and story. For the first time in Western literature the heart assumed the role of an independent actor capable of thinking and speaking for itself. Once we accept the premise that the heart has a will of its own, it's easy to be drawn into Charles's compelling lyrics and René's surreal plots.

Charles d'Orléans—grandson of King Charles V, nephew of King Charles VI, and father of King Louis XII—was taken prisoner by the English in 1415 at the Battle of Agincourt and spent twenty-five years in captivity. While imprisoned he treated his heart as an intimate friend with whom he conducted ongoing conversations, set down in the form of songs, ballads, and rondeaux.

The heart, representing the poet's most vulnerable part, languishes in despair over an unattainable lady but perks up when the speaker addresses it directly in a more hopeful vein:

> *The other day I went to see my heart*
> *To discover how it was faring.*
> *And I found Hope right beside him*
> *Sweetly offering him comfort.*
> *"Heart, you can now be joyful! . . .*
> *Since I can truthfully tell you*
> *That the most beautiful woman in the world*
> *Does love you with a loyal heart."*

The poet continues to converse with his heart, always about love's challenges. At one point he finds his heart desperately crying for help, having set fire to itself and everything around it. The poet vainly tries to put out the fire with his tears and begs his friends, if the heart should die, to have a mass said in its honor so it would be elevated to "the Paradise of lovers / Like a venerated martyr or saint." The heart is saved, only to suffer still further.

At another moment the poet expresses sympathy with his heart when he sees it writhing in sadness over the news that his lady "whom he has served most loyally for a long time / Is at present grievously ill." He acts as the heart's interpreter in their joint prayer for the lady's recovery: "All mighty God, through your goodness, / Cure her! My heart begs this of you." The lady, as well as the heart, recovers.

Although Charles d'Orléans's heart poems had their roots in an older literary tradition that allegorized emotions and personal attributes, such as Hope and Courtesy, they also prefigured the lyrical subjectivity of the Renaissance. During the next century Renaissance thinkers and poets, Montaigne and Shakespeare most prominently, would favor a more complex self, one whose parts could no longer be given such medieval labels as Sweet Looks and Mercy. Charles's split personality, torn between his loving heart and his personal torments, has a distinctly early modern ring. In fact, his method of dealing with despair could even be seen as prefiguring Freud. By separating his heart from the rest of his being, he tries to understand his inner turmoil by analyzing discrete parts of himself—those that Freud would call superego, ego, and id.

During the early period of Charles's captivity he asked his heart to help him counter the pains of unrequited or distant

love, but as the years passed and he became resigned to old age he instructed his heart to release him from desire. When Charles was finally allowed to return home, his beloved second wife, Bonne, had died, but he soon took another, twenty years younger, and apparently found love once more, even at the age of forty-six, which was considered old in his day. One of the three children issuing from that marriage became the popular King Louis XII.

CHARLES D'ORLÉANS'S COUSIN, RENÉ D'ANJOU, WENT ONE step further in granting the heart autonomy. In his allegorical *Book of the Love-Smitten Heart* (*Le livre du coeur d'amour épris*), the protagonist, at the outset, is René himself, whom the reader finds writing a letter to his nephew, John of Bourbon. But after a dream in which Love tore out René's heart and gave it to an allegorical character named Desire, the Heart replaces the narrator as the central character. The Heart is then transformed into a youthful knight with a body of his own and adventures typical of the quest narrative. Of course, the Heart's quest was directed toward a "lovely, young, noble, and fair lady" named Sweet Mercy, who was desperately in need of release from her captors, Shame and Fear.

Though *The Love-Smitten Heart* follows the allegorical conventions that had been set in place by *The Romance of the Rose*, it does not have the traditional happy ending. The Heart fails to unite with Sweet Mercy, who remains in the hands of Refusal. Instead, the Heart is guided to the Hospital of Love by Lady Pity, where he will "end the remainder of his days there in prayers and meditations."

As the last of the great French love allegories, *The Love-Smitten Heart* offers a window into the mentality of its time, one that is suffused by pessimism. Love, the most pow-

erful of forces, is often presented as the cause of man's undoing. One truly original section of the book describes the coats of arms hung by famous lovers and losers outside the Hospital of Love: Theseus, Aeneas, Achilles, Paris, Troilus, Tristan—each a mighty warrior and each vanquished by love.

War and love were dominant themes in the life and literature of René d'Anjou. His was a bloody century riven by the Hundred Years' War between France, England, Burgundy, and René's own Anjou as well as other European kingdoms. When he set out to write *The Love-Smitten Heart*, he had already known the horrors of warfare, imprisonment, murderous plots, political intrigue, and the complications of inheritance.

He was also a husband, father, and lover, with four legitimate children and three born out of wedlock. As a young man of nineteen, when he married Isabelle of Lorraine, he honored her by inscribing on his coat of arms the words "D'ardent désir" (With ardent desire). Years later, nearing fifty, he included himself in the section of famous lovers who hang their coats of arms outside the Hospital of Love. Starting with the words "I am René d'Anjou, who present myself as Love's beggar," he went on to boast of the many maids, town ladies, and shepherdesses who had thrown themselves at him both in France and Italy. The great number of "bastard" children recognized by their powerful fathers attested to the medieval belief that a ruler's virility was to be measured as much by his sexual prowess as by his courage in battle.

In addition to his accomplishments as a man of arms and prolific lover, René d'Anjou was one of the first French secular humanists known for his command of several foreign languages and his knowledge of world literature going back to the Greeks and Romans. The historical and literary names,

allusions, and quotations included in *The Love-Smitten Heart* and in René's other literary works would fill a fat scholarly monograph. And, as with the better-known Dukes of Burgundy, he was a great patron of the arts, credited with commissioning several illuminated manuscripts that survive and delight to this day.

The manuscript of *The Love-Smitten Heart* now in the Vienna National Library has highly imaginative heart imagery created by the Flemish painter Barthélemy van Eyck, who was in René's service from 1447 to 1469. In van Eyck's illustrations the character of Heart is shown completely encased within shining armor, and his head is hidden within a huge helmet so we never see the human face inside (Figure 19). But we have no doubt that the character inside is Heart because of the bright-red hearts with golden wings that adorn his cloak, sprout like a plume from the top of his helmet, and decorate the cloth covering over his horse. A bevy of winged hearts appear in illustrations with such labels as "Heart and Desire at the Home of Melancholy," "Heart and Desire at the Home of Hope," and "Hope Carrying Help to Heart."

René's heart, for all its independence, is ultimately defeated by outside forces. At the end of the narrative it submits to a fate devoid of any amatory satisfaction. In retreating from the world into a sanctuary for prayer and meditation, it is suggested that Heart will ultimately find solace in the love of God.

ALONGSIDE RENÉ D'ANJOU AND CHARLES D'ORLÉANS THERE is another fifteenth-century poet, François Villon, who must be mentioned in any account of the independent heart. Villon (1431–1463?) was a far more talented poet than René and at least the equal of his contemporary Charles d'Orléans. Unlike Charles, who received him at the Château de Blois for a poetry

contest, Villon was a commoner well known to the police for criminal acts and only saved from hanging by royal amnesty.

In a long poem titled "The Legacy" ("Le Lais"), Villon portrayed his heart as "broken" after a love affair that ended badly. He felt obliged to flee from "the prison of love" and leave Paris for the provincial city of Angers. In the testament he wrote before leaving he bequeathed his amorous heart— "pale, pitiful, dead, and done for"—to the woman who had ensnared it. Although she was not a woman of high rank but a commoner like himself, he gave free vent to the bitterness he experienced as a "martyr" for love. Villon's down-to-earth portrayal of the lover's deception seems closer to the anguished voices of our own times than the affected conventions still common among most late medieval poets.

Villon's short poem titled "The Debate of the Heart and the Body" ("Le Débat du Coeur et du Corps") is the most famous French incarnation of the independent heart. In the poem his heart is given a voice and becomes his conscience, upbraiding his corporeal self for its debauched existence. This is not so different from Freud's division between the superego and the id: here the heart has assumed the role of the superego trying to tame the id's cravings. Heart and body spar like two antagonistic friends, with one trying to persuade the other to change its lifestyle. The body, spokesperson for Villon's past self, attributes his bad luck to Saturn, the planet believed to have an evil influence on people's lives. The heart calls such thinking foolish and admonishes the body, already aged thirty, to take responsibility for its actions. Each stanza ends with a refrain expressing the weariness of both parties:

I've nothing more to say. That suits me fine.
(Plus ne t'en dis. Et je m'en passeray.)

Although God is mentioned only once in this poem, Villon's heart is imbued with a message that comes straight from the Bible. It calls for repentance before it is too late, advice the body does its best to ignore. Here the heart has wandered far beyond the boundaries of romance and crossed over into the realm of religion. Competing claims on the heart coming from romance and religion were increasingly characteristic of the late Middle Ages.

During this period the heart was accorded greater complexity, especially by the best poets of the age. It also achieved a level of prominence unknown before in the visual arts. As a symbol of love it would endure until our own time, but not without challenges to its supremacy that began in the sixteenth century.

Chapter 11

The Return of Cupid

FIGURE 20. Otto Vaenius (artist), Cornelis Boel (engraver), "Optimum amoris poculum, ut ameris, ama," 1608. From *Amorum Emblemata* (Emblem 5), Emblem Project Utrecht.

RENAISSANCE PAINTERS AND SCULPTORS, UNLIKE THEIR ME-dieval predecessors, looked to the Greeks and Romans for their artistic models. When illustrating the subject of ro-mance, artists resurrected the figures of Venus and Cupid, who soon shunted the heart icon to the side.

Cupid's mother was Venus, the goddess of love, but his paternity was less certain. Usually it was ascribed to Mars, the god of war, or Mercury, the god of merchants and mes-sengers, and less frequently to Vulcan, the god of metalwork-ing, who was Venus's cuckolded husband. It was understood that Cupid took after his mother and that they were the pri-mary catalysts of desire. With his trusty bow and arrow he sent darts of love into the hearts of young and old. In classi-cal antiquity he was represented as a strong, winged, naked youth. In Renaissance art he became even younger, a child or baby. Why settle for the heart symbol when artists could rep-resent the erotically charged flesh of Venus and Cupid?

Hearts were not pictured on objects produced in Renais-sance Italy to celebrate betrothals and weddings; instead, mythological or biblical scenes were painted or carved on the obligatory *cassone* (marriage chests) given to a bride at the time of her wedding and permanently on display in the bed chamber. Family arms, not hearts, decorated maiolica plates and bowls; some carried images of couples in profile facing each other or clasped hands with the inscription *fede* (faith). The heart was notably absent from the magnificent oil paint-ings that became the hallmark of Renaissance and baroque high culture. For some artists it was only a pleasing shape, to be used among other decorative elements.

Raphael and his assistants, for instance, included small hearts among cupids and other mythological figures, birds, owls, snails, and various grotesques on the spacious surface

of the Loggetta, a small washroom made for Cardinal Bibbiena at the Vatican in 1519. Within such mixed company the heart's amatory message was definitely diminished.

YET THE HEART'S CONNECTION TO LOVE NEVER COMPLETELY disappeared, and during the Renaissance it manifested itself in unexpected places. A woodcut made early in the sixteenth century during the reign of the French King Francis I celebrated two kinds of love in a single heart—the amorous love implicit in the union of a royal couple and the king's religious love for the Virgin Mary. To honor the king's engagement to Eleanor of Austria, the woodcut shows Francis and Eleanor on each side of Mary and the infant Jesus, asking for their blessing. Francis holds a neatly drawn heart in his hand, and Eleanor holds flowers. Though the marriage never took place and Francis eventually married another, the woodcut continued to be popular in France. Because he looks directly at Eleanor and lifts up his heart in the familiar pose of a lover, he seems to be offering it to her as much as to Mary. Here the heart simultaneously represents both sacred and profane love.

Two Italian editions of the poet Petrarch's sonnets, one from 1544 and the other from 1550, carried hearts on their title pages; these hearts, resembling pitchers, contained busts of Petrarch and his beloved Laura facing each other. Sometimes in Renaissance illustrations Venus herself held a flaming heart in her hand, but for the most part she stood or reclined on her own or was accompanied by her playful son Cupid.

A more unlikely use of the heart occurred in maps. Heart-shaped maps of the world, called *cordiform* by cartographers, appeared in Europe early in the sixteenth century. Those surviving from this period are exquisitely detailed and often show the latest geographical discoveries, including America.

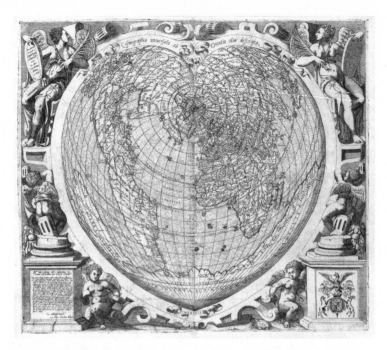

FIGURE 21. Giovanni Cimerlino, Copperplate reproduction of Oronce Finé's single cordiform map, 1566. Daniel Crouch Rare Books, London, England.

Maps of a heart-shaped world may have been related to the concept that personal emotions, most notably love, can even affect the physical world.

The map labeled as Figure 21 was made by the Veronese artist Giovanni Cimerlino in 1566. It is encircled by the gods of love—four nude putti or cupids at the bottom and two Venus-type figures at the top. As I stare at this map and think of a world imbued with love, the words of a twentieth-century song keep circling in my head: "It's love that makes the world go 'round, world go 'round, world go 'round." Would that it were so!

THE PROMINENCE OF CUPID AS A RIVAL TO THE HEART IS especially noticeable in the emblem books that began to appear during the 1530s. A new literary form that brought together short texts with illustrations, emblem books were intended to convey a moral truth. They typically contained a motto, a picture, and a poem. The text often appeared in both Latin and the vernacular, and some editions were polyglot, which made for a truly pan-European phenomenon. Many emblem books took love as their overall theme, but it was a new kind of love. Instead of heartfelt fervor, emblem books praised temperate love in marriage, advised wives to be faithful, and counseled the love of one's children. They took a dim view of unbridled passion, replacing it with the steadfast virtues of conjugal affection.

Thus, in the very first French emblem book, Andrea Alciato's *Livret des Emblèmes* of 1536, we find an emblem titled *De morte et amore* (*On Death and Love*) showing an old man lying on the ground with an arrow in his chest, obviously the work of Cupid, and the skeletal figure of Death hovering beside him. The moral is clear: this is what happens to an old man who has the misfortune of being struck by Cupid's arrows. In contrast to these frightening pictures, emblems extolling marital fidelity and parental love were accompanied by scenes of happy couples with flowers, dogs, and birds.

Emblem books reflected the new values promoted by Renaissance humanists and religious reformers. Turning their backs on the all-or-nothing passion characteristic of medieval romance, they looked to certain Roman writers, such as Horace, Virgil, Seneca, and Cicero, for more sober models. They aimed at convincing young people that carnal love is perilous and that only conjugal love can result in long-term happiness.

Instead of offering one's heart to another in a gesture of selfless abandon, the would-be lover was advised to be wary of Cupid. However cute the winged cherub appeared to be, his defining attribute was his deadly bow and arrow. Hardly a benign creature, Cupid aimed his darts to inflict desire into the hearts of the unwary. If it didn't literally kill you, unrestrained passion could bring about psychological, moral, and spiritual death.

AROUND 1600 A CIRCLE OF HUMANISTS AT THE UNIVERSITY of Leiden began to produce emblem books on the theme of love for the Dutch market. Surprisingly, though Leiden was known to be an austere Calvinist city, libidinous love poets, such as Ovid and Catullus, inspired their books. These sophisticated Dutch intellectuals were interested in exploring the nature of amorous love, how it began and developed, what kept it alive, and what destroyed it. They granted love a necessary role in natural law and lauded its virtues but also called for moderation as a means of warding off the destructive consequences of wild lust.

The philologist Daniel Heinsius, a professor and editor of classical texts, is credited with having written the first Dutch emblem book on love, *Quaeris quid sit Amor?* (*Do You Ask What Love Is?*), published anonymously in 1601 and republished in 1606/07 under the title *Emblemata amatoria* (*Love Emblems*). This book paved the way for several similar publications, most notably, in 1608, Otto Vaenius's *Amorum Emblemata* (*Emblems of Love*), which has been called "the most important of all love emblem books."

Vaenius enlisted a group of humanists and men of letters to contribute poems in various languages—Italian, Dutch, English, and French—each a loose translation of Latin texts

taken mainly from Ovid. (Some later editions included German and Spanish translations.) He himself wrote some of the Dutch poems, but the unique strength of the book lies in Cornelis Boel's 124 engravings. Each of these engravings, except one, features the figure of Cupid.

As in a running comic strip or graphic novel, Cupid is engaged in a multitude of human activities. In the emblem pictured in Figure 20, two playful Cupids are shooting arrows into each other's hearts. The accompanying poem tells us, "The woundes that lovers give are willingly receaved, / When with two dartes of love each hits each others harte." In other emblems we see Cupid tenderly embracing another Cupid, walking with Hercules as his guide, covering his ears to the trumpet of fame, stealing a bite to eat, prodding a sluggish turtle, leaning upon a steady oak in a storm, mixing butter, hunting deer, reading a love letter, carrying a candle, plucking roses, crying tears of love, treading on the tail of a proud peacock, wrenching a sword from the hand of Mars, carrying fresh flowers in each hand, and, of course, shooting his arrows into the chests of numerous victims. Pictured in so many different guises, Cupid comes across as an indefatigable and mischievous emissary of amorous love.

With the help of his contributors, his engraver, and his printer, Vaenius created a best-selling love manual. The epigram above each poem and the four-lined quatrains that followed not only proclaimed the power of love but generally lauded it. Consider the following exemplary headings:

> *Nothing resisteth love*
> *Love is not to bee measured*
> *Love is the cause of virtue*
> *All depends upon love*

Love excelleth all
Love is author of eloquence
Love pacifyeth the wrathful
Loves harte is ever young

Specific advice for the male lover was spelled out in the poems under the following headings:

Love grows by favour.
Perseverance winneth.
Fortune aydeth the audacious.
Out of sight out of mynde.
The chasing goeth before the taking.
Loves ioy is renuyed by letters.
Love enkindleth love.

Amorous love is generally presented in this book as a beneficent universal force. The emblem titled "All depends on love" shows Cupid aiming his darts at a globe in the distant sky, a globe that has already been struck with numerous arrows. The text tells us that this little god of love pierces the heavens and earth with his arrows and establishes "musicall accord" throughout the world, "For without love it were a chaos of discord."

Relatively few of the poems in *Amorum Emblemata* focus on love's sorrows. Among those that do, the emblem "No pleasure without payn" repurposes the old trope that all roses come with thorns. We rarely see gruesome pictures of Cupid's victims, as in some other emblem books. Even when Cupid is pointing his arrow at a target placed on the chest of a young man, it looks more like a game than a killing. Yes, the heart is

still the recipient of Cupid's arrows—"Right at the lovers hart is Cupids ayme adrest." But though it is mentioned frequently in the text, the heart itself is nowhere pictured in Vaenius's collection.

WHILE CUPID DOMINATED VAENIUS'S *AMORUM EMBLEMATA* and similar works, a few emblem books did feature the heart symbol in his stead. Jean Jacques Boissard's *Emblèmes mis de latin en françois* (*Emblems Translated from Latin to French*) (1595) updated the heart's meaning, drawing on Greek and Roman classics. In a plate titled *Libertas Vera est Affectibus non servire* (*One Is Truly Free Who Is Not Captive of His Passions*), a helmeted man grasps a heart with a pincer while a woman holds scales to weigh it. The weighing of the heart, a measure of one's worth going back to the Egyptian *Book of the Dead* and the medieval German Medallion Tapestry, now had a new purpose: moderation. The heart must submit to decorum and good judgment. Boissard argued that you cannot be free if you are ruled by your passions—a sensible philosophy modeled on the work of Latin thinkers such as Seneca rather than the immoderate Ovid. Boissard warned that the person with a generous heart must avoid being carried away by "the force of voluptuousness." Only one "who balances his affections, measures his thoughts, speech, and acts, and moderates the passions of his soul" will achieve contentment and wisdom. We are clearly far removed from the all-or-nothing cries of medieval lovers.

Some emblem books were decidedly wary of the amorous heart. In such works the heart was shown pierced, burning, tormented—suggesting the perils of erotic love. The title page of Pieter Cornelisz Hooft's *Emblemata amatoria: Afbeeldingen*

van minne (*Emblems of Love*, 1611, 1613) has a picture of a flaming heart perforated from front to back by an unusually sharp-looking arrow.

A more positive vision of the amorous heart appeared around 1618 in a little Dutch volume titled *Openhertighe Herten* (*Openhearted Hearts*). With sixty-two etchings and matching poems, the book became a publishing success not only in Dutch but also in French and German editions.

The title page established the tone for the entire work. It shows a plump vessel or pitcher-type heart set above a heart-shaped scroll (a similar heart appears in every subsequent illustration). A loving couple stands on each side of the page. To the right there is a lower-class man and woman, she all but obscured by his large presence except for her head and shoulder. He holds his heart upright in his right hand. On the other side there is a fashionably dressed upper-class couple. She stands in front of the man, covering up most of his body. In her hands she holds a fan and a book while the man holds a large "pin" or "prick" above the lady's book.

This "pin" or "prick" was used in a popular party game, which followed a prescribed sequence: each participant would place the pin randomly in an emblem book, read the emblem, and then solicit discussion. The foreword to *Openhertighe Herten* recommended the game for "all young people and honest company, at dinners and on other occasions to pass the time and avoid irregularities." To play, "one keeps the little book shut, another pricks into it, between the page, with a bodkin or needle, and if the latter does not find the inclinations of his heart, another member of the company may." Such amusement may seem tame to us today, but four hundred years ago it had great appeal among Dutch burghers.

FIGURE 22. J. van der Velde, title page, *Openhertighe Herten,* 1618. Engraving, Royal Academy of Dutch Language and Literature.

All sixty-two emblems in *Openhertighe Herten* argued in favor of the "open heart" as the best approach to love and life, meaning that lovers should be honest and transparent with each other. Emblem number one of the French version shows a convex heart representing a house with a large latticed window at its center. The epigram tells us that the speaker's heart, like an open window, "has never been false nor treacherous."

The heart icon and Cupid continued to have their followers among artists depicting amorous love. But increasingly during the sixteenth and seventeenth centuries Christianity encroached on the terrain of the secular heart. Both Catholics and Protestants claimed the heart icon and found different ways of making it their own.

Chapter 12

The Reformation and Counter-Reformation

FIGURE 23. Artist unknown, window with Lutheran rose (detail), ca. 1530. Stained glass, Cobstadt, Thüringen, Germany. Image credit: Claus Thoemmes.

MARTIN LUTHER IS NOT A FIGURE ONE WOULD INSTINC-
tively associate with a heart or a flower, yet this indomita-
ble man constructed his personal seal from a red heart placed
within a white rose, with a black cross set at the center of a
heart icon (Figure 23). In a letter of July 8, 1530, he explained
why these images were apt representations of his theology:
"The first should be a black cross in a heart, which retains its
natural color, so that I myself would be reminded that faith in
the Crucified saves us. . . . Such a heart should stand in the
middle of a white rose, to show that faith gives joy, comfort,
and peace."

Luther argued that the black cross symbolizing Christ's
death, the red heart symbolizing faith, and the white rose
symbolizing belief in the Resurrection all reinforced each
other. Because the five-petaled rose encircling the heart is so
dominant, the seal is usually referred to as "Luther's Rose,"
though a case could also be made for calling it "Luther's
Heart."

In the campaign to promote his revolutionary theology
Luther's seal enjoyed widespread prominence. It appeared on
the title pages of his published works as early as 1524 and on
medals and medallions that were made for him and his fol-
lowers. A tile imprinted with his seal still hangs on the ceil-
ing of the Lutherhaus in Wittenberg, and most recently I saw
it on a history coloring book for children celebrating the five
hundredth anniversary of the Protestant Reformation.

Whereas the Reformation destroyed many traditional
Catholic symbols and images, Luther "was largely responsi-
ble for rescuing the heart from Protestant iconophobes," ac-
cording to one modern scholar. With Luther's approval the
heart appeared in various Protestant churches and publica-
tions, stretching from Germany, France, and Switzerland to

the Netherlands, Scandinavia, Hungary, and England. The heart-shaped Colditz altarpiece made by Lucas Cranach the Younger in 1584 (now in the Germanisches Nationalmuseum in Nürnberg) is a remarkable example of the heart's ongoing presence in Reformation circles.

Many smaller hearts were also found in Lutheran and Calvinist emblem books. Georgette de Montenay's *Emblemes ou devises chrestiennes* (*Christian Emblems or Mottos*), published in Lyon in 1567 and 1571, quickly made its way into Calvinist circles in France and Switzerland. Several of its fine plates, made by the French engraver Pierre Woeiriot de Bouzey, contained striking heart images. One of them, titled *Non tuis viribus* (*Not by Your Own Strength*), shows a human heart drawn upward by a magnet, symbolizing Christ. Without the text it would be difficult to unravel the meaning of this bizarre configuration; fortunately the caption tells us that God, in the form of Christ, is the true magnet both for the material world and for the soul. Only God can effect human redemption—not man's virtue, nor his work, nor his merit. "In short, he [man] has nothing except through [God's] grace and mercy" ("Bref, il n'a rien que par grace & merci"). The Protestant doctrine of redemption solely through God's grace, as opposed to the Catholic notion of good works, has rarely been stated more succinctly.

Another fine engraving (Figure 24) shows a disembodied hand in the clouds holding the end of a piece of string attached to a large heart that is touching the ground. The French text tells us that "God sees everything, and penetrates the most subtle hearts / to their depths." Through a combination of picture and motto, this emblem portrays the biblical bond between man and the divine. Like Jews, Catholics, and Muslims before them, Protestants believed that God sees into

FIGURE 24. Jean Marcorelle (engraver), "Quas Iam Quaeras Latebras," 1567. From Georgette de Montenay, *Emblemes ou devises chrestiennes*, Glasgow University, Glasgow, Scotland.

every person's heart and that each heart is like a little homunculus containing the entirety of a person's spiritual, psychological, and moral self.

A third engraving shows a large heart topped by a royal crown, which is held in the outstretched hand of a figure hidden behind clouds. And if one has any doubts as to its meaning, the poem below it begins, "The King's heart is in the hand of God" ("Le coeur du Roy est en la main de Dieu").

Montenay's emblem book is a fine example of how Protestants appropriated the heart and made it their own. Because Reformation thinkers made a sharp distinction between the realms of matter and spirit, they did away with the gaudy flesh-and-blood hearts of Jesus and Mary along with the

material relics of saints. But they accepted the symmetrical heart icon because it was abstract enough for their sober style.

The German Lutheran writer Daniel Cramer took up the heart in his *Emblemata sacra* (*Sacred Emblems*), published in Frankfurt in 1624. One of the emblems called "Probor" ("I am tested") shows God's hands emerging from the clouds and placing a heart within a sturdy, round oven. This literal trial by fire suggests that the Christian heart needs ritual purgation—deep personal introspection that may cause pain but will ultimately produce a purer heart and stronger faith.

The seventeenth century saw the growth of the heart icon in both Protestant and Catholic emblem books and sometimes in highly original formats. For instance, the engraver Antonius Wierix made a series of eighteen plates featuring the heart in the hands of a playful infant Jesus. Jesus is shown piercing the heart with his arrows and forcing Profane Love to flee from within. In another image Jesus knocks at the door of the heart, enters, and drives away slimy creatures. In another, Jesus takes up a broom and brushes out a cascade of filth from the heart. Beginning with a French edition (*Le Coeur dévôt*, Paris, 1626), Wierix's plates made their way into several different European emblem books, all of which portrayed interventions Jesus made into a Christian heart.

The *Schola Cordis* (*The School of the Heart*) written by the Benedictine priest Benedictus van Haeften in 1640 was also very inventive in its heart imagery. In one illustration the heart is weighed on a scale; in another it is reflected in a mirror; in others it is crowned with thorns, crushed in a press, and tied with knots. Haeften's influential book intended for Catholics had a second life a generation later in the Protestant

world when it was transformed by the English clergyman
Christopher Harvey into a verse treatise titled *The School of the
Heart, or, The Heart of It Self Gone Away from God* (1676). Har-
vey presented the old theme of exchanging one's heart with
Jesus's heart in the following manner:

> *The only love, the only fear thou art,*
> *Dear and dread Saviour, of my sin-sick heart.*
> *Thine heart thou gavest, that it might be mine:*
> *Take thou mine heart, then that it may be thine.*

In comparison with the heart exchanges envisioned by
Gertrude of Helfta five centuries earlier, here one finds abso-
lutely no trace of sensual intimacy. Harvey, a Puritan, offers
his own "sin-sick heart" to Jesus and receives the heart of his
savior with fear and trembling. Though the heart is featured
prominently in the book's title, only one illustration actually
depicts it. An eye-catching engraving for Emblem 18, "The
Giving of the Heart," shows a woman offering her heart to
God before a mirror held by a winged youth (Figure 25).
Both the woman and the youth are fully clothed. The man
across from her is neither a lover nor God, as he would have
been in illustrations from a medieval romance or Catholic
text; instead, a mirror held by an ambiguous creature—half
angel, half Cupid—reflects her heart back to her. Protestant
theology asks the Christian to turn inward, to examine his
or her own heart, to recognize its sins and hope for God's
grace.

During the Reformation when Protestants destroyed
many Catholic images, they shunned the wounded, bleed-
ing Sacred Heart but allowed for the heart icon to survive as
a symbol of man's connection to God. God could read the

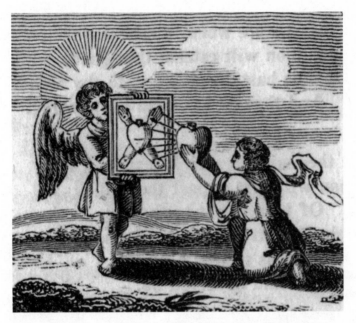

FIGURE 25. Christopher Harvey, "The Giving of the Heart," 1676. From *The School of the Heart, or, The Heart of It Self Gone Away from God, and Instructed by Him* (Embleme 18), Stanford University Special Collections, Stanford, California.

entire moral history of a person inscribed upon his heart. Puritans in particular were ever conscious that "Gods eye is principally upon the heart," as the pastor Thomas Watson told his flock.

IN RESPONSE TO PROTESTANT UPHEAVALS THROUGHOUT Europe as well as its own internal reform movements, the Catholic Church initiated what became a century-long Counter-Reformation at the Council of Trent in 1545. New orders, such as the Ursulines for women, the Discalced Carmelites for both women and men, and the Society of Jesus

(Jesuits) for men promoted the Sacred Heart, which was placed in their churches and on the title pages of their books. Spanish and Portuguese conquerors carried the Sacred Heart with them to Mexico and Brazil and other New World colonies. In short, whereas Protestants invented new roles for the heart, Catholics held on to earlier ones already familiar to Europeans and increasingly available to devotees in the New World.

Catholics drew from their medieval predecessors the theme of surrendering one's heart to God. They also perpetuated images of the Sacred and Immaculate Hearts, both in symmetrical and asymmetrical shapes. As medical science advanced, some pictures of the Sacred Heart of Jesus and the Immaculate Heart of Mary were made to resemble the plates found in anatomical studies. There was no attempt to deny the corporality of Jesus's heart. On the contrary, the more it resembled a human organ, the more credible its capacity to be wounded, to suffer, and to feel compassion for all men and women, even sinners. At the same time Catholic men and women, fixating on the wounded heart of their savior, were moved to experience compassion in their own hearts.

THE MOST FAMOUS TEXTUAL EXAMPLE OF THE CATHOLIC heart during the sixteenth century comes from the Spanish nun Teresa of Ávila (1515–1582), who founded the order of Discalced Carmelites. In her autobiography, *The Life of Teresa of Jesus*, she recounted how an angel pierced her heart and left her in a state of religious ecstasy.

> I saw in his hands a long golden dart and at the end of
> the iron tip there appeared to be a little fire. It seemed
> to me this angel plunged the dart several times into my

heart and that it reached deep within me. . . . The pain was so great that it made me moan, and the sweetness this greatest pain caused me was so superabundant that there is no desire capable of taking it away; nor is the soul content with less than God. The pain is not bodily, but spiritual; although the body doesn't fail to share in some of it, and even a great deal. The loving exchange that takes place between the soul and God is so sweet that I beg of Him in His goodness to give a taste of this love to anyone who thinks I am lying.

It is difficult to convey in English the passion of the original Spanish. The Spanish word for heart, *corazón*, is itself redolent of love, more so, I think, than its analogs in any other Western language. Though English has the same idioms and an equal, if not greater, number of heart-laden expressions, "heart" doesn't possess the same amorous overtones as "corazón." In an oral contest registering the affective vibes given off by *cor* in Latin, *heart* in English, *coeur* in French, *Herz* in German, *cuore* in Italian, and *corazón* in Spanish, I believe the Spanish word would win hands down.

Teresa's words are charged by an ecstatic current that is shared with other notable mystics. As in the case of the thirteenth-century nun Gertrude of Helfta, the penetration of Teresa's heart may appear to a modern reader as covertly sexual, whereas Teresa herself understood it as a spiritual encounter between her soul and God. The great baroque sculptor Bernini immortalized the moment of ecstasy in white marble for the Cornaro Chapel in Venice. He portrayed Teresa swooning as her heart is about to be pierced by an arrow held in the hand of an angel, who looks down on her with smiling satisfaction.

A CENTURY AFTER TERESA OF AVILÀ PENNED HER VISIONS of spiritual ecstasy, the French nun Margaret Mary Alacoque had similar experiences within the convent of the Visitation at Paray-le-Monial in France. She described in her autobiography how Jesus revealed his heart to her in the years between 1673 and 1675: "Jesus Christ, my sweet master, showed himself to me, shining with glory. His five wounds were brilliant like five suns, and flames burst forth, on all sides from this sacred humanity, but especially from his adorable breast; and it opened and I beheld his most loving and most beloved Heart."

Then, in a practice reminiscent of Gertrude von Helfta, Margaret Mary and Jesus exchanged their hearts: "He asked me for my heart. I begged him to take it; he did and placed it in his own divine heart. He let me see it there—a tiny atom being completely burned up in that fiery furnace. Then— lifting it out—now a little heart-shaped flame—he put it back where he had found it."

Margaret Mary's visions provided the impetus for renewed dedication to the Sacred Heart of Jesus as the symbol of divine love. She promoted it through her correspondence with other members of the clergy, both priests and nuns, and also through the production of new images of the Sacred Heart made by her sister nuns. Many of their exquisite works, ranging from paper drawings and oil paintings to fine silk embroideries, have been collected at the Museum of the Visitation in Moulins.

Margaret Mary Alacoque is generally recognized as the person most responsible for the dissemination of the Sacred Heart from the late seventeenth century onward; she was canonized in 1920. Yet the ground for her success had already been prepared in France by the priest Jean Eudes, who

had founded the Congregation of Jesus and Mary in 1643 and spent the rest of his life promoting devotion to both the mother and the son. His book, *Le Cœur Admirable de la Très Sainte Mère de Dieu* (*The Admirable Heart of the Very Saintly Mother of God*) joined the hearts of Jesus and Mary in a mystical alliance. Despite his best efforts, however, Rome did not recognize the Immaculate Heart until the nineteenth century and did not fully officialize it until 1944, when Pope Pius XII instituted the Feast of the Immaculate Heart of Mary. Today it is celebrated on the Saturday following the Feast of the Sacred Heart, which always falls on a Friday.

THE REFORMATION AND COUNTER-REFORMATION provided new venues for the heart icon in prayer books and stained-glass windows, in statues and paintings, in family seals and other personal objects of devotion. As a religious symbol it rivaled the amorous heart icon that had been so popular in the late Middle Ages.

But increasingly during the sixteenth and seventeenth centuries the heart began to expand beyond its earlier symbolic boundaries. Though it continued to stand for love, both religious and amorous, the heart acquired a new host of psychological meanings. It was understood to contain a variety of emotions jostling with one another, and the emotion or attribute that won out defined the owner of that particular heart. If your heart was loving, gentle, kind, and compassionate or hateful, vengeful, fearful, jealous, brutal, and avaricious, that was who you were. In a way the idea of an "independent heart," from late medieval allegory, became a template for a new theory of personal character.

Whereas outward signs of identity attested to one's membership in a certain class or religion, the truth of one's heart

could be ascertained only by oneself and God. This inner truth, with all its complexities, began to overtake the exclusive association of the heart with love that had prevailed in medieval Europe. The heart was becoming the repository of all the emotions. Yes, love would endure within the heart, whether directed toward another person or toward God. But love was obliged to share the heart with other feelings, which sometimes existed in a conflicted relationship with love or obliterated it entirely.

Chapter 13

How Shakespeare Probed
the Heart's Secrets

The English were slower than the Italians in creating great love poetry and slower than the French, Dutch, and Germans in publishing emblem books, but during the sixteenth century, English poets and playwrights produced immortal literature that illuminated the amorous heart. Since then readers worldwide have looked to Elizabethan writers for exemplary lovers, most notably those springing from the mind of Shakespeare.

But before turning to him, let us not forget his contemporary, Sir Philip Sidney, who wrote one of the most widely anthologized poems featuring the heart: "My True Love Hath My Heart."

> *My true love hath my heart and I have his,*
> *By just exchange one for the other given:*
> *I hold his dear, and mine he cannot miss;*

There never was a bargain better driven.
His heart in me keeps me and him in one;
My heart in him his thoughts and senses guides:
He loves my heart, for once it was his own;
I cherish his because in me it bides.
His heart his wound received from my sight;
My heart was wounded with his wounded heart;
For as from me on him his hurt did light,
So still, methought, in me his hurt did smart:
Both equal hurt, in this change sought our bliss,
My true love hath my heart and I have his.

Once again the exchange-of-hearts metaphor signals true love. It's an old trope, already deconstructed in the twelfth century by Chrétien de Troyes, and the idea of being "wounded" by the sight of the beloved had been commonplace for even longer. Yet when hearts are exchanged in iambic pentameter by a master craftsman, they effectively convey the harmonious sense of oneness that lovers—if they are lucky—come to experience.

Is the speaker who has wounded the lover's heart a woman? Most probably. But whatever hurt she has inflicted on him pains her as well. And whatever trials they have undergone, they have undergone together, creating a perfect union.

Sidney's version of the exchange of hearts carried medieval rhetoric into sixteenth-century England, where it was kept alive, reinterpreted, mocked, and ultimately displaced by Shakespeare's soaring depictions of hearts brimming with love. It has been estimated that the word *heart* appears more than a thousand times in Shakespeare's sonnets and plays, almost as often as the word *love*.

Shakespeare gave voice to the heart's turbulent emotions, ranging from youthful fervor to old-age fears and all else in between. His lovers knew not only desire and tenderness but also jealousy, rage, deception, and murderous revenge. Simple-hearted Othello, goaded on by the wicked Iago, ends up killing his beloved Desdemona. Large-hearted Antony is blindly led by his heart as he adulates Cleopatra, follows her into military defeat, and ultimately precipitates their dual tragedy. In Shakespeare the heart has characterological significance: one's heart determines one's destiny.

Very occasionally in a Shakespearean play a hardened heart is shocked into a renewed state of grace and recognizes the wrong it has done, usually to a guiltless woman. Such is the case of the block-hearted Claudio in *Much Ado*, who certainly doesn't deserve his loving bride, Hero. And such is the case of the heartless King Leontes in *The Winter's Tale*, who imprisons his wife, Hermione, on false grounds of adultery, obstinately rejects their baby daughter, and loses them both— until reunited sixteen years later in a classic happy ending.

Does the heart still stand primarily for amorous love in the world of Shakespeare? Yes, most certainly, but it has also taken on a broader emotional range. Examples of the traditional heart-equals-love metaphor jostle with many other metaphoric meanings.

In Act I, scene i of *Romeo and Juliet* a besotted Romeo bemoans the suffering inflicted upon him by the fair Rosaline. He complains to his friend Benvolio that "griefs of mine lie heavy in my breast" and repeats the ancient lament that Cupid has sent a deadly arrow into his heart while bypassing that of his lady. This love Romeo professes for Rosaline is mere imitation of an already outmoded fashion. But when he

falls in love with Juliet it's the real thing, and he recognizes the difference immediately:

> *Did my heart love till now? forswear it, sight!*
> *For I ne'er saw true beauty till this night.*

Juliet, too, barely fourteen, knows instantly that Romeo is the only man for her. Defying her father, who would have her marry her kinsman, Paris, she engages Friar Laurence to perform a secret wedding ceremony. To him she declares unequivocally, "God join'd my heart and Romeo's, thou our hands."

Juliet represents a new type of heroine who emerged in England during the second half of the sixteenth century. She is courageous, intelligent, steadfast, and endowed with a mind of her own. Unlike some of her medieval predecessors, worshipped from afar or tugged into adultery, Juliet insists upon marriage before she and Romeo consummate their love.

One result of the Protestant Reformation was that marriage gained greater prestige. Rejecting the notion that celibacy was a higher state than marriage, Protestants eliminated the celibate clergy and replaced it with the pastoral couple, exemplified by Luther himself and the former nun Katharina von Bora, who became his wife. In England, with the establishment of the Anglican Church, preachers spoke of husbands and wives as "yoke partners," implying that they bore equal weight, if not equal authority, in sustaining a conjugal union. And in this new kind of marriage the mind of the woman was beginning to be touted along with her beauty; indeed, many male Protestant writers made a point of stating a preference for mind and virtue over physical attributes, though this high-minded stance probably did little to change the practices of most people.

One of Shakespeare's most beloved sonnets begins, "Let us not to the marriage of true minds admit impediment." Several of Shakespeare's delightful heroines—Viola, Beatrice, Portia—are quick-witted women who find a way to bring to fruition the love matches they so fervently desire.

But then there is *The Taming of the Shrew*, where the heroine is a bit too clever for her own good. She becomes an out-of-control monster, and Shakespeare ultimately sends her back to the straightjacket of traditional bondage, placing in her mouth these words:

> *Thy husband is thy lord, thy life, thy keeper,*
> *Thy head, thy sovereign; one that cares for thee, . . .*
> *Such duty as the subject owes the prince,*
> *Even such a woman oweth to her husband.*

Following this speech Kate places her hand beneath her husband's foot to indicate the subservient path she plans to follow. For centuries readers have been debating why Shakespeare ended *The Shrew* on this note. Suffice it to say that most American women today would reject this feudal picture of the marriage bond.

HEARTS OF EQUAL VALOR RETURN TO THE STAGE IN *ANTONY and Cleopatra*. Indeed, some critics believe that this late play contains the fullest expression of Shakespeare's metaphorical heart and that by merging traditional conceptions of the heart with new meanings, it offers "one of the most heart-rich works of art in existence." The play opens with the news that Antony's wife, Fulvia, has died in Rome while he has been in Egypt famously consorting with Cleopatra. Though he must hasten back to Italy, he assures the Egyptian queen,

"my full heart remains in use with you." Whereas her heart is mainly devoted to erotic love, with a long history of lovers before Antony, his is divided between his love for Cleopatra and other loyalties that have nothing to do with eros. He has a military heart, a family heart, a Roman heart—all of which come into conflict with his amorous heart. After the death of his wife Antony accepts a second marriage to Octavia, young Caesar's sister. One of Caesar's close friends tells Antony that the marriage will make him and Caesar brothers and "knit your hearts."

And though Antony and Octavia do marry, the course of subsequent events is such that he must eventually fight against Caesar. In a major naval battle, when Antony should be directed by his warrior heart, he follows his amorous heart instead: he retreats to follow Cleopatra after she has withdrawn her own ships. Afterward, in full defeat, Antony cries out despondently to Cleopatra, "thou knows too well / My heart was to thy rudder tied by thy strings." He acknowledges that his love for Cleopatra has triumphed over his other loyalties.

In the end the two lovers display the magnanimity of their hearts when they choose to die in tandem from self-inflicted wounds. Along with Tristan and Isolde and Romeo and Juliet, Antony and Cleopatra belong to a small but impressive cohort of lovers whose hearts struggle against insurmountable obstacles and seek ultimate union in death.

It is beyond the purview of this single chapter to explore the many ways that Shakespeare's vocabulary of the heart enriched his own work and the English language. Still, one can fairly swiftly highlight a few heart-laden passages that have, over time, become so associated with a certain character as to become a sort of identity card.

Take an oft-cited passage in *Twelfth Night* when Duke Orsino compares his own heart to that of a woman—any woman—with the assumption that his heart is bigger, stronger, more passionate.

There is no woman's sides
Can bide the beating of so strong a passion
As love doth give my heart; no woman's heart
So big to hold so much: they lack retention.

Shakespeare put this masculinist credo into the mouth of his self-deluded hero as a way of suggesting that Orsino's love for the distant Countess Olivia—like that of Romeo for Rosaline—is not what he thinks it is. His one-sided adulation has merely the appearance of love. A truly deep, steadfast love belongs to the heart of Viola, the Duke's trusted servant, who has disguised herself as a man in order to gain employment and, once in the Duke's service, falls in love with her master. She serves him faithfully throughout this gender-bending plot until he eventually recognizes her as the woman who has, with spunk and steadfastness, worked her way into his heart.

The hearts palpitating in Shakespeare's comedies make for high-spirited drama. Who wouldn't want to be a lover in *Twelfth Night* or *As You Like It* or, most fancifully, *A Midsummer Night's Dream*? But when we turn to the tragedies, the heart takes on a darker hue.

Consider the villainous Iago in *Othello* when he declares, "I will wear my heart upon my sleeve." This is a way of saying that he will openly display his feelings, yet Iago only pretends to speak honestly so as to deceive his gullible entourage. His ploy convinces Othello of Desdemona's unfaithfulness and leads to their final tragedy.

The "heart upon my sleeve" expression is sometimes used today in the negative: "I won't wear my heart upon my sleeve," or, put another way, I won't let people know just how I feel about a certain man or woman. This idiom harkens back to medieval jousts, when knights wore the colors or insignias of their ladies on their sleeves, but the expression did not exist, according to lexicographers, until Shakespeare invented it circa 1600.

In *Macbeth* the duplicitous heart belongs to a more complicated character than Iago. From the start Macbeth knows that he and his wife, Lady Macbeth, will need both deceit and courage to murder Duncan, the king of Scotland, and usurp his throne. Macbeth admonishes himself: "False face must hide what the false heart doth know." Then, after Duncan's murder, Macbeth publicly attributes the murder to the king's two guards, whom he also kills under the pretense that the fierce love he felt in his heart for Duncan and the courage rooted in his heart had obliged him to do away with them at once.

In Shakespeare's time it was understood that love and courage often vied for supremacy in Englishmen's hearts. Queen Elizabeth I played upon the association between the male heart and courage in her oft-quoted 1588 speech to her troops at Tilbury after the defeat of the Spanish Armada, when she proclaimed, "I know I have the body of a weak and feeble woman, but I have the heart and stomach of a king." Clever lady!

The opposite of the courageous heart is the "pale-hearted fear" that enters into Macbeth's psyche after he has added to his list of murders. Fearfully, his "heart throbs to know one thing": whether the crown he has usurped will pass on to his own sons or, as predicted, fall to another line. Macbeth's

heart carries a stock of ignoble feelings—greed, envy, fear—buttressed by a modicum of courage and unwavering attachment to his wife. All of these sentiments coexist in his troubled heart, that metaphorical space that Shakespeare expanded more than any other Renaissance artist.

Compared to the simple figures in medieval allegories who had only one identity, Shakespeare's characters are considerably more complex and therefore more modern; not limited to the single-minded, all-or-nothing passion found in medieval romance, Shakespearean loving has "infinite variety," to borrow an expression he used for Cleopatra. It takes the form of naive astonishment when Miranda in *The Tempest* sees a male youth for the first time and exclaims, "Oh brave new world that has such creatures in it!" It exists in the amorous sentiments that Hamlet's mother, Queen Gertrude, feels for her new husband, her former brother-in-law, who, unbeknownst to her, had murdered her first husband. Even Macbeth and his wife demonstrate a strain of conjugal love, though their partnership becomes corrupted and eventually destroyed by their unbridled ambition. Lady Macbeth is a formidable accomplice, the worst of Shakespeare's headstrong women, yet we cannot deny that some twisted form of affection between her and her husband facilitated their horrific acts.

These few examples suggest the distance between courtly love, with its single code of conduct, and the diverse forms that love acquired in the world of Shakespeare. The courtly lover who routinely suffered for his beloved—usually another man's wife—has been replaced by a lover hoping to marry the lady of his choice. More often than not she is a willing accomplice in the love plot, scheming and suffering as much as her male counterpart. The old trio of husband, wife, and

her lover no longer commands the spotlight except in the deranged minds of men like Othello and Leontes. On the Shakespearean stage comedies end in happy marriages— sometimes more than one—and tragedies end in the destruction of amorous, conjugal, and filial bonds.

KING LEAR, THE GREATEST OF SHAKESPEARE'S TRAGEDIES, has at its core the theme of filial love experienced in two parallel families: the foursome made up of Lear and his three daughters—Goneril, Regan, and Cordelia—and the three-some consisting of Gloucester and his two sons, Edmund and Edgar. Put simplistically, the "good hearts" belong to Cordelia, Kent, Edgar, and Gloucester, and the "bad hearts" to Goneril, Regan, Cornwall, and Edmund. The very name *Cordelia* means "goddess of the heart." And Lear's heart? His "father's heart," his "rising heart," his "frank heart," to use his own words, will live to see the revolt of his "daughters' hearts / Against their father" and his own heart "break into a hundred thousand flaws."

In Act I Lear foolishly displays his need for lavish demonstrations of his daughters' filial love. At first he is satisfied when two of them, Goneril and Regan, claim to love him more than words can tell. But when his youngest and most beloved Cordelia is asked to flatter him in a manner similar to her sisters', she answers only:

> . . . *I cannot heave*
> *My heart into my mouth: I love your Majesty*
> *According to my bond; nor more nor less.*

Given her hope that she will, in time, love a husband as much as she now loves her father, she cannot in all honesty promise to love her father exclusively.

Lear's angry response to Cordelia's honesty is swift: he tells her that henceforth she will be "a stranger to my heart" and can expect nothing from him as a dower. His overweening self-love is the enemy of familial affection. Shakespeare lived at a time when children were beginning to assert their love choices against the wishes of their parents, and this great social transformation was reflected in several of his plays, tragically in *Romeo and Juliet* and comically in *A Midsummer Night's Dream*. *Lear* brings the conflict between parents and children to a cataclysmic conclusion. Where is the heart in all this? Broken, shattered, the pieces caught up in a whirlpool of destruction.

LOVE IN ALL ITS COMPLEX FORMS—AMOROUS, FILIAL, parental, brotherly, sisterly—requires a different environment, a place immune to the hostilities created by men. Shakespeare imagines such settings in *The Tempest*'s magical island and in *Twelfth Night*'s Illyria, where love flourishes as if in the Garden of Eden. But in the real world the longing to love to one's "heart's content" (another expression coined by Shakespeare) encounters myriad obstacles, both external and internal. Although we can do little to change the world we live in, we look to Shakespeare for reminders of the need to know our own hearts, to fathom their secrets, and to listen to the beat that signals the presence of other hearts compatible with our own.

Chapter 14

Heart and Brain

IN 1628 THE ENGLISH PHYSICIAN WILLIAM HARVEY PUB-
lished a short book in Latin that was to revolutionize med-
icine. His seventy-two-page *Exercitatio anatomica de motu
cordis et sanguinis in animalibus* (otherwise known as *On the
Motion of the Heart and Blood in Animals*) offered proof that
the heart's main function was to pump blood through the
body. This radically new conception of the heart contradicted
two thousand years of medical belief.

As far back as the ancient Greeks, physicians such as
Pythagoras in the sixth century BCE and Hippocrates two
centuries later believed that there were four humors cours-
ing through the human body—blood, phlegm, black bile,
and choler. These humors supposedly determined a person's
character and mood. Too much blood or phlegm made you
sanguine or phlegmatic. Too much black bile made you sad or
melancholic. And too much choler made you angry (choleric).
A proper balance between the four humors was considered

necessary for an individual's health. The heart's role, like that of the sun in relation to Earth, was to heat the blood and thus regulate the humors. In addition, followers of Hippocrates believed that all mental functioning was situated in the heart, including human intelligence.

Philosophers, however, had differing views about the heart's functions. Plato believed it was primarily the seat of emotions and the brain was the seat of intelligence. Aristotle granted the heart even greater importance: it was the central organ of life, the origin of all pleasure and pain, the source of the body's heat. It also produced *pneuma*, the air that animated the soul. As for the intellect or what the Greeks called *nous*, in Aristotle's scheme it was not assigned to any specific organ.

The influential Greek physician Galen in the second century CE contested the supremacy of the Aristotelian heart. He believed the heart worked in conjunction with both the liver and the brain. Rational thought was centered in the brain, emotions in the heart, and nutrition in the liver. Though Galen recognized the unusual muscular strength and endurance of the heart, he judged it as secondary to the liver, where, he thought, blood is formed and then carried by the veins to all parts of the body. Galen's ideas dominated medical education and practice long after his death through numerous Arabic and then Latin translations.

During the Middle Ages, thinkers attempting to reconcile medical ideas with Christian doctrine joined the debate between Aristotelian and Galenic models of the heart. If the heart was the seat of the soul, according to Judeo-Christian pronouncements, just how did the soul gain entry into the heart?

Alfred the Englishman's *De motu cordis* (*On the Motion of the Heart*) is an example of the way medieval thinkers

answered this question. Because the body, "whose material is solid and obtuse," and the soul, "which is of a very subtle and incorporeal nature," have such different properties, he postulated the presence of "a certain medium which, participated in the nature of both." That "medium" entered the body through the air we breathe and mixed with the blood in our hearts. Christian philosophers from the thirteenth and fourteenth centuries thought of bodies as connected to the universe rather than as independent entities. In this interconnected system between humans and the cosmos, hearts were the crucial agents that assisted the "spirit" in and out of the blood.

The Renaissance brought about a new understanding of the heart as both medical practitioners and artists began to observe the body with their own eyes rather than blindly repeat earlier theories and to reproduce the body's components more accurately in drawings, paintings, sculpture, and book illustrations. The famous notebooks of Leonardo da Vinci (1452–1519), covering some five thousand pages, contained hundreds of sketches of the human body, several showing the heart. Leonardo profited from the practice of human dissection, which had been revived as early as 1315 in Italy but could be banned once again at any time according to the mood of the pope. Leonardo conducted many of his dissections on animals, and his knowledge of cardiac anatomy was based largely on the ox heart. His brilliant written observations and sublime drawings were the fruits of his longstanding dedication to cardiac research.

Andreas Vesalius (1514–1564), born shortly before Da Vinci's death, is considered the father of modern anatomy. He set a new standard for scientific investigation in his masterpiece, *De humani corporis fabrica* (*The Fabric of the Human Body*), first

published in 1543. As a student of medicine and then professor of surgery and anatomy at the University of Padua, Vesalius was allowed to dissect cadavers, thanks to a judge who supplied him with the bodies of executed criminals. During the sixteenth century dissection was still practiced discreetly. When I visited the University of Padua some years ago and was led into the lower depths of a very old medical building where dissections had taken place, I was told that cadavers were originally brought into the amphitheater through an underground passage at night.

Vesalius's groundbreaking book, known simply as the *Fabrica*, was an immediate success and reprinted in many editions—some pirated, some abridged, some translated, some amended by Vesalius himself. What was the cause of its unprecedented success? Surely not Vesalius's turgid Latin prose. Rather, it was his use of the scientific method. He drew conclusions based on his own observations, experimentation, and discoveries. Though he had started his medical career as a confirmed Galenist like all the other European doctors, he went on to reveal where Galen had simply been wrong. For example, there is no bone at the base of the heart. The heart's septum (the partition dividing a body space) is not porous. Men and women have an equal number of ribs; Galen claimed that men had one fewer, based on the biblical story of Adam and Eve. Though he retained some aspects of Galen's physiology, Vesalius did more than any other sixteenth-century scientist to dethrone Galen from the position of authority he had enjoyed for thirteen hundred years. The interior landscape of the human body was changed forever.

Another reason for the success of the *Fabrica* was its two hundred illustrations. These were made by several artists, one

of whom, Jan van Calcar, had already worked with Vesalius in 1538 to produce the very large plates of the *Tabulae anatomica sex (The Six Anatomical Tables)*. Five years later Vesalius's *Fabrica*, published in a superb folio edition by a Basel printer, set a new artistic standard for medical works. For three hundred years before the publication of *Gray's Anatomy*, medical students looked to Vesalius for their lessons in anatomy.

Still, even as Vesalius was making great advances, unfounded ideas about the human body continued to thrive. One of the most peculiar beliefs associated the female uterus with the heart. Because the heart was popularly considered the seat of love and the uterus known to bear the product of lovemaking, the uterus was endowed with qualities that had long been attributed to the heart, such as love, joy, and receptivity. Indeed, a 1522 publication contained the image of a heart-shaped uterus—the same form that represented amorous love in books of romance.

This particular misconception survived for several decades. In the 1560s an English midwifery manual described the uterus as "not perfectly round . . . but rather like the form of a man's heart, as it is painted." This comparison with the heart obviously derived from the medieval artistic tradition rather than from the new anatomical knowledge gained from dissection. The association between the heart and the uterus persisted not only in midwifery manuals but also in other serious medical works published in England and on the continent. The anatomical studies initiated by Vesalius were not enough to abolish older, fanciful interpretations of fetishized body parts like the heart, the uterus, and the penis. Indeed, Vesalius himself was responsible for an engraving in the *Fabrica* that depicted female vaginal anatomy as heart-shaped.

WILLIAM HARVEY PUT TO REST ALL THE FALSE IDEAS ABOUT the heart from Galen, Vesalius, and other previous authorities. He showed for the first time that arteries pump blood from the heart throughout the body and that veins return the blood back to the heart. The heart, not the liver, is the source of blood's movement, with the heart's regular contractions driving the flow of blood. Each pulse beat signals a contraction of the heart, as it pushes blood out into the arteries. All the blood in the right ventricle goes to the lungs and then through the pulmonary veins to the left ventricle that, in turn, pumps blood to the rest of the body.

Readers may be asking themselves why I am devoting so much time to medical history. What relationship is there between the amorous heart and the medical heart? Very little, if any. And that's the point. Once the scientists took over, as they did increasingly from the Renaissance onward, the metaphoric heart had to defend itself from being reduced to a mere pump.

IN SHAKESPEARE'S *MERCHANT OF VENICE* BASSANIO, ONE OF many suitors for the hand of Portia, must choose between three caskets—gold, silver, and lead. If he chooses the correct one, he will win the fair Portia. While he ponders over his choice, a song is heard in the background that begins with this line: "Tell me where is fancy bred / Or in the heart, or in the head?" If we take "fancy" to mean romantic inclination—as in, "take a fancy to someone"—we find ourselves confronted with a new question concerning the source of love: Is it a product of the heart or the brain? What part of the body generates "fancy"? Or, put more broadly, what is the relationship of the material body to the emotion of love?

Men and women in medieval times had no trouble answering those questions, since the heart was universally accepted as the unambiguous home of love. The dart of love came through the eyes without injuring them and struck the heart full force. All the pleasure and pain of "fancy" dwelt in the heart.

The new medical discoveries starting in the Renaissance challenged longstanding ideas about the seat of human emotions. By 1598, when *The Merchant of Venice* was first performed, it was no longer a given that the heart had an exclusive claim to love. Not long after Shakespeare raised the question of love's connection to heart or head, seventeenth-century physicians and philosophers weighed in on the subject, launching a controversial debate that was to last throughout the Scientific Revolution and into the eighteenth century.

Once Harvey had demystified the heart's anatomy and functions, French and English thinkers began to treat the brain as the abode of love. Descartes in France and Hobbes and Locke in England identified *all* aspects of consciousness with the brain, thus depriving the heart of any association with love.

For Descartes (1596–1650) the defining feature of man was his mind, spirit, or soul—words he used somewhat indiscriminately. Though the heart was vital to life, it was understood to be a mere organ of the body that had little to do with emotion or thought. This separation of body and soul (of mind and spirit) became the keystone for his philosophical dualism. His well-known formula, "I think, therefore I am," situated man's essence in his head and dismissed the affective claims of the heart. In earlier times advocates for the heart might have written, "I feel, therefore I am."

Although Descartes could easily pinpoint the heart's location within the chest and the brain's within the head, he didn't know where to situate the immortal soul. Classical authorities, like Plato and Galen, had placed the soul in the head, whereas others, like Aristotle and Hippocrates, favored the heart. Catholicism clearly associated the soul with the heart, but because the heart was material, like the rest of the body, Descartes could not conceptualize it as the seat of the soul.

He came up with the bizarre idea elaborated in *Les passions de l'âme* (*The Passions of the Soul*) (1649) that the soul had its home in the pineal gland, located at the center of the brain. He wrote, "The part of the body in which the soul directly exercises its functions is not the heart at all, or the whole of the brain. It is rather the innermost part of the brain, which is a certain very small gland situated in the middle of the brain's substance."

The pineal gland provided a point of interaction between the material body, subject to the laws of nature, and the insubstantial soul, subject only to God. Descartes set in motion a debate over the mind-body problem that has continued in many forms until our own time.

In this same work Descartes attempted to figure out exactly how the brain, the soul, and the heart interacted to produce emotions. With the precision of a mathematician, he isolated five passions: love, hatred, joy, sadness, and desire.

As for love, Descartes wrote that when one sees a love object, a thought forms in the brain that is then carried to the heart by the blood. The blood, "rarefied many times in passing and repassing through the heart," sends toward the brain what Descartes calls "spirits." "These spirits, strengthening the impression which the first thought of the lovable

object has formed there, compel the soul to dwell upon that thought. And this is what the passion of Love consists in."

And this is what the passion of love consists in? God forbid! Anyone who has ever been in love will find such an analysis lacking, if not totally ridiculous. Descartes was wrong on two counts. First, his view of physiology was incorrect, even if he had learned something from Harvey's medical discoveries—shown by his reference to blood passing and repassing through the heart. Second, he presented love as nothing but physiology. This reductionistic analysis of love tells us as much about love as a recipe tells us about the taste of cake.

DESCARTES'S DEMOTION OF THE HEART DID NOT GO UNCONtested. His chief antagonist was his younger contemporary Blaise Pascal (1623–1662), who was also a mathematician, scientist, and philosopher. Pascal never abandoned the heart, always considering it superior to the brain. He separated heart from brain, feeling from thinking, in an oft-quoted statement: "The heart has its reasons which reason does not know." Without denying the value of reason, Pascal pointed to a different kind of knowledge perceived instinctively by the heart and inaccessible to rational thought. Pascal's heart remained open to the mystery of love in both its human and divine forms.

The rivalry between heart and head only quickened during the second half of the seventeenth century. The English empiricists Thomas Hobbes and John Locke attacked the heart and promoted the brain, in conjunction with the senses, as the primary determinants of human behavior. Before they were done, Hobbes, Locke, and, later, David Hume had reversed centuries of thinking about human nature. They

imposed a new understanding of how men and women arrive at their thoughts and emotions, in which human beings were understood to be subject to the vagaries of their minds. And what of the heart? Hobbes, in his groundbreaking *Leviathan* (1651), answered mechanistically: "For what is the *Heart* but a *Spring*; and the *Nerves*, but so many *Strings; and the Joints giving motion to the whole Body?*"

Locke continued the assault against the heart's significance. He defined a person not by the contents of his heart but by the workings of his mind. In his *Essay Concerning Human Understanding* (1690) he argued that the brain, or mind, begins as a blank slate and gains knowledge through the senses. Humans learn through a combination of sense perception and reflection upon their experiences. Man is defined as a thinking being, an intelligence, a consciousness, and this sets him "above the rest of sensible Beings." Notably, Locke never speaks of the heart.

Eric Jager, in his fine *Book of the Heart*, concludes that the self envisaged by Locke had relocated its core from heart to head, abandoned its religious or romantic underpinnings, and "turned resolutely secular." I'm not so sure that Locke's psychology was "resolutely" secular. He thought of himself as a devout Christian and argued that belief in God was necessary for an ethical universe. But as for Locke's role in diminishing the heart, Jager is certainly right. Locke contributed considerably to the new cartography of the self in Western thought. Along with other seventeenth-century thinkers, Locke gave the heart a sound beating. Henceforth, Enlightenment philosophers as well as physicians would conceptualize the heart materialistically and abandon its ancient metaphoric meanings.

Chapter 15

Exposing the Female Heart

FIGURE 26. Artist unknown, child's ring token, eighteenth century. Foundling Home Museum, London, England.

IN 1741 THE FOUNDLING HOSPITAL WAS ESTABLISHED IN London for the city's sizeable number of abandoned children. Along with their babies, mothers often left tokens of love, such as a piece of jewelry or a poem, which could be used in identifying the child if the mother ever came back to claim the boy or girl. Unfortunately, most of the mothers never saw their children again.

A few of these tokens now preserved at the Foundling Museum, such as the ring pictured in Figure 26, were in the shape of hearts. They spoke for the mother's heart grieved by the loss of her baby and for the affectionate bond between them that would henceforth be severed by space and time.

The real-life stories of those mothers and their orphaned children fed the imagination of British writers and led to some of the best-known novels of the eighteenth century. *The History of Tom Jones, A Foundling* (1749) by Henry Fielding has as its protagonist a bastard son who had been left in the bed of the local squire and raised by him under the mistaken belief that Tom's mother was Jenny, one of the servants. After years of rollicking adventures, the secret of Tom's birth is ultimately revealed to his advantage—his birth mother was the squire's unmarried sister—and Tom is then able to marry the woman of his choice. Because this is a comic novel, the reader rightfully expects a happy ending.

But what of Tom's mother? Her story is less than happy. Single women who had the misfortune of becoming pregnant were often cast out from their families, especially if they came from middle-class circles. (Lower-class country girls were often pregnant at the time of their marriage to the baby's father, and aristocrats sometimes had the means to cover things up.)

Given the lamentable situation of the unwed mother, a maiden's chief obligation was to protect her "virtue." Many, if not most, eighteenth-century English and French novels of the heart revolved around the theme of seduction, with men hell-bent on ravishing a chosen woman—and generally more than one. In so doing, novelists placed women center stage and, to borrow words from Samuel Boswell in his *Life of Johnson*, dove "into the recesses of the human heart." Boswell

had written those words to describe the eponymous young women in Samuel Richardson's best-selling novels, *Pamela: or Virtue Rewarded* (1740) and *Clarissa: or The History of a Young Lady* (1748).

It is difficult for us in the twenty-first century to imagine the torrential reaction to *Pamela* when it first appeared. Within a year after its publication there were five printings plus a French translation as well as pirated editions in London and Dublin. *Pamela* was a media sensation unlike anything that had ever occurred before in British literature. But along with its many admirers, *Pamela* also had its detractors, such as Fielding, who wrote a burlesque novel, *Shamela*, in direct response to it. Why the uproar? What had Richardson done to elicit such a response?

Pamela is an investigation of a maiden's heart as she determinedly fights off the equally determined advances of her youthful master. It takes the form of a series of letters written by Pamela, a sixteen-year-old girl from a poor family. Who would want to read such unsophisticated utterances? Apparently tens of thousands of readers in England, France, and, eventually, the rest of Europe.

Pamela's heart has a starring role in her tale. She invokes it more than two hundred times along with references to her young master, who has "Mischief in his Heart." Pamela's parents, too, in letters to their daughter, often speak of their feelings in terms of their hearts: "our Hearts ake for you," they say, when they begin to suspect the young man's designs on their daughter. Once Pamela realizes he is intent upon taking liberties with her, she declares to herself, "my heart's broke, almost; for what am I likely to have for my Reward, but Shame and Disgrace, or else ill Words and hard Treatment."

Over and over again, as Pamela tries to ward off the master's advances, she expresses her pain in terms of her heart: a broken heart, a poor heart, a sorry heart, a full heart, a heavy heart, a sick heart, a throbbing heart, a pure heart, a heart that fails her, a heart that is in her mouth. Her heart invariably contrasts with the "proud," "false," and "poisonous" heart of the man who, for at least half the novel, stops at nothing in his efforts to seduce her.

The hearts invoked in *Pamela* are significantly different from those in medieval romances. In the first place, Pamela's heart belongs to a woman and not to the troubadours who poured their amorous cravings into songs and narratives. Though Pamela's heart will prove itself capable of love, its primary duty is self-protection—to protect her *against* male desire. Her concerns—which are the same as women's concerns in most eras and most cultures—are to keep her body intact, unharmed from a would-be intruder. And because she is a sincere Christian who subscribes to notions of virtue that focus on the purity of body and soul, her heart initially stifles any erotic impulses. Richardson knew exactly what he was doing in creating a heroine whose heart was a religious-moral fortress, impervious to attacks upon her chastity. Anything less would have been met with censure from the growing number of middle-class readers who were his primary audience.

Pamela manages to fight off her master's designs on her body, even when he climbs into her bed and a vicious female accomplice holds her down. What she doesn't anticipate is that he will ultimately have a change of heart and come to realize that he truly loves Pamela. Likewise, she will discover that the master has found his way into her own heart. At this point in the narrative Pamela speaks of her heart in an entirely new language. "I felt something so strange, and my

Heart was so lumpish!—I wonder what ail'd me!" "I resign'd myself to this strange wayward Heart of mine, that I never found so ungovernable and awkward before." "O how my heart went pit-a-pat!" "O my exulting Heart! How it throbs in my Bosom!" Pamela's heart is evoked, euphemistically, as a barometer of the lustful feelings awakened in her body.

But even if her heart and his are now in accord, there is the question of their difference in status. The master belongs to a wealthy, distinguished family in possession of several important estates, and marrying his servant is anathema to members of his class, especially to his proud sister. In the end the master sets aside these considerations and asks Pamela to be his wife. With what one imagines were the rousing cheers of Richardson's delighted readers, she, of course, accepts.

RICHARDSON'S CLARISSA HARLOW IS LESS FORTUNATE. SHE, too, is the victim of "assaults to her heart" coming not only from the libertine Lovelace but also from her own family. Her affluent parents insist that she marry a certain Mr. Solmes in order to contract a socially advantageous union. When Clarissa defiantly refuses this match because she finds Solmes repugnant, her parents curse her and Clarissa faints to the floor. As she later writes, "*There* went the dagger to my heart, and down I sunk."

A daughter's refusal to accept her parents' selection of a husband was, by the mid-eighteenth century, an old story. Shakespeare's Juliet, one of the most defiant daughters of literary fame, rebelled against her parents' choice and came to a tragic end. And in *Clarissa*, 150 years later, the everlasting battle between parental will and youthful rebellion in matters of the heart was still in progress. From their pulpits Protestant pastors, especially those of a Puritan persuasion,

enjoined children and wives to obey their fathers and husbands without question. Clarissa, brought up to honor her father and mother, is horrified when she feels forced to disobey them. The urgency of her refusal comes from something even deeper than conventional Christian morality: as she puts it, "the integrity of my heart [is] concerned in my answer." To marry Mr. Solmes without loving him would go against her heart, the home of her most authentic self. Following the Judeo-Christian tradition the heart is linked to the soul, and Clarissa, like Pamela, is more concerned with her immortal soul than with worldly satisfactions. But unlike Pamela, Clarissa has the double burden of preserving her integrity against both her family's wishes and Lovelace's designs on her person.

Lovelace, whom her family has treated badly, eventually tricks Clarissa into eloping with him and turns her into a literal prisoner. Though he wants to marry her from the start—unlike Pamela's master, at least early in their relationship—Clarissa consistently refuses Lovelace's offers. The dynamic between the two of them reflected a society where blatant inequalities of sex, as of class, were taken for granted. But what distinguishes this novel from many others is the claustrophobic intensity of the romantic duo engaged in mutual destruction.

Lovelace's obstinate desire to possess this lovely, virtuous, strong-minded woman grows into an obsessive passion. He keeps her imprisoned in a number of establishments, including a brothel. He muses upon "the female heart (all gentleness and harmony by nature)" and hopes that he will eventually be able to prevail upon Clarissa's. Eventually, driven to distraction by her determined resistance, Lovelace finds the means to drug and rape her.

Clarissa lies comatose for two days, grief-stricken for a week, and when she finally regains full consciousness, she is more adamant than ever in her refusal to become the wife of such an immoral rake. She tries, unsuccessfully, to shame Lovelace and to open his eyes to the evil he has done her. As she explains in a letter to her friend, Anna Howe, the deplorable actions of her family, followed by those of Lovelace, have almost destroyed her. She will find salvation in renewed dedication to scripture and in writing her personal religious meditations. But after the rape Clarissa never fully regains her physical strength, and she wastes away until an untimely death ends her torments. She goes to meet her maker with the hope that her violated heart will be made whole again.

And Lovelace, her demonic tormentor? His heart becomes ever more unruly. He declares before Clarissa dies, "My heart is bent upon having her . . . though I marry her in the agonies of death. . . . I will overcome the creeping folly that has found its way into my heart, or I will tear it out in her presence, and throw it at hers, that she may see how much more tender than her own that organ is."

And after she dies he is still insistent on his right to Clarissa's heart, this time quite literally. As he states to his friend Belford, "I think it is absolutely right that my ever-dear and beloved lady should be opened and embalmed. . . . But her heart, to which I have such unquestionable pretensions, in which once I had so large a share, and which I will prize above my own, I *will* have. I will keep it in spirits. It shall never be out of my sight."

If we accept *Pamela* and *Clarissa* as partial reflections of English society during the 1730s and 1740s, we come to the conclusion that the female heart was obliged to fulfill two different functions: it had to be both a moral compass and a

guide to true love. Women were expected to provide checks on male desire, first for their own good but also for the good of the men who purported to love them. Pamela, through the strength of her character, not to mention her beauty, succeeded in arousing her future husband's tender feelings long after he had experienced the physical cravings of lust. But poor Clarissa, equally endowed in beauty and virtue, would not live to see the remorse that took hold of Lovelace's proud heart in the aftermath of her death.

RICHARDSON'S NOVELS WERE HUGE HITS NOT ONLY IN ENgland but also across the channel in France, where they inspired a slew of epistolary novels, the most famous being *Julie, ou la nouvelle Héloïse* (*Julie, or the New Heloise*) (1761) by Jean-Jacques Rousseau. It eventually surpassed Richardson's novels in sales, going through about seventy printings by the end of the century. Once again the inner workings of the female heart are at play, as Julie tells her story to her friend Claire in a series of letters. And once again class differences shape the narrative: Julie comes from a noble family, and Saint-Preux, the man who has taken hold of her heart, does not. Though the two hold off as long as they can, eventually Julie, like the original Héloïse, falls into Saint-Preux's arms and they share the joys of lovemaking. This encounter does not result in a happy ending for the pair. They are obliged to separate, and although Julie eventually marries an older, thoroughly honorable man, she continues to hold Saint-Preux in her heart. Rousseau's readers, most of them women, identified fully with the young lovers, cried copiously as they followed their tribulations, and wrote hundreds of letters to Rousseau lauding his portrayal of the female heart.

DURING THE EIGHTEENTH CENTURY RICHARDSON, ROUSseau, and other sentimental novelists endowed their heroines with tender, virtuous hearts and only a smidgeon of sexual desire, which was ultimately aroused only through the promptings of a determined male admirer. Pamela did not know what to make of her "strange," "lumpish," "awkward," "wayward," "exulting" heart when it was first awakened. Clarissa resisted her creaturely urges until the end, and Julie, even though she succumbed to Saint-Preux, hid whatever pleasure she took in lovemaking under a veil of modesty and guilt.

Yet other eighteenth-century male authors recognized that some women possessed passionate hearts and healthy sexual appetites unhampered by virtue and honor. The heroine of *Manon Lescaut* by the Abbé Prévôt (1731) is a very young woman of common origin who runs off with a noble youth and lives with him in a state of concubinage, only interrupted by flings with other men whenever she and her lover need money. This scandalous novel inspired at least two successful operas in the late nineteenth century, one by the Frenchman Jules Massenet and the other by Puccini.

Les liaisons dangereuses (*Dangerous Liaisons*) (1782) by Choderlos de Laclos gave us the unforgettable portrait of Madame de Merteuil, a widow whose guiding principle is to have her way with men and to be the one who always ends the affair while remaining respectable in the eyes of society. She shared her "female heart" once with the Vicomte de Valmont, but then the two of them, in a verbal pact, agreed to take as many lovers as possible without falling in love. In Valmont's case, he found particular pleasure in seducing a virginal girl straight out of the convent as well as a notably virtuous married woman. From behind the scenes Madame de Merteuil

pulled the strings, in part to keep Valmont from falling in love with anyone else. In the end, however, Valmont does just that. It is the virtuous matron who gains his heart (surprise!), though not before so much evil has spewed from Madame de Merteuil's heart that the novel concludes catastrophically for everyone. This brilliant novel—my favorite of the lot, I must confess—at least has the temerity of presenting a female protagonist with a libido equal to that of her male counterpart and a diabolical intelligence superior to his.

THE ENGLISHMAN JOHN CLELAND TRAVELED FAR BEYOND the pale of good taste in publishing *Fanny Hill, Memoirs of a Woman of Pleasure* (1748–1749). An openly erotic novel that verges on the pornographic, *Fanny Hill* is the story of an orphaned country girl who comes to London to enter into service and ends up in a brothel. She manages to escape from the brothel with a young gentleman named Charles, who deflowers her and becomes the love of her life. Even though they are separated against their will and Fanny spends many years as a prostitute, her heart always belongs to him. Like many before him, Cleland tried to distinguish between simple lust and heartfelt love, with Fanny clinging to the love in her heart regardless of her body's promiscuous behavior.

The characters of Manon Lescaut, Madame de Merteuil, and Fanny Hill depart significantly from the portraiture of sexless women with hearts governed by conformist morality. And if we were to look further into frankly obscene literature, from Daniel Defoe's *Moll Flanders* (1722) to the Marquis de Sade's *Justine* (1791), we would find women who were unwilling or unable to maintain even a semblance of sexual purity.

On the whole, eighteenth-century erotic literature showcased two kinds of women: those with pure and tender hearts

(even if they lost their virginity) and those who lusted just like men. The French doctor and philosopher Julien La Mettrie tried to avoid this "virgin/whore" dichotomy by arguing that women have the same needs as men and that they should indulge in voluptuous pleasure (*volupté*) just like their male counterparts. His philosophical essay *L'Art de jouir* (*The Art of Pleasure*) (1751) devotes long passages to the benefits of both male and female orgasm.

For all his well-known materialism, La Mettrie fell back on heart metaphors when he wanted to express the delights derived from sensual love. His statement "all nature is in the heart of the one who feels" restores to the heart its primacy not only in relations between people but also in our relations with the natural world. The amorous heart absorbs emanations from other human beings and from our natural surroundings. In the novels of Richardson, Rousseau, Prévôt, and others, we can perceive the heart's transports during the Age of Reason as well as glimmers of the coming Romantic era.

THERE ARE TWO NOTABLE ABSENCES IN THIS HISTORY OF women's hearts during the eighteenth century. The first is the absence of women's voices. Though some English, French, and other European women did write sentimental novels, they did not wield the authority or gain the popularity of male writers. This is not to say that women were absent from the discourse on the heart—far from it. They were the novelists' primary readers and ran the salons showcasing male authors, participating through their speech and letters in the never-ending conversation on love. Women writers who ventured into the realm of novels and essays would not come to the forefront of literature until the following century when authors including

Jane Austen, Charlotte Brontë, Emily Brontë, and George Sand challenged the male literary hegemony and injected a feminine viewpoint into affairs of the heart.

The second absence concerns graphic images of the heart. Venus, cupids, mythological and biblical figures, kings, queens, princes and princesses, nymphs and shepherdesses, youthful lovers, noble and bourgeois families and an occasional peasant, not to mention floral arrangements and *natures mortes*—these filled the many paintings, drawings, and engravings that issued from European studios during the eighteenth century. Given my familiarity with the bucolic and boudoir trysts painted by Watteau, Boucher, and Fragonard, I was surprised to realize that none within my memory included a heart image. Love letters, yes. Stolen kisses, yes. Bedroom scenes showing lovers narrowly escaping a husband's entry. Desire pulsating within finely shaped female bodies, but not a single graphic heart. Could this be possible? Determined research turned up Boucher's *Amours des Dieux* series showing a heart icon at the center of a target punctured by Cupid's arrows. There are probably more eighteenth-century high-culture paintings with hearts, but they are so rare as to make one ask: Where did the amorous heart icon go?

Chapter 16

The Heart in Popular Culture

DURING THE EIGHTEENTH CENTURY, EVEN WHILE ELITE artists were ignoring the heart icon and scientists were promoting the brain, ordinary folk were not abandoning the heart. Frenchmen carved hearts into their outdoor window shutters and on the backrests of chairs and settles. Germans painted hearts on wooden or papier-mâché boxes, some to be used as containers for love letters. Swiss maidens embroidered hearts on textiles to be folded carefully into their hope chests, and the Romansch-speaking Swiss decorated their New Year's greetings with slightly asymmetrical hearts, their points curving to the left-hand side.

German speakers carried the heart icon across the Atlantic to colonial America, where it assumed a new life among the Pennsylvania Dutch (*Dutch* being a deformation of the word *deutsch*). Between 1750 and 1850 the heart symbol appeared on numerous birth and baptismal certificates, marriage and house blessings, bookplates and writing samples

FIGURE 27. Artist unknown, *Birth and Baptismal Certificate (Geburts und Taufschein) for Maria Catharina Raup*, 1810. Laid paper, watercolor, and ink, the Free Library, Philadelphia, Pennsylvania.

known as *Vorschriften*. These were written in Fraktur, a distinctive artistic style of German writing, and embellished with ink and watercolor drawings.

The birth and baptismal certificate above (Figure 27) is typical of the genre. Hand drawn and hand lettered with a large heart dominating the center, the document begins with these words: "To these two married people, namely Daniel Raup and his lawful wife Catharina, born Schumacherin, a daughter was born into the world, named Maria Catharina, in the year of our Lord Jesus 1810, the 29 day November, at 11 o'clock at night, in the sign of Capricorn." The names of

the mother and daughter, Catharina and Maria Catharina, appear in tiny letters beneath the name of their husband and father, Daniel Raup, which dominates the document both in placement and size. The two small hearts below the central heart contain religious messages. The one on the left reads, "I am baptized, I stand united with my God through my baptism. I therefore always speak joyfully in hardship, sadness, fear and need. I am baptized, that's a joy for me. The joy lasts eternally." The one on the right continues, "I am baptized, and when I die, how can the cool grave hurt me?"

In colonial America, birth records were kept by churches, where baptisms took place. Because there was no bureau of vital statistics, church records written in English as well as Pennsylvania Dutch birth and baptismal certificates written in German acted as de facto legal documents. Following the American Revolution the demand for Fraktur documents soared, and professional printers took over their production. Given its long history as a symbol of love, the heart was a natural embellishment for birth, baptismal, and marital records, whether they were produced privately or professionally. In the private registers kept by families in New England a pair of hearts often symbolized a married couple, with smaller hearts representing their progeny.

WHEN FRATERNAL ORGANIZATIONS BECAME POPULAR IN eighteenth-century Europe and America the heart found its way into their iconography. Freemasons used the heart as one of their primary occult symbols along with the Masonic Eye, symbol of God's all-seeing presence. Not surprisingly, the heart stood for love, broadly speaking, and brotherly love in particular. Masons were encouraged to establish close bonds

FIGURE 28. Artist unknown, heart-in-hand carving from an Odd Fellows lodge, nineteenth century. Carved wood and paint, private collection. Image credit: Aarne Anton.

with fellow Masons and to promote charity for the needy, which they continue to do in numerous ways to this day.

A specifically American group, the Independent Order of Odd Fellows (IOOF), adopted the heart-in-hand as its official emblem. Like the Freemasons, IOOF was a male-only organization founded on the principles of brotherly love, mutual support, and Christian values. Carved into a wooden staff or embroidered into a textile, the heart-in-hand motif represented the IOOF dictum that "Whatever the hand goes forth to do, the heart should go forth in unison." Put another way, the hand should be guided by the heart.

Similarly, the Shakers, a religious sect that emigrated from England to northeastern America in the eighteenth century, were also devotees of the heart-in-hand symbol,

following the words of their founder, Mother Ann Lee: "Put your hands to work, and your hearts to God." Known for their work ethic, cleanliness, and simple lifestyle, Shakers in the nineteenth century began to manufacture furniture and other products whose clean-cut design has had lasting influence on American style. In private they made drawings of their ecstatic visions, consisting of minuscule writing and multiple symbols, including numerous hearts. It takes patience and a keen eye to read these intricate documents made by Shaker girls and women, who were inspired by the words of scripture, as interpreted by Mother Ann Lee. For example, the outline of a heart on a "spirit drawing" from 1849 surrounds the following words: "My treasure is not on the Earth, But in the heavens far away, where the cares of time cannot find them. When my work on earth is done, how gladly will I fly to the arms of the saints, who have watched over me in the days of my youth, for they love me & I love them & nought can separate us from each other."

These unique Shaker drawings, crammed with hearts, flowers, leaves, vines, trees, feathers, birds, apples, moons, suns, scrolls, lyres, houses, cups, eyes, and faces, were understood to come from supernatural sources and expected to be kept for oneself or given as gifts to other members of the community. Though the practice came to an end in the 1850s, a few hundred have survived and can sometimes be seen in museums and exhibitions devoted to Shaker culture.

Another American religious sect, the Church of Latter-Day Saints, also welcomed the heart into their iconography. Their attention to the heart derived from a scriptural passage in which the prophet Elijah predicted that the Lord "would turn the heart of the fathers to the children, and the heart of their children to their fathers" (Malachi 4:6). Mormon

drawings coupled the heart, the symbol of love, with keys, the symbol of patriarchal authority. This vision of family members linked together by the hearts of fathers and children simply passed over the role of the mother.

NINETEENTH-CENTURY AMERICAN FOLK ARTISTS EMBRACED the heart motif as never before. They made everything in the shape of a heart, from muffin molds and cookie cutters to butter presses, hat boxes, snuff boxes, keepsake boxes, pin cushions, mirror frames, metal trivets, and locks. Hearts were painted on dower chests and cupboards, carved into cradles and chair backs, stamped into stoneware jugs, pressed into glass, sewn into quilts, and hooked into rugs. They also were and remain popular on horse bridles.

Brides living in Virginia and North Carolina sometimes received baskets decorated with hearts for the storage of household keys. It was a meaningful gift, meant to mark the passage of the bride into her new position as matron and keeper of the keys. These little baskets were usually made of cow or pig hide, sturdy enough to last a lifetime. Occasionally one turns up today at auction and fetches the handsome sum of ten or twenty thousand dollars.

Many hearts were expressions of friendship, especially female friendship, which was valued in nineteenth-century American culture almost as much as romantic love. Hearts that spoke for one's loving feelings appeared on the pages of diaries, memory albums, invitations, holiday messages, and, of course, valentines.

American cemeteries also began to feature hearts in the nineteenth century, depending on the deceased person's religion, ethnicity, and place of burial. Among other western states California welcomed the heart motif on tombstones,

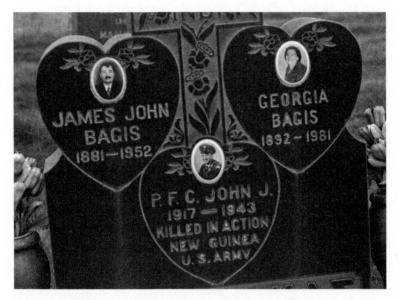

FIGURE 29. Reid Yalom, *Tombstone with Three Hearts*, Greek Cemetery, Colma, California, 2008. Digital print.

usually for a married couple. In the Santa Rosa rural cemetery complex, twin hearts adorn the grave of Flora and George Buckmaster and a single heart commemorates the lives of M. J. and Catherine Bower. A few years back, when my photographer son Reid and I were traveling across the United States in preparation for a book on American cemeteries, we discovered a Greek American tombstone in Colma, California, that told a wrenching story common to many families at the time: mother, father, and their soldier son, who had been killed in action during World War II at the age of twenty-six, all wrapped in hearts.

Americans have had a love affair with the heart for a very long time. From colonial times to the present, the heart has adorned a plethora of everyday items suitable for a democratic

society. No longer reserved for the elite, the heart belongs to everyone. We call upon it to express our deepest emotions, from love to loss. When misfortune strikes, it symbolizes our own broken hearts and our sympathy for others. Yet most of all, as in the Middle Ages when the heart icon was born, it continues to represent the ineffable allure of romance and our shared belief, since around 1800, that love should be the primary ingredient in the choice of a spouse.

Chapter 17

Hearts and Hands

"NEVER COULD I GIVE MY HAND UNACCOMPANIED BY MY heart."

These words were written by a young American woman named Eliza Chaplin to one of her friends in 1820. Eliza had no need to explain the meaning of "heart and hand," for everyone in her time and place would have understood that "heart" meant love and "hand" meant marriage. Regardless of the many transformations undergone by the heart motif since the beginning of recorded time, the nineteenth century began in the West with a common understanding that "heart" could not be ignored in the making of a happy marriage.

Reflect for a moment on Eliza Chaplin's words. They seem ordinary enough to us today, and given the history traced in this book, they come as no surprise. But why does the "hand" represent marriage in the Western world? That question takes us as far back as ancient Rome when, during the wedding ceremony, the matron of honor (*pronuba*) joined

the spouses' right hands, and the bride received the wedding ring she would wear throughout her marriage. Sometimes the ring itself bore the image of two clasped hands that represented the marriage contract.

The hand as a marital symbol was even written into law. The Romans had two kinds of marriage: marriage *cum manu* and marriage *sine manu*—literally "with hand" and "without hand." The first meant that a woman became a member of her husband's family and was subject to his authority. The second meant that a woman, even after her marriage, remained under the tutelage of her father and kept her premarriage inheritance rights. Though these two specific forms of marriage have disappeared, Western inheritors of Roman law have held on to the symbol of the marital hand for over two thousand years. The picture of two hands clasped together became the sign of a harmonious union, whether molded into a fourteenth-century German Jewish wedding band, painted at the center of a sixteenth-century Italian maiolica plate, or carved into a nineteenth-century American tombstone.

Clasped hands took further physical form in the tradition of "handfasting," a betrothal ritual practiced in England until the mid-eighteenth century and in Scotland until the twentieth. During the ceremony, which often took place outdoors, the couple took hold of each other's hands and declared that they accepted the other as a spouse. With or without witnesses, it was a binding contract and, for many, the equivalent of marriage. A proper church wedding usually took place within six months, by which time many of the brides— between 20 and 30 percent—were already pregnant.

In church, couples enacted a similar ritual. The Anglican Book of Common Prayer from 1552 stated explicitly that the bride and groom should join hands during the marriage

ceremony and loosen them only when "the Man shall give unto the Woman a Ring, . . . to put it upon the fourth finger of the Woman's left hand. And the Man holding the Ring there . . . shall say, 'With this Ring I thee wed, with my body I thee worship, and with all my worldly goods I thee endow.'" Beautiful words that still move us when they are pronounced in weddings today!

WHY, WE MAY ASK, DID ELIZA CHAPLIN FIND IT NECESSARY to say that she would never give her hand without her heart? The answer is that love had not been a prerequisite for marriage during most of written history. Family connections, property, social position, and religion counted considerably more than love in most eras and most places. A Roman girl's marriage would have been arranged by her father, and she would not have been given the opportunity to "fall in love" before the wedding. She was, however, required to add her consent to that of her father and mother for the match to be legal. The main purpose of matrimony was to produce children. If the couple developed tender feelings for each other, all the better. If not, and if the husband found reason to be dissatisfied with the arrangement, divorce—at least for the man—was relatively easy. Women, however, were not allowed to initiate it.

During the Middle Ages the Catholic Church gradually took over the jurisdiction of marriage. In 1181, when matrimony was made a sacrament, it subsequently required not only monogamy, indissolubility, and exogamy but also mutual consent. Of course, mutual consent was by no means tantamount to love. In fact, as we have seen from the court of Marie de Champagne, the possibility of marital love between members of the nobility was considered highly unlikely. As

for the broader population, it is impossible to make blanket statements about the whole of medieval Europe. Still, I would venture to say, from a lifetime of medieval studies, that most marriages were marriages of convenience and that mutual inclination was not the first—or even the last—determinant in forging a conjugal union.

Just when did love become the primary basis for marriage? From around 1600 onward a small but growing number of unions were initiated by love. In England this new spirit was linked to the Reformation. From their pulpits Anglican clergymen began to emphasize the joys of nuptial love in addition to companionship, mutual support, and, of course, progeny. And in less hallowed spaces Shakespearean theater gave voice to the passionate desires of men and women who prized amorous love above all other considerations and sometimes risked their parents' wrath in choosing a mate. Like Eliza Chaplin two centuries later, Shakespeare recognized the need for both heart and hand in the creation of a satisfying union. Speaking with certainty and satisfaction, Juliet remarked to the priest after he had wed her to Romeo: "God join'd my heart and Romeo's, thou our hands."

Even the Catholic Church, during the Counter-Reformation, took into consideration the new emphasis on love in marriage. As a response to pressure from individuals in unhappy marriages, it loosened some aspects of its marital laws. Legal records from the late sixteenth and early seventeenth centuries show that some men and women found a way to have their unhappy marriages annulled on the grounds that one or both of the spouses had been coerced into matrimony by their families and had not truly given their consent. Petitions for annulment began with the formula "I said yes

with my mouth but not with my heart," the implication being that only the consent of the heart gave validity to a marriage.

Seventeenth-century French plays, most notably those of Molière, and eighteenth-century English novels like *Clarissa Harlowe* suggest ongoing parental opposition to their children's love matches. Yet by the end of the eighteenth century love had become the most notable consideration in marital arrangements, even if socioeconomic concerns also weighed heavily in the decision. This trend can be seen in the history of "Lonely Hearts" ads placed in British newspapers.

The first known ad, published in 1695, listed the female attributes required by a demanding gentleman, most notably wealth. Early ads were forthright in their search for a wife with "a Fortune of 3000 [pounds] or thereabout." Lest we find this ad unusually mercenary, we do well to remember that a person's fortune was usually common knowledge and that newspapers often printed at the end of the wedding announcement the sum that a woman brought to the marriage. But from the mid-eighteenth century onward romantic love was emphasized over practical considerations, following the model found in sentimental novels. More and more often during the second half of the eighteenth century the ads placed by men expressed their hope to find a woman with a "feeling" or "tender" heart, attributes considered the province of women, though some men, too, described their own hearts as "full of affection, sensibility, and delicacy."

Around 1700, when the first Lonely Hearts ads were published, the Irish came up with a combined image of the heart and hand known as the Claddagh symbol, to be used on

wedding and engagement rings. These rings produced in the fishing village of Claddagh near Galway were inscribed with a heart symbolizing love that was placed between two open hands symbolizing friendship and surmounted by a crown symbolizing loyalty. The Victoria and Albert Museum in London owns an early Claddagh ring in enameled gold that is inscribed with the words "Dudley & Katherine united 26. Mar. 1706." Claddagh rings became increasingly popular during the nineteenth century and are still made in Ireland to this day.

Products bearing the Claddagh symbol are now popular on a variety of objects such as rings, earrings, pendants, and crystal jewelry boxes. Some of the most elegant items are unisex wedding bands that combine the Claddagh heart with Celtic eternity knots as a joint expression of enduring love and Irish identity.

HEARTS AND HANDS ARE MAJOR LEITMOTIFS IN JANE AUSten's novel *Pride and Prejudice* (1813), which evoked the sentimental longings and the new conception of marriage among the English gentry. From the famous first sentence—"It is a truth universally acknowledged, that a single man in possession of a good fortune must be in want of a wife"—Austen fixates her pen on the marital aspirations, successes, and failures of the Bennett family, consisting of two ill-paired middle-aged parents and their five nubile daughters. It is taken for granted that people will fall in love before marriage or at least be attracted to one another but that money and social position will also weigh heavily in the choice of a spouse.

The male protagonist, Darcy, says as much when he proposes marriage to Elizabeth Bennet. After declaring how much he admires and loves her, he immediately adds that "there were feelings besides those of the heart" he feels

obliged to express. Those feelings spring mainly from the vast difference in their socioeconomic situations, he being immensely wealthy and of noble stock, whereas she is of relatively modest circumstances. And then there is the problem of her family, some members of which—namely her mother and her younger sister Lydia—are lacking the graces Darcy would expect from members of his own class. Nonetheless, he offers marriage to Elizabeth fully expecting "her acceptance of his hand" (Chapter 34).

Of course, as any Janeite knows, Elizabeth at first refuses his offer. From the start she finds his "pride" overbearing and wraps herself within her "prejudice" against him. It takes the full novel for them to acknowledge, first to themselves and then to each other, their innermost desires. As their prickly romance proceeds, we witness several other matches where considerations of love and money jostle for primacy. Like Darcy and Elizabeth, Jane Bennet and Mr. Bingley ultimately follow the dictates of their hearts and embark upon an auspicious marriage based on mutual love—and his property. But Elizabeth's close friend Charlotte Lucas accepts the hand of the clergyman Mr. Collins without the pretense of love because, as she says to Elizabeth, "I am not romantic. . . . I ask only a comfortable home" (Chapter 21). Their marriage is destined for humdrum endurance. And Lydia, the frivolous young sister, elopes with the reprobate officer Wickham, without first insisting upon marriage, but is fortunately saved from disgrace by the interventions of her uncle and Darcy. Lydia had learned nothing from her parents' bad marriage, which had been based solely on physical attraction and quickly degenerated into mutual disappointment.

What, then, is Jane Austen's view of the makings of a successful marriage? The amorous heart must certainly be

involved when men and women join hands in matrimony, but the heart, alone, is not enough. Darcy's friend Colonel Fitzwilliam puts it most bluntly: "Not many of my rank . . . can afford to marry without some attention to money" (Chapter 24). And even love and money may not be enough to achieve the harmony in marriage that Austen's protagonists aspire to. Intelligence, wit, kindness, compassion, and mutual respect—these are the qualities her most congenial couples possess.

Austen admits that the feeling called love "could not exactly be defined" and that it could just as easily lead one astray as provide the basis for conjugal happiness. In her wariness of love Austen is not a romantic. Yet in all her novels love, or at least inclination (a weaker sentiment than love), plays a primary role in the path toward marriage. Austen's heroines give their hands in conjunction with their hearts, hoping that their husbands will satisfy their sentimental longings *and* provide material support. We rarely get to see what happens afterward, as many British novels, from Austen's time onward, usually close with the wedding.

IN THE PREVIOUS CENTURY MAJOR BRITISH WRITERS, including Fielding and Richardson, had written novels of seduction from a male point of view. But beginning with Jane Austen and a few of her female contemporaries, novels of romance and marriage written by women elbowed their way to the forefront of British literature. Later in the century Charlotte Brontë, Emily Brontë, and George Eliot took their place alongside Dickens, Trollope, and Thackeray. These women brought to the reading public an awareness not only of the heart but also of the hand, for if men could go it alone as bachelors, most women were dependent on a husband to

provide a position in society and a roof over their heads. For most women marriage was not just one of several options; it was their only option. If a woman never married, she could expect to face financial hardship and social marginality unless she came from a prominent family with means, and even then she would probably be placed at the least desirable end of the dining table. And even when married, British and American wives would discover that their unions were rarely equal partnerships.

To begin with, the law held that wives had virtually no rights. In the words of Sir William Blackstone's *Commentaries on the Laws of England* (1765–1769), which provided the basis for marital laws in England and America, "the husband and wife are one person in law: that is, the very being, or legal existence of the woman is suspended during the marriage, or at least incorporated and consolidated into that of the husband." As the popular saying went: "husband and wife are one person, and that person is the husband."

As to material possessions, the law left no doubt as to ownership. "A woman's personal property, by marriage, becomes absolutely her husband's." This included whatever property a woman owned before marriage and her earnings as a wife. Insofar as children were concerned, their legal custody belonged to the father. If she were widowed, a woman was entitled to "jointure"—that is, a third of her husband's estate. For a woman, to give her hand in marriage literally meant to give her whole person over to the control of another. Of course, it was hoped that love would soften the edges of legal dictates and infuse marriage with mutual regard so that both women and men might be able to consider themselves, in the words of Charlotte Brontë's Jane Eyre after ten years of marriage, "supremely blest."

WHEREAS THE DOMINATING HAND IN MARRIAGE WAS UN-derstood to be that of the husband, who even possessed the right to beat his spouse as long it was only "moderate correction," the heart was increasingly assigned to the wife. This doctrine of separate spheres of influence was spelled out clearly in Tennyson's nineteenth-century poem "The Princess":

> *Man for the field and woman for the hearth:*
> *Man for the sword and for the needle she:*
> *Man with the head and woman with the heart:*
> *Man to command and woman to obey;*
> *All else confusion.*

This gendered division, with the "male" brain granted authority over the "female" heart, widened the split between brain and heart that had begun in the seventeenth century. Victorian thinkers and writers like Tennyson were trying to reestablish traditional norms after the excesses of Romanticism, the early nineteenth-century cultural movement that shook up the whole social order.

Chapter 18

Romanticism, or the Reign of the Heart

THERE ARE UNEXPECTED EVENTS IN THE WRITING OF A BOOK that crystallize your thoughts and incarnate the essence of what you want to say. Such an event happened to me in the fall of 2016 when I went to the opera in Paris and saw Bellini's *Norma*. Led by the magnificent Cecilia Bartoli, the entire ensemble gave voice to the turbulent emotions that roil within passionate hearts. Predominantly amorous but also maternal, paternal, sororal, fraternal, nationalistic, and vengeful, the overwrought sentiments expressed in *Norma* could have been unleashed only by a creator steeped in Romanticism.

The composer, Vincenzo Bellini, and his librettist, Felice Romani, were Italian, yet the spirit animating *Norma*—the overwhelming belief in the priority of emotion—was a pan-European phenomenon. Beginning in the second half of the eighteenth century and continuing through the first

half of the nineteenth, writers including Rousseau, the young Goethe and Novalis; Wordsworth, Coleridge, Keats, Shelley, and Byron; Alphonse de Lamartine, Victor Hugo, George Sand, Théophile Gautier, Alexandre Dumas, and Alfred de Musset turned their backs on Enlightenment reason and unconditionally embraced emotion, most notably love. Not surprisingly, *Norma* was first produced in Paris in 1831, the year after Victor Hugo's play *Hernani* had mobilized Romantics as a force to be reckoned with.

Watching and listening to *Norma* I was swept away by the torrent of emotions released onstage. Feelings I had rarely known in a theater forced their way into my chest and brought continuous tears to my eyes. At the intermission and again at the end my French friends and I agreed that the experience had been *bouleversant* (overwhelming). During the opera's most intense moments the Italian word *cor* (heart) punctuated the music.

Later, when I read the libretto, it did not surprise me to discover that *heart* was the key word for each of the major characters. The opera is set in mythical Gaul occupied by Roman soldiers. Initially the Roman protagonist, Pollione, announces to his friend Flavius that he no longer loves Norma, the Druid high priestess. In his words, Norma is "a name which freezes my heart." He can no longer honor his commitment to her, although she has been his lover and is the mother of his two children, all unbeknownst to her subjects. He now loves another, the virgin priestess Adalgisa.

Norma, asked by her people to attack Pollione and his Roman troops, restrains them and admits to herself, "My heart does not know how to punish him." While sensing his abandonment, she sings nostalgically of the past "when I offered you my heart."

When the younger priestess, Adalgisa, comes onstage, she too immediately invokes the heart. Hers was won by Pollione the very first moment she saw him. Now waiting for him to appear, her heart is gladdened at the thought of his *caro aspetto* (dear looks) and *cara voce* (dear voice). Thus, the three protagonists offer three very different hearts, each inflamed by love and each in conflict with the others.

By now some readers of this book are perhaps wondering why I am making such a fuss about *Norma*. Without the music to back me up, I am hard put to convey its powerful impact. "I've gotta use words when I talk to you" (to borrow from T. S. Eliot's "Fragment of an Agon"), so let me try to explain why *Norma* represents a high point in the history of the amorous heart.

Pollione appeals to Adalgisa's heart in an attempt to draw her away from her virginal vows as a priestess: "Your heart gave itself to me." "Don't you hear a voice speaking in your heart?" He tries to persuade her that the love she feels is more sacred than her religious vocation.

Adalgisa, in a tensely ironic scene, reveals her feelings to the high priestess Norma and asks for her mentor's guidance: "Save me from my heart." Norma, recognizing her own story in Adalgisa's, is initially sympathetic until she learns that Adalgisa's desired lover is none other than Pollione. Then Norma explodes and cries out, "Just as he has deceived my heart, the impious one has betrayed both your heart and mine."

Lesser artists than Bellini and Romani might have funneled the plot into spasms of jealousy between the two women. Certainly men throughout history have often represented two women at odds with one another as monstrous rivals. But *Norma* is not your standard love triangle; instead,

Norma and Adalgisa bond together against Pollione. They recognize each other as sister spirits and pledge to fight against a shameful destiny. Together they sing, "I shall hold my head up high, as long as I feel your heart beating against mine." It's an amazing operatic moment, with two women, rather than a man and a woman, proclaiming the mutual beating of their hearts. The Romantic heart is capable of expanding from heterosexual to sisterly love.

And that's not all. In a subsequent scene the resistant Gauls sing of their own hearts, which are filled with rage for the Roman oppressor, and for the need to contain their anger until the time is right for revenge. The heart, predominantly the seat of love, can also know ire and hatred when circumstances call them forth. The human heart is a hothouse of seething emotions, all struggling for release.

How these conflicts resolve themselves provides momentum for the last act. Norma rises to her greatest tragic moment when she sings in front of Pollione, "What a heart you have betrayed, what a heart you have lost." She identifies completely with her heart: her heart is who she is. And Pollione, to his great regret, recognizes the value of this "sublime woman" when she confesses her treachery to the Gauls, who then condemn both Pollione and Norma to death.

ROMANTICISM WAS A MOVEMENT THAT HONORED THE heart as the ultimate font of love and truth. Whether it expressed itself artistically in opera, theater, poetry, fiction, or passionate behavior, faith in the heart became the credo of countless men and women during the first half of the nineteenth century.

The poet Lord Byron demonstrated his complicated relationship to the heart throughout his life and work. In his

oft-quoted poem of 1810 he addressed the young girl he had
fallen in love with in Greece:

> *Maid of Athens, ere we part,*
> *Give, oh give me back my heart!*
> *Or, since that has left my breast,*
> *Keep it now, and take the rest!*

This sweet poem, familiar to generations of schoolchil-
dren, relies on the conventional metaphor of the poet's amo-
rous heart captured by the beloved. In another famous poem,
"She Walks in Beauty, / like the night," Byron writes of *her*
heart rather than his own—one that is pure and innocent:

> *And on that cheek, and o'er that brow,*
> *So soft, so calm, yet eloquent,*
> *The smiles that win, the tints that glow,*
> *But tell of days in goodness spent,*
> *A mind at peace with all below,*
> *A heart whose love is innocent!*

Yet his own heart was growing weary from so much love,
as expressed in a poem called "We'll go no more a-roving,"
written in 1817 when Byron was living in exile in Italy.

> *So, we'll go no more a-roving*
> *So late into the night,*
> *Though the heart be still as loving,*
> *And the moon be still as bright.*
>
> *For the sword outwears its sheath,*
> *And the soul wears out the breast,*

And the heart must pause to breathe,
And love itself have rest.

Though the night was made for loving,
And the day returns too soon,
Yet we'll go no more a-roving
By the light of the moon.

By this period of his life Byron's love affairs with both women and men had resulted in the scandalous reputation he is still known for. But no one could deny his genius. When the cantos of his great satiric poem "Don Juan" began to appear, some of his contemporaries dismissed him as irredeemable while others lauded him as the master of romance. Sir Walter Scott maintained that its creator "has embraced every topic of human life, and sounded every string of the divine harp, from its slightest to its most powerful and heart-astounding tones."

SCOTT WAS IN A FITTING POSITION TO JUDGE LITERATURE OF the heart. His Waverley novels, written between 1814 and 1832, were replete with love stories set in the Middle Ages and Scottish history, and sixteen of them were subsequently turned into operas. Among the best known, *The Bride of Lammermoor* told the tale of Lucie Ashton and Edgar Ravenswood, who secretly exchanged rings and vowed to wed, but were impeded by her family. Forced to break her engagement and marry the wealthy Sir Arthur Bucklaw, Lucie falls into a deep depression. On her wedding night she goes mad, stabs the bridegroom, and dies.

The novel is better known today in the form of Donizetti's tragic opera *Lucia di Lammermoor*. Produced in 1835, *Lucia*

catapulted Donizetti into the position of Italy's foremost *bel canto* composer. Heart imagery is not as prominent in *Lucia* as it was in Bellini's *Norma*, yet the moment the two lovers appear onstage, they inevitably invoke their hearts. Edgardo, after expressing his longtime fury at Lucia's family, tells her, "But I saw you and another emotion / stirred in my heart, and anger fled." And she responds, "Banish all other feelings / save love from your heart." The heart remained the honored home of love, even if it could also become inflamed with rage.

The counterpoise of the amorous heart with the enraged heart endows *Lucia di Lammermoor* with its basic tension, which snaps in the famous mad scene when Lucia comes onstage after she has murdered her husband. This scene, associated with several of opera's greatest sopranos (including Joan Sutherland and Maria Callas), gives the expression "crazy with love" a literal meaning. In real life, mental breakdowns have many complex biological causes, and "crazy with love" won't be found in a psychiatric diagnostic manual, but literature, opera, and the visual arts portray abstract phrases like "love crazed" and "brokenhearted" so that we see and feel them in the flesh.

NOWHERE IN EARLY NINETEENTH-CENTURY EUROPE DID the heart have more prominent proponents than in France, where Romantic ideals were expressed in poetry, drama, fiction, and outlandish acts directed against bourgeois society. Victor Hugo rose to fame in the 1820s and 1830s with five volumes of poetry that announced a bold new voice in the annals of love. "To love is even more than to live" (Aimer, c'est plus que vivre), he wrote to Juliette Drouet, who would be his mistress for fifty years. Of course, that did not stop Hugo from continuing to live with his wife, Adèle, and their children.

He loved them too in his own way, and being the most fa-
mous French writer of his century, he got away with it.

Even the second-most-famous nineteenth-century French
writer—a woman—was able to live unconventionally in mat-
ters of the heart. George Sand, the pen name for Aurore
Dupin Dudevant, who became a successful author of Roman-
tic fiction as of the 1830s, managed to follow her heart's de-
sires, especially after she separated from her husband. Her
lovers included the French poet Alfred de Musset and the
Polish composer Frédéric Chopin, both six years younger
than she was, in keeping with a French tradition that often
paired an older woman with a younger lover.

In Sand's fictive world there were two types of love, one
sensual and earthy, the other spiritual and pure. In her early
novel *Indiana* the hero Raymon loved one woman "with his
senses" and another "with all his heart and soul." This divi-
sion between carnal and spiritual love, with roots going back
to the Church Fathers, persisted into the nineteenth century
and even beyond. It was understood in *Indiana* that loving
with one's "heart and soul" was superior to loving only with
one's senses.

The situation in Sand's fourth novel, *Lélia*, was more
complicated. The titular character, Lélia, embodied the as-
cetic path but only because she had become disillusioned with
the man she had originally worshiped. Her long-lost sister,
Pulchérie (Pulchritude, or physical beauty) had taken a diver-
gent route and lived the life of a courtesan. It becomes clear
in the course of the novel that neither woman represents a
satisfying solution to the conundrum of love. To satisfy the
body without engaging the heart turns out to be a travesty of
love; to love only from the "heart and soul" without engaging
the body defies basic creaturely needs. In her fiction, as in her

life, Sand sought a union of spirit and flesh that would rise to the level of her personal desires and fulfill the insistent claims of Romanticism.

SAND WAS BORN THIRTY-NINE YEARS AFTER JANE AUSTEN and twelve years before Charlotte Brontë. All three wrote about love from a female perspective, yet major differences between Sand and her English counterparts are clearly visible. Whereas Austen remained unmarried and undoubtedly a virgin and Brontë married at the advanced age of thirty-eight only to die less than a year later, Sand was already wed at eighteen and then went on to have a series of flamboyant love affairs.

It has been said that nineteenth-century English novels end with a wedding and that nineteenth-century French novels begin after marriage. French stories of adultery have a very long history going back to the figures of Tristan and Isolde and Lancelot and Guinevere and to the medieval tales known as *fabliaux*, which satirized the triangle made up by a wife, her lover, and her cuckolded husband. Among Frenchmen extramarital affairs have often been condoned and even considered a badge of honor. Not so for the female, with the possible exception of fin' amor romances in the twelfth and thirteenth centuries (see Chapter 4). Thus Sand's behavior as a married woman with lovers shocked her contemporaries and ultimately contributed to separation from her husband after thirteen years of marriage. From that point on, she was free to submit to the dictates of her amorous heart—and she did just that to the very end.

When Sand died in 1876 at the age of seventy-two she had amassed thousands of admirers, including such eminent Victorians as William Thackeray, John Stuart Mill, Charlotte

Brontë, George Eliot, Matthew Arnold, and Elizabeth Barrett Browning; an entire generation of Russian luminaries led by Dostoevsky and Turgenev; and the Americans Walt Whitman and Harriet Beecher Stowe. Like Victor Hugo, whose initial Romantic revolt had evolved into social and political concerns, Sand broadened her personal passions far beyond herself. Ultimately she voiced the hopes and aspirations of countless men and women responding to the cry for freedom in matters of the heart. Women in particular heard Sand and incorporated her message into their psyches, whether they acted upon it or not.

An unlikely Sand admirer was Charlotte Brontë. Raised in the morally austere environment of her father's parsonage, Brontë was uniquely gifted as a writer, as were her two sisters, Anne and Emily, each in their own way. Charlotte Brontë found unexpected fame in 1847 with her novel *Jane Eyre*. The story of a strong-willed young governess, small and plain like Charlotte herself, who falls in love with her demonic master and succeeds in taming his heart, startled the British public. Though *Jane Eyre* had been published under the male pseudonym of Currer Bell, some readers recognized its female point of view and raised questions about the author's true gender. One of her first reviewers, the novelist and critic G. H. Lewes, noted its difference from all other British novels. He suggested that the author must have personally known the throbbing emotions experienced by its protagonist—and was therefore a woman. (Lewes had not yet met George Eliot, with whom he would live for over twenty years.) In a letter to Lewes dated November 6, 1847, and signed C. Bell, Charlotte Brontë acknowledged the importance of "real experience" in the creation of fiction but also insisted that "imagination is a strong, restless faculty,

which claims to be heard and exercised." Whether Brontë, in her life at the parsonage and elsewhere as a student and governess, had personally known the passions Jane Eyre experienced is a question that intrigues literary scholars to this day.

But she had certainly read the sentimental novels written by other women, including Jane Austen and George Sand, which inspired her to examine the female heart. Surprisingly, it was not her compatriot Jane Austen whom she most admired but the outrageous George Sand. In a subsequent letter to Lewes dated January 12, 1848, she wrote, "she [Sand] is sagacious and profound;—Miss Austen is only shrewd and observant." A few days later, in another letter to Lewes, she agreed with his statement that "Miss Austen is not a poetess, has no 'sentiment' but must be admired as a great painter of human character." Brontë's grudging acknowledgment of Austen was immediately followed by praise for Sand. "It is *poetry*, as I comprehend the word, which elevates that masculine George Sand, and makes out of something coarse, something Godlike." By "something coarse" Brontë was probably referring to the sex act, which she had not yet known at this point in her life. By "something Godlike" she was undoubtedly referring to the ecstatic descriptions of love found in Sand's novels, among them Brontë's favorite, *Consuelo*.

By preferring Sand to Austen, Brontë revealed her true colors as a Romantic. "Heart" mattered more than "hand," though in the tradition of Jane Austen, Jane Eyre will not give her heart without the proper marital rites. Brontë may have been French in her imagination, but her moral realism was decidedly English.

Though I consider myself a faithful "Sandiste," I am obliged to admit that the author of *Pride and Prejudice*, *Sense and Sensibility*, *Emma*, *Mansfield Park*, *Northanger Abbey*, and

Persuasion is the greater writer. And following close behind I would add the Brontë sisters, Charlotte with *Jane Eyre* and Emily with *Wuthering Heights*, to the list of authors who most brilliantly portrayed the human heart. They do so with passion, depth, and style so that their fictive heroines remain in the reader's imaginative landscape long after their novels have been reshelved. The Brontë sisters spoke to me as a teenager, and they speak to me still. I learned from them that girls and women—as well as boys and men—were capable of fierce emotions and courageous acts. They did not have to be the prey of male seducers, as in the novels of Richardson, nor descend into the delusive Romanticism of a Madame Bovary. They, too, could possess "great hearts."

THAT ROMANTICS SAW THE HEART AS A METAPHOR FOR love and other passionate emotions is not surprising. What still surprises us is the extent to which some of them actually acted on their passions in defiance of conventional morality and common sense.

The poet Elizabeth Barrett Browning, dominated by a controlling father who forbade his children to marry, eloped with the poet Robert Browning, six years her junior and barely able to support a wife. A now-famous letter from Robert evokes his heart as he declares his love for her poetry and her person. The letter begins, "I love your verses with all my heart, dear Miss Barrett" and ends "I do, as I say, love these books with all my heart—and I love you too." Their subsequent marriage and life in Italy was the stuff of romance, both for themselves and for generations of readers, historians, novelists, and playwrights inspired by their story. Not incidentally, Elizabeth was a great admirer of George Sand; in one of her sonnets she called Sand a "large-brained

woman and a large-hearted man," thus inverting the stereotypical connection of the brain with men and the heart with women.

Italy, like France, was seen as a haven for Romantically inclined Englishmen and Englishwomen. The poet Shelley and Mary Godwin decamped to Italy after his estranged first wife, Harriet, drowned in Hyde Park and thus made it possible for him to marry the woman he had already been living with. In 1818 he and Mary settled in Venice, where Byron was already living. The Shelleys' four-year Italian idyll was fruitful for literature—Shelley wrote some of his most beloved poems, and Mary Godwin authored her famous *Frankenstein*.

On July 8, 1822, Shelley drowned off the coast of La Spezia. His body washed ashore and was cremated on the beach in the presence of several notables, including Byron. His ashes were interred in the Protestant Cemetery in Rome, which quickly became a destination site for Shelley devotees. His tomb bears the Latin inscription, "Cor Cordium" (Heart of Hearts).

Both Shelley and Byron are remembered as major poets who led unconventional lives. Shelley, an open atheist, was uncompromising in his revolt against religious beliefs and conventional mores, which he saw as stifling and inauthentic. During his adult life, cut short less than a month before his thirtieth birthday, he attempted to honor a radical code of ethics enshrined within his heart of hearts.

Byron, more hedonistic than his younger friend, lived to the age of thirty-six—hardly old age, even for his time. His credo was passion, and he lived his credo fully to the very end. While in Genoa in 1823 he became involved in the Greek independence movement against the Ottoman Empire. He set sail to join up with Greek forces in Missolonghi, but illness laid him low, and he died there of a fever on April 19, 1824.

Romantic men and women shared the view that the heart was a better guide to life than the brain. They believed that the amorous heart corresponded to one's best self, a self invigorated by passion and compassion. Today when we use the word *romantic* it is almost always in association with love. A romantic story is usually one in which two people are drawn to each other by erotic magnetism and aspire to a lasting union. But the word can also be used derisively to suggest that a romantic person's aspirations are impractical; we often add "hopeless" as a modifier. I wonder how many people today are likely to refer to themselves as "romantics"?

I BEGAN THIS CHAPTER WITH DONIZETTI AND WILL END IT with Wagner (1813–1883) because opera is perhaps the Western genre most in thrall to the heart. Moreover, Wagner's work often reflected a pervasive nineteenth-century nostalgia for the Middle Ages. Wagner's fascination with medieval culture provided the context for some of his most successful operas: *Tannhäuser, Lohengrin, Tristan and Isolde, Die Meistersinger von Nürnberg,* and *Parsifal.*

Consider *Tristan and Isolde,* a legend that goes back almost a thousand years in both French and German versions, not to mention its earlier Celtic roots. In Wagner's opera, when Isolde first encountered Tristan, love entered through their eyes and pierced her heart. Later, on the boat that carries her across the sea to marriage with King Mark in Cornwall, Isolde remembers Tristan and sings of the emotions seething in her "credulous heart," her "oppressive heart," and her "heart destined for death." When she and Tristan unknowingly drink the love potion that seals their fate, they recognize each other as the irresistible fulfillment of love's

yearning. And they express their rapture in lofty romantic as well as boldly sensual terms:

> *Wie sich die Herzen wogend erheben!*
> *[How our hearts are borne aloft!]*
> *Wie all Sinne wonnig erbeben!*
> *[How all our senses pulsate with bliss!]*

Act II includes the garden scene, already famous from Gottfried von Strassburg's medieval narrative, in which Tristan and Isolde consummate their love.

> Tristan: Seh' ich dich selber?
> [Is it you I see?]
> Isolde: Dies deine Augen?
> [These your eyes?]
> Tristan: Dies dein Mund?
> [This your mouth?]
> Isolde: Hier deine Hand?
> [Here your hand?]
> Tristan: Hier dein Herz?
> [Here your heart?]

They sing together of bodily delight, through their eyes, their mouths, their hands, and, of course, their unseen but ever-present hearts. Their duet ends with Tristan's rapturous words, which foresee their eventual *liebestod* (love-in-death).

> *So starben wir,*
> *um ungetrennt,*
> *ewig einig*

ohne End',
ohn' Erwachen,
ohn' Erbangen,
namenlos
in Lieb' umfangen,
ganz uns selbst gegeben,
der Liebe nur zu leben!
[Thus might we die,
that together,
ever one,
without end,
never waking,
never fearing,
namelessly
enveloped in love,
given up to each other,
to live only for love!]

To live only for love—that is the Romantic credo par excellence. Wagner aficionados are aware that his belief in redemption through love took on more complex dimensions in his later works, but many agree that he never again reached the amorous heights achieved in *Tristan and Isolde*. This opera is the ultimate expression of erotic desire, the total intermingling of heart and mind, the complete merging of body and soul. Listen to Isolde's *Liebestod* at the end of Act III and see for yourself if such passion has a place within your heart.

Chapter 19

Valentines

Figure 30. Artist unknown, *Pensez à moi*, ca. 1900. Paper valentine, image courtesy of the author.

ON FEBRUARY 14, VALENTINE'S DAY, THE HEART ICON COMES out in full force. Tens of millions of valentines travel through the mail to our loved ones—not only to sweethearts and spouses but also to children, grandchildren, mothers, fathers, other relatives, and friends. And most of these cards, whether physical or digital, carry bright red hearts as symbols of ever-lasting love.

It would not be far-fetched to rename Valentine's Day as the Day of the Heart, for on that day hearts are every-where in view. Stores feature an ingenious variety of heart-shaped items: red-satin candy boxes, floral bouquets, candies, cookies, cakes, paper weights, jewelry and jewelry boxes—all tempting gifts for our loved ones. No other holiday is so closely associated with the heart. World Heart Day, started in 2009 to promote an awareness of cardiac diseases, has a long way to go before acquiring a similar level of popularity.

Though we might assume that Valentine's Day is the cre-ation of the modern card-making industry, its history is much older—indeed, so old that that its origins are clouded with uncertainty. Yes, there is a Saint Valentine on the Catholic roster. In fact, there are two third-century men named Valen-tine listed in the annals of Roman martyrology, and the two men may very well have been the same person. In any event, Saint Valentine of Rome was added to the Catholic calendar by Pope Gelasius in 496, to be commemorated on February 14, the same day it still occupies.

There have been various theories of why Saint Valentine became associated with love. For many centuries one of the most pervasive explanations was that Valentine's Day was linked to a pre-Christian Roman feast called Lupercalia cel-ebrated on February 15. On that day Roman boys supposedly drew the name of girls from a love urn and the two "coupled"

during the duration of the festival. But the association between Lupercalia and Valentine's Day has no firm foundation in historical fact.

More reliable sources indicate that Valentine's Day developed during the late Middle Ages in the context of Anglo-French courtly love. Ironically, it was during the Hundred Years' War between England and France (1337–1453) that the first Saint Valentine's Day texts were composed by both English and French poets. The French claim Oton de Grandson's "Songe de la Saint-Valentin" ("Saint Valentine's Dream") and the English claim Geoffrey Chaucer's "Parliament of Fowls" as the very first Valentine poems. Chaucer and Grandson—not only poets but also diplomats and friends—were undoubtedly familiar with each other's work.

Chaucer's "Parliament of Fowls," circa 1380, and his shorter poem "Complaint of Mars," circa 1385, take place on Valentine's Day. The relevant lines in the former are as follows:

For this was on Seynt Valentynes day,
Whan every foul cometh there to chese his make.
[For this was on St. Valentine's Day,
when every bird comes there to choose his mate.]

Comparable lines from "Complaint" read,

Seynt Valentyne, a foul thus herde I sing
Upon thy day er sonne gan up-sprynge.
[On Saint Valentine's day, I thus heard a bird sing,
at the time of day when the sun springs up.]

Chaucer and Grandson both associated Saint Valentine's Day with birds as harbingers of springtime and love.

Two other friends of Chaucer's—the trilingual poet John Gower (who wrote in English, French, and Latin) and the Welsh diplomat, soldier, and poet Sir John Clanvowe—also wrote Valentine poems with similar references to birds. This shouldn't surprise us; poets often pick up motifs from one another. What is perhaps surprising—and reassuring—is that these poets, in the midst of a war that pitted some of them against each other, continued to exchange ideas, to praise love, and to take pity on the fate of unhappy lovers, whether they be "englois ou alemens, / De France né ou de Savoye" ("English or German, from France or Savoy"), as Grandson wrote in his "Saint Valentine's Dream."

All these poets promoted the priority of the heart in human affairs. As John Gower put it, "Où le coeur est / le corps doit obéir." ("Where the heart is / the body must obey.")

THE ONE NOTABLE FEMALE POET FROM THIS PERIOD WAS Christine de Pizan, a French woman of Italian origin brought up at the court of Charles V of France. She, too, wrote about Saint Valentine's Day in a poem that began "Tres doulz ami" (Very dear friend) and in a long verse narrative titled *Le Dit de la Rose* (*The Tale of the Rose*). Dated February 14, 1402, *Le Dit* describes a dream in which the god of love expressed his dismay at the fact that men were no longer treating women with courtesy. To correct that ill, Christine was instructed to proclaim the Order of the Rose and to enlist the support of true lovers on the Feast of Saint Valentine. All of this was supposed to have taken place at the Parisian residence of Louis d'Orléans, one of the sons of King Charles V and the father of Charles d'Orléans, whom we met in Chapter 10.

A generation later Charles d'Orléans himself would write a dozen Valentine's Day poems during his long English

imprisonment from 1415 to 1440. The one he sent to his wife, Bonne, from the Tower of London, now in the manuscript collection of the British Library, is considered the first known valentine card. In it he addressed his wife as "Ma tres doulce Valentinée" ("My very gentle Valentine") and assured her that his love for her endured in spite of everything.

Another poem written by Charles during his English captivity starts out by saying that on Saint Valentine's Day all the birds assemble to share the spoils of love, each with his chosen partner—Charles, too, obviously knew Chaucer's "Parliament of Fowls." On that day designated for lovers, when the sun shines its "candle" into his room, he rises from bed and hears the birds singing. Then, wiping his teary eyes, he regrets his difficult destiny and wishes that he, like the birds, could share the day's pleasures with a chosen companion. The envoy—the four-line stanza at the end of the ballad—reads,

> *This year the men and women who are*
> *Lovers choose Saint Valentine.*
> *I remain alone, without aid,*
> *On the hard bed of painful thoughts.*

In a later exchange of poems called "Complaints," Charles's friend Fredet sent him a verse description of Saint Valentine's Day in Tours, France.

> *. . . in the name of Love*
> *They organized a big festival*
> *In Tours on Saint Valentine's Day.*
> *According to custom, they proclaimed*
> *In all the courts*
> *That everyone should participate.*

It is hard to imagine a more fitting setting for a Valentine's Day fête than a fifteenth-century Loire Valley château. After he was released from English captivity and returned to France, Charles had the opportunity to celebrate this holiday in his own Château de Blois, where the festivities were similar to those described by Fredet. Several of Charles's poems begin by invoking "this day of Saint Valentine / When everyone should chose his partner." There are even pictures of this Saint Valentine's Day event in two manuscripts from the 1450s that show scenes of men and women reaching into an urn and drawing the names of their "valentines." Charles's special attention to Saint Valentine's Day was undoubtedly shaped by the poetic tradition he had inherited from Chaucer, Oton de Grandson, and Christine de Pizan, but there is another reason why this particular saint may have appealed to him. Charles's own beloved mother, who died when he was only fourteen, was named Valentine. Her death occurred at the end of 1408, after her husband had been murdered by the Duke of Burgundy, John the Fearless.

TWO CENTURIES LATER THE FRENCH PRIEST AND PROLIFIC writer Jean-Pierre Camus, showed nothing but contempt for Saint Valentine's Day. In a priggish novel that mixed fact and fiction, published in English under the title *Diotrephe, or An historie of valentines*, he set out to show how the devil was at work under the auspices of Saint Valentine. The author began by describing a French village church named Saint Valentine near the city of Brianche that attracted bands of merrymakers in the month of February. "It is needless to say the disorders both of belly cheer and dancing . . . [are] the cause of much evil." Then he zeroed in on a potentially vice-laden custom.

"They write upon azure's paper in gold letters, the name of all the women and maids" and stuff them into a large box. Then, after the names are drawn out of the box by random, "she that thus by lot falls to a man, be she either wife, widow, or maid, is his Valentine." For the following year he becomes "the servant of this woman, she practicing an absolute authority over her Valentine, and he yielding . . . as lovers do."

Though the French villagers "thinke no harme . . . in this drawing of Valentines," the author assured us that the consequences could be catastrophic, especially when married men select their neighbors' wives or daughters as their Valentines or, reciprocally, when married wives end up with single young men or other women's husbands. We are told that such extra-marital engagements inevitably lead to licentiousness. Falling back upon the heart as a metaphor for legitimate love, the author concluded that "love in marriage is like the heart which cannot suffer division; . . . it cannot contain the husband and the Valentine . . . one cannot have two loves in one heart."

IN ENGLAND, AS EARLY AS THE FIFTEENTH CENTURY, THE word *valentine* meant at least two things: a declaration of love sent to the beloved, often in the form of a poem, or the beloved herself or himself. Letters preserved from the Paston family, dating from February 1477, suggest that Valentine's Day was considered a propitious time for love. The Pastons and the Brews were trying to agree upon the dowry that Margery Brews would bring into her marriage with John Paston III. Margery's mother, Elizabeth Brews, suggested that John visit with her and her husband to settle the matter the night before Saint Valentine's Day, when "every bird chooseth him a make"—again, words taken from Chaucer. Elizabeth's letter

to John on February 10, 1477, expressed the hope that the engagement would be easily formalized.

But things did not go as planned. Margery's father, Sir Thomas Brews, was only willing to offer the sum of one hundred pounds, far less than John had anticipated. So Margery herself intervened to write her intended two letters with references to Saint Valentine that might soften his pecuniary concerns. The letters began by addressing John as her "well-beloved Valentine" and her "good, true, and loving Valentine." The second letter ended by calling herself "your Valentine." To the extent that it was proper for a maid to lean upon a suitor, Margery found the appropriate language. "Mine heart me bids evermore to love you / Truly over all earthly thing." In the end John Paston III listened to the stirrings of his own heart, and the couple embarked upon what appears to have been a love match.

BY THE MID-SEVENTEENTH CENTURY THE CELEBRATION OF Valentine's Day in England had become customary for those who could afford its costly rituals. Affluent men drew lots with women's names on them, and the man who picked a certain lady's name was obliged to give her a gift.

The famous diary of Samuel Pepys gives a colorful picture of this practice among the well-heeled. On February 13, 1661, Pepys and his wife dined at the home of Sir William and Lady Batten, and chose by lot the persons who would be their Valentines. In his diary entry Pepys wrote, "we chose Valentines against tomorrow. My wife chose me, which did much please me." In his next entry, dated "Valentine's Day," Pepys noted that he drew the name of Martha, the Battens' unmarried daughter, and that Sir Batten picked Pepys's wife. Pepys had Martha as his Valentine once more the next year,

each time with little enthusiasm on his part. Yet on February 18, 1661, he, his wife, and Martha went to the Exchange, a London commercial center, to buy Martha a pair of embroidered gloves and six pairs of plain white gloves for the sum of forty shillings. Mrs. Pepys received even more extravagant gifts from Sir William Batten, as Pepys noted in his diary entry of February 22: "half-a-dozen pair of gloves and a pair of silk stockings and garters, for her Valentine's gift." Valentine's Day was not a one-day affair, and celebrating it in the style of Pepys and Batten was certainly not for the masses.

THE EARLIEST ENGLISH, FRENCH, AND AMERICAN VALENtines were little more than a few lines of verse handwritten on a sheet of paper, but as of the eighteenth century their makers began to embellish them with pictures as well. Hearts, birds, flowers, and leaves were drawn or painted on handmade valentines, which were then folded, sealed with wax, and placed on a lady's doorstep. Some contained complicated puzzles, acrostics, and rebuses (pictures that represent words or parts of words). The Pennsylvania Dutch created highly artistic valentines in either German or English, such as the one on the cover of the book in your hands (Rebus Valentine, circa 1760. Pen and ink on paper).

The first commercial valentines appeared in England at the very end of the eighteenth century. These "mechanical" valentines were printed, engraved, or made from woodcuts and sometimes colored by hand. They combined traditional symbols of love—flowers, hearts, cupids, birds—with doggerel verse of the "roses are red" variety.

Individuals who continued to make their own valentines or wanted to add a personal touch to a machine-made card could find help in pamphlets designed for the poetically

challenged. In 1797 *The Young Man's Valentine* appeared in Britain, and thereafter, throughout the nineteenth century in England and America, other manuals followed, with such titles as *Saint Valentine's Sentimental Writer* and *Introductory Treatise on the Composition of a Valentine by a Master of Hearts.*

The self-styled Master of Hearts let it be known that he was appalled by the "trashy . . . coarse and sometimes disgusting productions which soon after Christmas, begin annually to people the hucksters' shop windows, in the shape of penny Valentines." As a remedy he proposed that the lovestruck write their own valentines—a task to be undertaken with his help. As he put it, "in writing a Valentine, the very best way of all is to write an original one . . . nothing can be so telling or so pungent as an immediate emanation from your own heart." Even if the valentine was only a copy of his text or a rearrangement of his words, writing with one's own pen was generally considered more personal and more authentic than sending a commercial card.

Some guides were written specifically for women, such as *The Lady's Own Valentine Writer.* An 1848 publication titled *People's Valentine Writer, by a Literary Lady* may well have been written by a woman, though one can't be sure, as sometimes men published under the assumption that a female author, even an anonymous one, would appeal to women.

That same year, on February 17, the eighteen-year-old American poet Emily Dickinson wrote to her brother, Austin Dickinson, from her room at the Mount Holyoke Female Seminary that she would not forget the fun she had had during "Valentine week." Though she herself had not received any valentines and was still longing for one, many of the other girls had. As a group they managed to send out 150 valentines, despite an interdiction by the Holyoke

faculty. Emily remarked that one instructor in particular was adamant: "Monday afternoon, *Mistress* Lyon arose in the hall and forbade our sending 'any of those foolish notes called valentines.'"

Such a negative attitude did not discourage another Mount Holyoke graduate, class of 1847, from entering into the valentine business. Esther Howland of Worcester, Massachusetts, wanted to produce quality cards constructed according to her own design—cards that would raise the artistic level of the genre through the use of embossed and colored papers. Within three years the top floor of the Howlands' spacious house owned by Esther's father had been converted into a factory where girls assembled valentines under Esther's direction. After she had made the initial mock-up, each working girl had a specific task, such as laying out the background or cutting out paper pictures to be pasted on by a third girl. Howland's exquisite, three-dimensional valentines were minor works of art, comparable to fine embroidery or complex collages. They sold for no less than $5 each and, in toto, filled the Howland coffers with as much as $100,000 in a single year!

While Howland's cards favored cupids, flowers, human figures, and birds rather than hearts, the heart icon appeared on many other valentines manufactured elsewhere. One titled "Cupid in Ambush" pictured Cupid aiming his arrow at a winged heart in the sky. The verses on the card read, "MY FLUTTERING HEART / DOTH FEEL LOVE'S SMART."

With the Industrial Revolution in full swing, mass-produced Valentine's Day cards all but obliterated the handmade variety. In 1879, when George C. Whitney bought out the Howland business, he brought in printing presses and cheap paper to reduce costs. His valentines often featured hearts or were themselves heart shaped, just as his Christmas

cards often depicted or took the shape of Christmas trees. In time Whitney became the biggest producer of American valentines.

In the Anglo-Saxon world Victorian valentines varied greatly in price and quality, ranging from cheap paper cutouts to expensive lithographs on embossed paper. There were specialized cards for different trades and professions—for example, a series of valentines for sailors, which portrayed ships at sea and sweethearts waiting for their return: "For she who inclines to a sailor's own heart, / In the gale of adversity— never will part."

One could also buy comic valentines that conveyed a message of derision rather than love: these mean-spirited "vinegar" valentines made fun of skinny spinsters, fat bachelors, female bluestockings, male dandies, alcoholics, overbearing wives, or anyone else you wanted to ridicule. In the United States lower-class minorities including the Irish or free "negroes" were often the targets of such insulting valentines. Printed on single sheets and priced cheaply, at between one and five cents, they were usually sent anonymously.

But the overwhelming majority of valentines remained sentimental and carried a romantic message. Some of the fanciest contained a piece of real lace or an actual lock of hair. Even the blind were not forgotten; Braille valentines offered embossed figures of birds and hearts accompanying the verse.

THE FRENCH, TOO, BEGAN EXPLOITING THE COMMERCIAL valentine during the late nineteenth century. The angel-like cupids surrounded by hearts found on French cards circa 1900 (as in Figure 30) had a saccharine quality that was far removed from some of the mischievous, even dangerous, cupids of the past.

Today in France as well as Italy Valentine's Day is strictly for lovers and does not extend to a wide variety of family members and friends, as it does in England and America. Frenchmen offer chocolates and roses to their romantic partners or perhaps a dinner out at a favorite restaurant.

In Japan the situation is reversed. The women give men chocolates on Valentine's Day. Such gifts are not limited to husbands and boyfriends but may also be offered to family members and colleagues. Men are expected to reciprocate a month later on "White Day," March 14, with anything white, namely white chocolates, cakes, biscuits, marshmallows, and candies. Not surprisingly, White Day was an invention of Japanese confectioners. A reliable Japanese source tells me that these days most people do not care about the color but just give sweet things—dark or white—on White Day.

Valentine's Day is now celebrated in many different countries worldwide, with many regional variations. But in at least two countries various authorities actually forbid it: Malaysia and Iran. In Malaysia on Valentine's Day 2011 religious authorities arrested more than one hundred Muslim couples who were celebrating the holiday in defiance of the ban. The same year, in Iran, the printing-works owners' union issued a directive that banned the printing of any goods promoting Valentine's Day. The directive specifically targeted "boxes and cards emblazoned with hearts or half-hearts." I'm trying to imagine what the half-hearts looked like.

TODAY APPROXIMATELY 200 MILLION PAPER VALENTINES ARE sent in the United States alone, and the rise of e-cards increases that number beyond estimate. Hearts still make their appearance on both paper and e-cards, but they have rivals in images of flowers, loving couples, and, surprisingly, animals.

Yes, cuddly animals seem to be the rage in today's valentine cards, especially those destined for children, who constitute a large portion of American recipients.

Even though the sale of all American greeting cards has declined considerably during the last few years, the valentine is holding its own. Saint Valentine, whose name is now equated with a greeting card, could take some comfort in knowing that he has sweetened the union of countless loving couples.

What does it mean that a special day set aside for love has survived for at least six hundred years? It speaks for the enduring power of romance, even in an age when casual sex is more acceptable than it was in earlier eras. Even if we no longer believe there is only one predestined heart for each of us, we still want to feel our hearts "flutter" at the approach of the loved one. Because we live much longer than people in the past, it may be possible to fall in love several times—as adolescents and young adults, and even in middle and old age. Some of us are lucky enough to find a partner to love for a lifetime. But no matter how many times we fall in and out of love, there is always the hope that this time it will be for real, this time it will last, this time the heart and brain, the body and soul will all be satisfied.

Chapter 20

I ♥ U

FIGURE 31. Milton Glaser, *I Love New York*, 1977. Trademarked logo, New York State Department of Economic Development, New York, New York.

IN 1977 THE HEART ICON BECAME A VERB. THE "I ♥ NY" logo was created to boost morale for a city that was in severe crisis. Trash piled up on the streets, the crime rate spiked, and New York City was near bankruptcy. Hired by the city to design an image that would increase tourism, Milton Glaser created the famous logo that has since become both a cliché and a meme (Figure 31).

FIGURE 32. Robert Indiana, *LOVE*, 1973. Postage stamp, US Postal Service.

Compositionally, if not in content, Glaser's brainchild broadly resembled Robert Indiana's LOVE design, which had first appeared publicly in 1964 on a Museum of Modern Art Christmas card and later on a 1973 US postage stamp (Figure 32).

With his "I ♥ NY" logo, Glaser joined a tradition of artists who, since the Middle Ages, have portrayed the heart as the preeminent symbol of love. However, he extended its meaning beyond the romantic and the religious to embrace the realm of civic feelings and thereby opened the gateway to countless new uses for the heart icon. Once it had become a verb, ♥ could easily connect a person with any other person, place, or thing. Imitations of the original logo have sprung up in so many arenas that the city of New York, which earns millions of dollars from copyright permissions, is hard put to go after all violations.

After the terrorist attacks of September 11, 2001, New Yorkers had tragic reasons for loving their city all the more. Glaser even designed a modified version of his logo saying, "I ♥ NY More than Ever," with a little black spot on the heart to mark the site of Ground Zero.

BOTH MILTON GLASER, BORN IN 1929, AND ROBERT INDI-ana, born in 1928, are associated with the pop art movement that engulfed the American scene in the early 1960s. The same can be said, to a somewhat lesser extent, about Jim Dine, born in 1935. Whereas Glaser focused largely on the graphic arts and found a receptive audience for his posters, Indiana and Dine made their mark with paintings of everyday objects—Indiana, with American road signs; Dine, with tools, bathrobes, and especially hearts. A brief search for "Jim Dine hearts" on the Internet will reveal a myriad of fanciful depictions in his oil paintings, watercolors, drawings, prints, collages, and sculptures. Often these hearts are simply colorful and decorative, playful expressions of Dine's technical virtuosity, but sometimes they are more than that and manage to suggest personal and even metaphysical layers of meaning.

To tell the truth, I was never a big Dine fan until I saw his 2010 paintings called "The Magnets." These twin paintings, one red against a blue background, the other blue against a red background, burrow deeply into the soul of the heart. They evoke its vital presence in our physical and affective lives and even the mysteries of life itself. Recalling the transcendent paintings of Mark Rothko, "The Magnets" suggest the cosmic spirit that surrounds and sustains every individual heart.

When queried in a 2010 interview about his fixation on the heart, Dine answered, "I use it as a template for all my

emotions. It's a landscape for everything. It's like Indian classical music—based on something very simple but building to a complicated structure. Within that you can do anything in the world. And that's how I feel about my hearts."

For a 2015 retrospective of his work in Los Angeles, when asked again about the heart, he said, "I've never wanted to be a bleeding heart or wear it on my sleeve; it just so happens that was the subject matter because that was my condition." Paradoxically, by using the heart as a mirror of his own "condition," Dine has offered many of us an unexpected entrance into our own.

AT THE VERY END OF THE TWENTIETH CENTURY A NEW graphic form appeared that soon disseminated the heart icon as never before. This time the innovation was Japanese rather than American. In 1999 the Japanese provider NTT DoCoMo released the first emoji made specifically for mobile communication. The original 176 emojis were designed by Shigetaka Kurita and rendered in black and white, before they were painted one of six colors—black, red, orange, lilac, green, and blue. This set is now in the permanent collection of the Museum of Modern Art in New York City (Figure 33).

Among the original 176 emojis there were five of the heart, and like all the other emojis, each was made within a grid just twelve pixels wide and twelve pixels long. Of the five heart emojis, one was colored completely red, one included white blank spots to suggest three-dimensional depth, another had jagged white blanks at its center forming the crack in a broken heart, one looked as if it were in flight, and one pictured two small hearts sailing off together.

Even with the limitations of pixel technology, which give the pictograms an archaic quality, most of them are

FIGURE 33. NTT DOCOMO. *Emoji* (original set of 176), 1998–1999. Software and digital image files, Museum of Modern Art, New York, New York. Copyright NTT DOCOMO.

recognizable, though we might be hard put to decipher the original smiley face, with its three pixels for each eye and a rectangle for the mouth. Along with the heart, the smiley face has by now become our most familiar digital icon. When combined with a heart, smiley faces can express various shades of love. ☺ ♥

Our online messages are regularly punctuated by heart emoji in multiple colors and combinations. There is the classic red heart for amorous love ♥; the heart with an arrow recalling Cupid ♥; two pink hearts, one larger than the other, suggesting love "in the air" ♥; a heart tied with a ribbon to signal a gift ♥; a tremulous heart ♥; and a heart fractured in two by the ache of a traumatic breakup ♥. There are blue hearts, green hearts, purple hearts, yellow hearts, black hearts, and undoubtedly more to come. And even without these, any person with a typewriter or computer can press down on two keys to create this common heart emoticon: <3.

The variety of heart images today is astonishing. Online one can find a plethora of photos culled from the worlds of romance, religion, and nature that are truly breathtaking. A number of these show heart shapes occurring in the wild—in leaves, rock formations, cloud patterns, a heart-shaped pond, a flock of birds that fly in a heart formation, a stag with heart-shaped antlers, the entire island of Galešnjak in Croatia as seen from the sky. Discovering the heart shape in nature has prompted some viewers to experience a kind of new-age pantheism, as expressed poetically by one observer: "Staying aligned with your heart and soul connects you to the universe." Human love, as symbolized by the heart, radiates outward to embrace the entire natural world—or perhaps the reverse is true, and the heart shape existing in nature led to the creation of the first heart icons and their ultimate association with love. Regardless, today the familiar heart form can inspire the protective concerns many of us feel for our planet and a desire to shield it from further destruction.

OVERALL, BOTH GRAPHICALLY AND VERBALLY THE HEART IS still primarily associated with romantic love. The contemporary version of "Lonely Hearts" ads thrives in the form of online dating sites, with target audiences for singles under fifty or over fifty, for Catholics or Jews, for Latinos and blacks, for affluent singles, for singles in your region, for divorced singles, for single parents, for men seeking women, for men seeking men, for women seeking men, for women seeking women, and on and on.

A site founded by Ellen Huerta that specializes in the "brokenhearted" (letsmend.com) set out "to erase the shame and taboo of heartbreak" based not only on her own experience but also on the latest psychological research. Ms. Huerta

drew upon studies demonstrating that romantic love stimulates the same part of the brain as addictive drugs, causing similar symptoms of euphoria and dependence. To combat love's addictive cravings, Huerta now offers an entire program ranging from meditation and tea cleansing to psychological counseling. Yet despite mounting evidence for the brain's key role in the experience of love, the heart continues to be the metaphor of choice when we talk or write about love. Witness Ms. Huerta's own online postings that announce, "We're capturing hearts." "Heartbreak Cleanse." "We are your personal trainer for heartbreak."

In tandem with the amorous heart, the religious heart continues to have currency throughout the world. Most religions claim a special connection between the human heart and the divine. Muslims are still enjoined to come before Allah "with a pure heart." Buddhists emphasize the compassion of "the wise heart." Hindus believe in the concept of Paramatman, a sort of universal life force that resides in the hearts of all living beings and even in every atom. Hebrews still look to the Bible, which emphasizes the heart's moral and spiritual significance, as in Proverb 4:23: "Above all else, guard your heart, for everything you do flows from it." Christians have adopted the heart to express one of their most cherished beliefs: that God is love (1 John 4:8).

I would like to believe that God is love. I would like to believe in God. I envy the certainty of some of my friends—Christian, Jewish, Muslim, and Bahai—who have faith in a beneficent God. Their loving hearts have irradiated my own and augmented the love I have shared with my parents, children, and grandchildren.

And I have also had the incomparable experiences of falling in love and staying in love—two overlapping but different

forms of loving. The first takes you by surprise, pierces you to the core, leaves you elated and vulnerable. Even with greater access to sex outside marriage, Americans of all ages are still receptive to the unique combination of disquiet and delight that distinguishes falling in love from all other feelings.

Staying in love is more demanding. It is not only a feeling but an act of will requiring commitment, adjustment, caring for your partner at least as much as yourself. You need to listen at all times to that person's heart and make sure it is beating in unison with your own.

The heart may be only a metaphor, but it serves us well, for love itself is impossible to define. Throughout the ages men and women have been trying to put into words the various shades of loving they experience. We attempt to distinguish between fondness, affection, infatuation, attachment, endearment, romance, desire, erotic passion, and "true love." We fall in love, write love letters, make love, become lovelorn or lovesick, create a love nest, even resemble lovebirds. We hold back from saying "I love you" until we have reason to hope for a similar response. College students seem to know that "hooking up" is not the same thing as love, but many satisfy themselves with the former until they feel they are ready for the latter. Most people love to love, for what else in life can give you the same intense pleasure, the same vitality, the same raison d'être?

And when words fail us, we fall back on signs. We add ♥ to our emails, texts, and letters. We send valentines adorned with hearts and cupids to those most dear to us. A scarf with a pattern of hearts makes a great gift for a female relative or friend. We make heart-shaped cookies for children's parties. When we receive a present embellished with a heart, that form makes it all the more special. Sometimes we even give

ourselves gifts bearing the heart shape. Long ago I bought myself a red glass Lalique heart pendant that I still wear frequently.

I am drawn to the metaphoric heart because it represents the best of human nature. To love and care for another is not just the province of poets but of every mortal existence lived to its fullest. Heartfelt love can be experienced in so many different ways, not just between two erotically charged individuals but also between intimate friends, close members of a club or community, doctors and their patients, not to mention blood relatives. When I look back on my eighty-five years I am startled by the realization that I have loved a surprising number of people, each one unique and yet all sharing space in my heart.

The global popularity of the heart symbolizing love offers a small dose of hope in a world scarred by so much hatred. Ideally, it serves as a reminder of the ageless assumption that only love can save us.

Now that the heart icon appears everywhere, there is, of course, the danger of overuse. Can it serve as a commercial logo on low-fat foods and T-shirts and still maintain its sublime aura? Is the scalloped heart losing its punch? For the moment it seems to be very much alive, still beating strongly in endless settings. Photographers find it in nature, and artists keep coming up with new ways to transmit its message. Who will be the next Jean de Grise, Milton Glaser, or Jim Dine? Who will make the heart sing in the tradition of Sappho, Ovid, Walther von der Vogelweide, Dante, Charles d'Orléans, Sir Philip Sidney, and Bellini? Who will give the age-old icon and metaphor a vital transfusion so it continues to speak the silent words enshrined within our hearts?

Acknowledgments

First and foremost I wish to thank Stanford University, which has provided an intellectual home for my husband and me for more than fifty years. Without the resources of Green Library and the new Bowes Art and Architecture Library, my work on this book would have been nearly impossible.

At Stanford I am indebted to English professor John Bender for pointing me in the direction of European emblem books, to French professor Marisa Galvez for her work on medieval songbooks, to English professor emerita Barbara Gelpi for advice on Catholic religious devotions, to history professor Fiona Griffiths for medieval bibliographical suggestions, to Professor Robert Harrison for insights into medieval Italian literature, to professor emeritus Van Harvey of religious studies for strengthening my knowledge of the Reformation and Counter-Reformation, and to G. Salim Mohammed, director of the David Rumsey Map Center, for helping me research cordiform maps. I am also grateful to Edith Gelles, senior scholar at the Michelle Clayman Institute for Gender

Research, for comments on the American material. Gelles, along with Clayman senior scholar Karen Offen, Professor Barbara Gelpi, and writer and translator Stina Katchadourian offered a combined critique of Chapter 8.

Graduate student Natalie Pellolio from the Stanford Art Department was invaluable in choosing and procuring illustrations.

Author Kim Chernin made important suggestions for Chapter 18, and her partner, author Renate Stendhal, offered ongoing advice and encouragement.

Theresa Donovan Brown, my close friend and coauthor of *The Social Sex*, nurtured *The Amorous Heart* from its earliest stage of development.

My literary agent and longtime friend, Sandra Dijkstra, made sure to find the right publisher for *The Amorous Heart*, and Dan Gerstle, my editor at Basic Books, was a major influence in shaping the book's content.

My psychiatrist husband, Irvin Yalom, was the first and last reader of the text and an ever-present support. Our photographer son, Reid Yalom, helped produce the photos. With such family members, colleagues, and friends, writing a book about the heart as a symbol of love came naturally.

Notes

Introduction

3 **One Egyptian poet visualized his heart:** Diane Ackerman, *A Natural History of Love* (New York: Vintage Books, 1995), 10–11.

4 **Starting with the Bible, the heart was understood:** William W. E. Slights, *The Heart in the Age of Shakespeare* (Cambridge: Cambridge University Press, 2008), 22.

4 **Among the Church fathers, the one most associated with the heart:** Eric Jager, *The Book of the Heart* (Chicago and London: University of Chicago Press, 2000), 28–29. Illustrations of Augustine holding his heart in his hand began to appear in the fourteenth century—for example, on the 1340 German altar panel now in Cologne's Wallraf-Richartz-Museum and in late medieval French and Flemish manuscripts, such as the Morgan Library's "Da Costa Book of Hours," MS M. 399, f. 299v.

5 **Perhaps more than any other Church figure, Saint Augustine:** Stephen Greenblatt, "The Invention of Sex: St. Augustine's Carnal Knowledge," *New Yorker*, June 19, 2017, 24–28.

Chapter One: The Amorous Heart in Antiquity

8 **Yet in old age Sappho bemoaned:** "Sappho. Selected Poems and Fragments," trans. A. S. Kline © 2005, www.poetryintranslation .com/PITBR/Greek/Sappho.htm#anchor_Toc76357048.

8 **When Antiochus fell in love with his stepmother:** Plutarch, *Parallel Lives: The Lives of the Noble Grecians and Romans*, trans. John Dryden (New York: The Modern Library, 1992), 1095.

8 **"drawing wide / apart with both hands":** Bruce S. Thornton, *Eros: The Myth of Ancient Greek Sexuality* (Boulder, CO: Westview Press, 1997), 15.

9 **In his *Timaeus* he established the reign:** Robert A. Erickson, *The Language of the Heart, 1600–1750* (Philadelphia: University of Pennsylvania Press, 1997), 1.

11 **"You ask, Lesbia, how many kisses should":** This and the following are my loose translations of Catullus's poem number 7.

11 **The second-century Greek physician Soranus suggested:** John M. Riddle, *Eve's Herbs: A History of Contraception and Abortion in the West* (Cambridge, MA, and London: Harvard University Press, 1997), 44–46.

12 **"Love is a warfare: sluggards be dismissed":** This and the following quotations are from Ovid, *The Love Poems*, trans. A. D. Melville (Oxford and New York: Oxford University Press: 1990), 114, 100, 126, 127.

14 **"When the human body is cut open":** Ackerman, *A Natural History of Love*, 36.

14 **In medieval Salisbury, England, the liturgy for the marriage service:** Emilie Amt, ed., *Women's Lives in Medieval Europe: A Sourcebook* (New York and London: Routledge, 1993), 86.

14 **The Roman wife who lived up to expectations:** This and the following quotation are from Mary Beard, *SPQR: A History of Ancient Rome* (New York: W. W. Norton, 2015), 304, 310.

15 **Because the Romans disapproved of public displays of grief:** Anthony Everitt, *Cicero* (New York: Random House, 2003), 243–244.

15 **Catullus, when he was not writing about Lesbia, described:** Catullus, "Epithalamium," *The Latin Poets*, ed. Francis. R. B. Godolphin (New York: Modern Library, 1949), 25–31.

16 **Many of Ovid's contemporaries shared his skepticism:** Tim Whitmarsh, *Battling the Gods: Atheism in the Ancient World* (New York: Vintage, 2015).

16 **Some Greeks and Romans were probably fervent believers:** Richard Tarnas, *The Passion of the Western Mind* (New York: Harmony Books, 1991), 13.

17 **Helen, joined to Paris by the machinations of Aphrodite:** Thornton, *Eros*, 4.

17 **Greek vases featured scenes of copulation:** Eva C. Keuls, *The Reign of the Phallus* (Berkeley: University of California Press, 1985).

Chapter Two: Arabic Songs from the Heart

19 **Arabic bards known as *rawis* memorized:** Robert Mills, "Homosexuality: Specters of Sodom," in *A Cultural History of Sexuality in the Middle Ages*, ed. Ruth Evans (Oxford and New York: Berg, 2011), 69.

19 **Afterward religion supplanted amorous love:** Suheil Bushrui and James M. Malarkey, eds., "Introduction," in *Desert Songs of the Night: 1500 Years of Arabic Literature* (London: SAQI, 2015).

19 **Thus, one poet, Ka'b Bin Zuhair, cried out":** This and the following quotations from Bushrui and Malarkey, *Desert Songs*, 17, 27, 22, and 4.

21 **These lines are "among the most licentious":** Raymond Farrin, *Abundance from the Desert* (Syracuse, NY: Syracuse University Press, 2011), 10.

21 **Created by three different poets, these couples interest us:** Gaston Wiet, *Introduction à la Littérature Arabe* (Paris: Editions G. P. Maisonneuve et Larose, 1966), 43.

22 **Still, he continued to adore her, even in her married state:** Farrin, *Abundance from the Desert*, 98.

23 **In *On Love and Lovers* Ibn Hazm set out to:** This and the following quotations from Ibn Hazm, *Le Collier de Pigeon ou de l'Amour et des Amants*, trans. Léon Bercher (Algiers: Editions Carbonel, 1949), 5, 33, 68–69, 369, and 371–373 (my translations from the French).

Chapter Three: The Heart Icon's First Ancestors

26 **Perhaps they were related to wine, as this is a drinking vessel:** Roman Ghirshman, *Persian Art: The Parthian and Sassanian Dynasties, 249 BC–AD 651*, trans. Stuart Gilbert and James Emmons (New York: Golden Press, 1962), 216.

27 **Was this small "heart" merely a fanciful shape:** *Le Monde, Science et Médicine*, October 12, 2016, 4–5.

27 **The examples pictured in his book, *The Shape of the Heart*:** Pierre Vinken, *The Shape of the Heart* (Amsterdam: Colophon, 2000), 17–18.

27 **Some of the most intriguing can be found:** John Williams, *The Illustrated Beatus*, vols. I–V (London: Harvey Miller Publishers, 1998). See also Natasha O'Hear and Anthony O'Hear, *Picturing the Apocalypse. The Book of Revelation in the Arts over Two Millennia*, vols. I–V (Oxford: Oxford University Press, 2015).

28 **According to the medieval manuscript expert:** Christopher de Hamel, *Meetings with Remarkable Manuscripts* (London: Allen Lane/Penguin, 2016), 209. De Hamel, email to author.

28 **Perhaps the illuminator of the Morgan Beatus had seen:** The relevant images in the Morgan Beatus are reproduced in Barbara Shailor and John Williams, *A Spanish Apocalypse: The Morgan Beatus Manuscript* (New York: George Braziller, 1991), f. 22v, f. 156, f. 157, f. 214, and 181v.

31 **Facundus placed "hearts" on animals in a few other illustrations:** For the relevant Facundus hearts, see f. 109, f. 135, f. 160,

f. 230v, and f. 240 reproduced in John Williams, *The Illustrated Beatus*, vol. III.

Chapter Four: French and German Songs from the Heart

34 **Fin' amor is impossible to translate:** Jean-Claude Marol, *La Fin' Amor: Chants de troubadours XIIe et XIIIe siècles* (Paris: Editions du Seuil, 1998), 22.

34 **Bernart began one of his song-poems with the assertion:** Christopher Lucken, "Chantars no pot gaire valer, si d'ins dal cor no mou lo chans: Subjectivé et Poésie Formelle," in *Micrologus, XI, Il cuore, The Heart* (Florence: Sismel, Edizioni del Galluzzo, 2003), 380.

34 **Bernart claimed he sang better than any other troubadour:** Arnaud de la Croix, *L' érotisme au Moyen Age: Le corps, le désir l'amour* (Paris: TEXTO, 2003), 47.

35 **Another troubadour, Arnaud Daniel, maintained:** Andrea Hopkins, *The Book of Courtly Love: The Passionate Code of the Troubadours* (San Francisco: HarperSanFrancisco, 1994), 22.

35 **When she wrote, "I grant him my heart":** De la Croix, *L' érotisme au Moyen Age*, 31.

35 **Thus, Gace Brulé, a prolific minstrel active around the turn:** Samuel N. Rosenberg and Samuel Manon, eds., and trans., *The Lyrics and Melodies of Gace Brulé* (New York and London: Garland Publishing, 1985). Quotations from *Gace Brulé*, RS 413, RS 643, RS 1690, RS 801, RS 1465, RS 1934, and RS 1757.

36 **He wrote, "He who has put all his heart and all his will":** This and the following quotation are from Thibaut de Champagne, *Recueil de Chansons*, trans. Alexandre Micha (Paris: Klincksieck, 1991), 23 and 25.

36 **"Love engraved / Your features in an image":** This and the following are from Jager, *The Book of the Heart*, 69–71.

36 **When this poem was anthologized:** Pierpoint Morgan Library, MS M.819. fol. 59r.

36 **An anonymous trouvère was happy to offer his joyful heart:** The references in this paragraph are from Samuel Rosenberg and Hans Tischler, *Chansons des Trouvères* (Paris: Livre de Poche, 1995), 132–133, 136–137, and 364–365.

37 **And in each region love staked out its place:** René Nelli, *Troubadours et trouvères* (Paris: Hachette, 1979), 15–16.

38 **Locking love into one's heart quickly became a common:** For example, miniature in *Le Roman de la Rose*, British Museum Ms. 42133, f. 15.

38 **"Come, come, my heart's loved one, / Full of longing I await you!":** H. G. Fiedler, ed., *Das Oxforder Buch Deutscher Dichtung vom 12ten bis zum 20sten Jahrhundert* (London: Oxford University Press, 1948), 1 (my translations).

39 **These songbooks and others written:** Marisa Galvez, *Songbook: How Lyrics Became Poetry in Medieval Europe* (Chicago and London: University of Chicago Press, 2012).

39 **Walther's poems were miniguides to this high-minded approach:** Maria Effinger, Carla Meyer, and Christian Schneider, eds., "Der Codex Manesse und die Entdeckung der Liebe," *Universitätsverlag* (Winter 2010), in conjunction with the "Codex Manesse and the Discovery of Love" exhibition at the University of Heidelberg, 2010.

41 **Certainly the rise of queenship during:** Marilyn Yalom, *Birth of the Chess Queen: How Her Majesty Transformed the Game* (New York: HarperCollins, 2004).

Chapter Five: Romances of the Heart

44 **In her words, "I can expect no reward from God":** Héloïse and Abélard, *Lettres et vies*, ed. Yves Ferroul (Paris: GF-Flammarion, 1996), 103 (my translation).

45 **In a long monologue he takes up an old theory:** Joseph J. Duggan, "Afterword," *Cligès*, trans. Burton Raffel (New Haven, CT, and London: Yale University Press), 215–229.

45 **"It's not the eye that was hurt / But the heart":** This and the following quotations are from *Cligès*, trans. Raffel, lines 698–715, pp. 23–24; lines 458–459, p. 16; lines 2281–2283, p. 73; lines 2798–2835, pp. 89–90.

47 **These negative sentiments lodged in the heart:** Begoña Aguiriano, "Le cœur dans Chrétien," and Micheline de Combarieu du Gres, "Un coeur gros comme ça," in *Le "Cuer" au Moyen Âge, Senefiance*, no. 30 (Aix: Centre Universitaire d'Etudes et de Recherches Médiévales d'Aix, 1991), 9–25, 77–105.

47 **As Chrétien de Troyes wrote in his masterful *Lancelot*:** Chrétien de Troyes, *Lancelot: The Knight of the Cart*, trans. Raffel (New Haven, CT, and London: Yale University Press, 1997), lines 1237–1239, p. 40.

47 **Similarly the chaplain Andreas Capellanus:** Andreas Capellanus, *On Love*, trans. P. G. Walsh (London: Gerald Duckworth & Co., 1982), 221.

47 **Here and elsewhere Capellanus echoed:** De la Croix, *L' érotisme au Moyen Âge*, 73–76.

48 **Women of noble birth were constantly surrounded:** Georges Duby, ed., *A History of Private Life: Revelations of the Medieval World*, vol. II, trans. Arthur Goldhammer (Cambridge, MA, and London: Harvard, Belknap Press, 1988), 77–83.

48 **Indeed, when asked her opinion, she answered unequivocally:** This and the following quotation are from Capellanus, *On Love*, 157 and 283.

49 **"Holding him tight against / Her breast, making the knight":** Chrétien de Troyes, *Lancelot*, trans. Raffel, 147.

50 **To quote only a few lines from this paean to love:** Gottfried von Strassburg, *Tristan*, trans. A. T. Hatto (Harmondsworth: Penguin Books, 1967), 262–263.

51 **One modern critic, in commenting on *Tristan*:** Ole M. Høystad, *A History of the Heart* (London: Reaktion Books, 2007), 118.

51 **One indication of their popular appeal:** Michel Pastoureau, *Une histoire symbolique du Moyen Age occidental* (Paris: Editions du Seuil, 2004), 340–341.

52 **Although the text itself does not constitute:** Christine Marchello-Nizia, ed., *Le Roman de la Poire par Tibaut* (Paris: Société des anciens textes français, 1984).

54 **Medieval authorities, including the Persian philosopher Avicenna:** Vinken, *The Shape of the Heart*, 13–16.

57 **At one point he finds a superb rose garden:** This and the following quotations are from Guillaume de Lorris and Jean de Meun, *The Romance of the Rose*, trans. Frances Horgan (Oxford and New York: Oxford University Press, 1994), 26 and 27.

Chapter Six: Exchanging Hearts with Jesus

60 **Pious individuals meditated upon the crucifix:** Stephen Greenblatt, "Mutilation and Meaning," in *The Body in Parts: Fantasies of Corporeality in Early Modern Europe*, eds. David Hillman and Carla Mazzio (New York and London: Routledge, 1997), 223.

61 **In his prayers he begged Jesus to take him:** Anselm of Canterbury, *The Prayers and Meditations of St. Anselm*, trans. Benedicta Ward (London: Penguin, 1973), 224.

62 **He stretched out his hand toward her and said:** This and the following quotations are from Gertrude d'Helfta, *Œuvres Spirituelles*, Tome II, *Le Héraut* (Livres I et II), ed. Pierre Doyère (Paris: Les Editions du Cerf, 1968), 228, 230, 248, 250, 138, 140, and 288 (my translations).

64 **In Gertrude's other prayers, meditations, litanies, and hymns:** The following quotations are from *Gertrude the Great of Helfta: Spiritual Exercises*, trans. Gertrude Jaron Lewis and Jack Lewis (Kalamazoo, MI: Cistercian Publications, 1989), 33, 35, 38, 40, 48, 68, 74, 77, 81, and 91.

65 **She was comfortable mentioning Venus several times:** Madeleine Grace, CVI, "Images of the Heart as Seen in the Writings

of Beatrice of Nazareth and Gertrude the Great," in *Cistercian Studies Quarterly* 37, no. 3 (2002): 269.

65 **After a mystical experience when she was about twenty-one:** Caroline Walker Bynum, *Holy Feast and Holy Fast: The Religious Significance of Food to Medieval Women* (Berkeley: University of California Press. 1987), 246. See also Martin Kemp, *Christ to Coke: How Image Becomes Icon* (Oxford and New York: Oxford University Press, 2012), 101–102.

65 **Once in a vision, when she asked Jesus why:** Catherine of Siena, *The Letters of St. Catherine of Siena*, vol. I, trans. Suzanne Noffke (Binghamton, NY: Medieval & Renaissance Tets and Studies, 1988), 254.

68 **Fouquet's miniature shows Jesus's heart:** *"Les Heures d'Etienne Chevalier,"* Louvre, département des arts graphiques, R.F. 1679.

68 **Another striking Sacred Heart from a Book of Hours:** Morgan Library, MS M.7, f. 24r.

Chapter Seven: *Caritas*, or the Italianized Heart

70 **"Then beauty appears in a virtuous woman":** Robert Pogue Harrison, *The Body of Beatrice* (Baltimore, MD, and London: Johns Hopkins University Press, 1988), 50.

71 **"She is the best that nature can produce":** Ibid., 39.

71 **The sonnet ends with lines that follow the route of love:** Ibid., 43.

72 **As the Italianist Robert Harrison eloquently puts it:** Ibid., 44.

72 **What follows next is shocking: "In one hand":** Milad Doueihi, *A Perverse History of the Human Heart* (Cambridge, MA, and London: Harvard University Press, 1997), 57.

75 **Siena, too, boasts a Caritas fresco:** For photos of these *Caritas* figures see Doris Bietenholz, *How Come This Means Love?* (Saskatoon, Canada, 1995), and Vinken, *The Shape of the Heart*, 34–41.

75 **In *Madonna with Caritas*, painted by the Master of the Stephaneschi:** Vinken, *The Shape of the Heart*, figure 25, p. 35.

77 **Somehow, with all that traveling and a wife who bore him:** Antoine Thomas, *Francesco da Barberino et la Littérature Provençale en Italie au Moyen Age* (Paris: Ernest Thorin, Editeur, 1883), 9–20.

78 **Red hearts painted in one manuscript, black and white hearts:** Vatican Library manuscripts Barb., nos. 4076 and 4077.

78 **And if we still have any doubts about the items:** Francesco da Barberino, *I Documenti d'Amore* (Milan: Archè, 2006), 411.

78 **The great art historian, Erwin Panofsky, called attention:** E. Panofsky, "Blind Cupid," in *Studies in Iconology*, 1962, 95–128; Vinken, *The Shape of the Heart*, 44–45; and Jean Canteins, *Francesco da Barberino: L'homme et l'oeuvre au regard du soi-disant "Fidèle d'Amour"* (Milan: Archè, 2007), 217–301.

81 **Panofsky likened the bandolier across Cupid's body:** Panofsky, "Blind Cupid" (New York: Harper and Row, 1962), 115.

82 **In the lower portion of the miniature a kneeling woman:** J. A. Herbert, *Illuminated Manuscripts* (Bath: Cedric Chivers Ltd. [1911], 1972), plate xxxix.

Chapter Eight: Birth of an Icon

84 **One of its illustrations has the distinction:** *The Romance of Alexander*, Bruges, 1344. Bodleian Library, Oxford, Ms. 264.

85 **The heart icon became visible not only on the pages:** James Robinson, *Masterpieces: Medieval Art* (London: British Museum Press, 2008), 223–224.

85 **Artisans in Parisian workshops carved ivory heart offerings:** Koechlin, *Ivoires gothiques*, vol. I (Paris, 1924), 440–441.

85 **The two figures stand surrounded by hummocks:** Richard H. Randall, Jr., *The Golden Age of Ivory: Carvings in North American Collections* (New York: Hudson Hills Press, 1993), no. 213. A more elaborate French mirror case with a carved heart offering, circa 1400, is in the Cluny Museum in Paris (OA 119).

87 **To head off any confusion in interpreting this scene:** Reproduced in Bietenholz, illustrations 43 and 44.

88 **If so, perhaps they and their descendants:** Leonie von Wilck-ens, *Museum der Stadt Regensburg. Bildteppiche* (Regensburg, 1980), 8. See also Martin Angerer (Hg.), *Regensburg im Mit-telalter. Katalog der Abteilung Mittelalter im Museum der Stadt Regensburg* (Regensburg, 1995), 147–149.

88 **The heart became especially popular as a love motif:** Marian Campbell, *Medieval Jewelry in Europe 1100–1500* (London: Vic-toria and Albert Publishing, 2009).

88 **One from fourteenth-century Italy bears a heart-shaped ruby:** Sandra Hindman, *Take This Ring: Medieval and Renaissance Rings from the Griffin Collection* (Verona: Les Enluminures, 2015), 87, www.medieval-rings.com.

89 **Two Italian heart-shaped manuscripts have also been pre-served:** The Italian heart-shaped books preserved in Pesaro are discussed in Jager, *The Book of the Heart*, 84–85.

89 **Sala's tiny book was meant to be held in the palm:** Christopher de Hamel, *Manuscript Illumination: History and Techniques* (Lon-don: British Library, 2001), 35.

91 **In an engraving by Baccio Baldini, an elegantly clad:** This and the following Italian references are reproduced in Andrea Bayer, ed., *Art and Love in Renaissance Italy* (New Haven, CT, and London: Metropolitan Museum of Art and Yale University Press, 2008), 92 and 89.

92 **Even more macabre, a wooden casket made in Basel:** His-torisches Museum, Basel, reproduced in Michael Camille, *The Medieval Art of Love* (New York: Harry Abrams, 1998), figure 102, p. 115.

93 **Symbols were so common to the medieval mentality:** Michel Pastoureau, *Une histoire symbolique du Moyen Age occidental* (Paris: Editions du Seuil, 2004), 11.

93 **The Anglophone world got its four suits:** Timothy B. Husband, *The World in Play: Luxury Cards 1430–1540* (New York: Metro-politan Museum of Art, 2016), 9.

Chapter Nine: A Separate Burial for the Heart

97 **A recumbent statue of Charles was laid out:** Andreas Bräm, "Von Herzen: Ein Betrag zur Systematischen Ikonographie," and Murielle Gaude-Ferragu, "Le coeur 'couronné': Tombeaux et funérailles de coeur en France à la fin du Moyen Age," in *Micrologus, XI, Il cuore, The Heart,* 175, 255–256, and figure 14.

98 **His epitaph read, "Here lies the body":** Gaude-Ferragu, "Le coeur 'couronné'," 246.

99 **And to make certain that viewers understood:** Ibid., 256.

99 **It was an eminently political act, affirming Anne's rule:** Claire de Lalande, "L'écrin du coeur d'Anne de Bretagne," *Anne de Bretagne, L'Objet d'Art,* Hors-Série, no. 75 (2016): 20–21.

100 **One of the students at La Flèche was none other:** Doueihi, *A Perverse History of the Human Heart,* 128.

100 **That was sold to an artist, to be ground up and used:** John Rogister, "Born to Be King: The Life, Death, and Subsequent Desecration of Louis XIV," *Times Literary Supplement,* August 5, 2016, 25.

101 **All of James's remains were destroyed:** "James II of England," Wikipedia, https://en.wikipedia.org/wiki/James_II_of_England.

Chapter Ten: The Independent Heart

106 **For the first time in Western literature the heart:** Per Nykrog, "Literary Tradition," in René of Anjou, *The Book of the Love-Smitten Heart,* trans. Stephanie Viereck Gibbs and Kathryn Karczewska (New York and London: Routledge, 2001), xiv.

106 **"The other day I went to see my heart":** Charles d'Orléans, *Poésies,* ed. Pierre Champion (Paris: Honoré Champion Editeur, 2010), *Ballade* XXXVII, vol. I, 98 (my translations).

107 **The poet vainly tries to put out the fire:** Ibid., *Poésies, Ballade* XXVI, 88.

107 **He acts as the heart's interpreter in their joint prayer:** Ibid., *Poésies, Ballade* LV, 117.

107 **Charles's split personality, torn between his loving heart:** See A. B. Coldiron, *Canon, Period, and the Poetry of Charles of Orleans* (Ann Arbor: University of Michigan Press, 2000), 61–73.

108 **Of course, the Heart's quest was directed toward:** This and the following quotations are from René of Anjou, *The Book of the Love-Smitten Heart*, 9 and 267.

110 **And, as with the better-known Dukes of Burgundy:** The most famous is Vienna National Library Codex Vindobonensis Ms. 2597. Another beautiful manuscript is the French National Library Ms. Fr. 24399.

110 **The manuscript of *The Love-Smitten Heart* now:** René d'Anjou, *Le livre du coeur d'amour épris*, ed. and trans. Florence Bouchet (Paris: Livre de Poche, 2003), 53.

111 **Villon's down-to-earth portrayal of the lover's deception:** François Villon, *Poems*, trans. David Georgi (Evanston, IL: Northwestern University Press, 2013), 4–25.

111 **"I've nothing more to say. That suits me fine":** Villon, *Poems*, trans. Georgi, 186–189.

Chapter Eleven: The Return of Cupid

115 **Within such mixed company the heart's amatory message:** A section of this fresco is reproduced in Alain Gruber, ed., *The History of Decorative Arts: The Renaissance and Mannerism in Europe* (New York, London, and Paris: Abbeville Press, 1994), 223.

115 **Here the heart simultaneously represents:** This woodcut from the Château de Panat, Aveyron, is reproduced in Orest Ranum, "The Refuges of Intimacy," in *A History of Private Life: Passions of the Renaissance*, vol. III, eds. Philippe Ariès and Georges Duby (Cambridge, MA, and London: Belknap Press of Harvard University, 1989), 233.

115 **Two Italian editions of the poet Petrarch's sonnets:** Vinken, *The Shape of the Heart*, figure 62, p. 73.

115 **Those surviving from this period are exquisitely detailed:** A cordiform map produced by the German humanist Petrus Apianus in 1520 is one of the first maps to bear the name *America*.

118 **This book paved the way for several similar publications:** Otto Vaenius, "Introduction," *Amorum Emblemata*, ed. Karel Porteman (Aldershot Hants, England, and Brookfield, VT: Scolar Press, 1996), 1.

119 **Each of these engravings, except one, features:** John Manning, *The Emblem* (London: Reaction Books, 2002), 170.

119 **Consider the following exemplary headings:** Vaenius, *Amorum Emblemata*, 22, 30, 32, 34, 64, 80, 208, and 236.

120 **Specific advice for the male lover was spelled out:** Ibid., 78, 98, 106, 126, 130, 132, and 234.

120 **The text tells us that this little god of love:** This and the following quotations are from ibid., 34–35, 160, 152.

122 **With sixty-two etchings and matching poems:** Marc van Vieck, "The *Openhertighe Herten* in Europe: Remarkable Specimens of Heart Emblematics," *Emblematica. An Interdisciplinary Journal for Emblem Studies* 8, no. 1 (Summer 1994): 261–291.

122 **To play, "one keeps the little book shut":** This and the following quotation are from van Vieck, "The *Openhertighe Herten* in Europe," 266–267 and 278.

Chapter Twelve: The Reformation and Counter-Reformation

126 **In a letter of July 8, 1530, he explained why:** For the original German of this letter and insightful comments on Luther's seal see Klaus Conermann, "Luther's Rose: Observations on a Device in the Context of Reformation Art and Theology," *Emblematica: An Interdisciplinary Journal for Emblem Studies* 2, no. 1 (Spring 1987): 6.

126 **It appeared on the title pages of his published works:** Conermann, "Luther's Rose," figures 1 to 12.

126 **Whereas the Reformation destroyed many traditional:** Slights, *The Heart in the Age of Shakespeare*, 101.

128 **And if one has any doubts as to its meaning:** Reproduced in Peter M. Daly, *Literature in the Light of the Emblem* (Toronto, Buffalo, NY, and London: University of Toronto Press, 1979), 86.

129 **This literal trial by fire suggests that the Christian heart:** Slights, *The Heart in the Age of Shakespeare*, 59–60.

129 **In another, Jesus takes up a broom and brushes out:** Mario Praz, "Sacred and Profane Love," *Studies in Seventeenth Century Imagery* (Rome: Edizioni di storia e letteratura, 1964), especially figure 61, p. 153.

131 **Puritans in particular were ever conscious that:** Cited by Erickson, *The Language of the Heart*, 13.

132 **As medical science advanced, some pictures:** Scott Manning Stevens, "Sacred Heart and Secular Brain," in Hillman and Mazzio, *The Body in Parts*, figure 13, p. 262.

132 **"I saw in his hands a long golden dart":** St. Teresa of Avila, *The Collected Works*, trans. Kieran Kavanaugh and Otilio Rodriguez (Washington, DC: ICS Publications, 1987), 252.

134 **She described in her autobiography how Jesus revealed:** This and the following quotation are from Emily Jo Sargent, "The Sacred Heart: Christian Symbolism," in *The Heart*, ed. James Peto (New Haven, CT, and London: Yale University Press, Wellcome Collection, 2007), 109–110.

134 **Many of their exquisite works, ranging from paper drawings:** Gérard Picaud and Jean Foisselon, *A tout coeur: L'art pour le Sacré Coeur à la Visitation* (Paris: Somogy éditions d'art, 2013).

Chapter Thirteen: How Shakespeare Probed the Heart's Secrets

138 **Sidney's version of the exchange of hearts carried:** See Stanley Wells, *Shakespeare, Sex and Love* (Oxford and New York: Oxford University Press, 2010).

138 **It has been estimated that the word** *heart* **appears:** Stephen Amidon and Thomas Amidon, *The Sublime Engine: A Biography of the Human Heart* (New York: Rodale, 2011), 81.

140 **In England, with the establishment of the Anglican Church:** Marilyn Yalom, *A History of the Wife* (New York: HarperCollins, 2001), ch. 3, 97–145.

141 **Indeed, some critics believe that this late play:** Amidon and Amidon, *The Sublime Engine*, 85.

147 **But in the real world the longing to love to one's:** "Such is the Fulnesse of my hearts content," *Henry VI*, Part II, Act I, Scene 1, and "I wish your Ladiship all hearts content," *The Merchant of Venice*, Act III, Scene 4.

Chapter Fourteen: Heart and Brain

150 **Though Galen recognized the unusual muscular strength:** Kemp, *Christ to Coke*, 87.

151 **In this interconnected system between humans:** Heather Webb, "The Medieval Heart: The Physiology, Poetics and Theology of the Heart in Thirteenth- and Fourteenth-Century Italy" (PhD dissertation, Stanford University, 2004), 48; Webb, *The Medieval Heart* (New Haven, CT: Yale University Press, 2010).

151 **Leonardo conducted many of his dissections on animals:** Francis Wells, "The Renaissance Heart: The Drawings of Leonardo da Vinci," in Peto, *The Heart*, 80–81.

152 **Men and women have an equal number of ribs:** Famous Scientists, www.famousscientists.org.

153 **Indeed, a 1522 publication contained the image of:** *Isagoge*, by Jacobus Carpensis Beregarius. This image is reproduced in Bette Talvacchia, ed., *A Cultural History of Sexuality in the Renaissance*, vol. II (Oxford and New York: Berg, 2011), figure 1:19, p. 32.

153 **In the 1560s an English midwifery manual described:** Cynthia Klestinec, "Sex, Medicine, and Disease: Welcoming Wombs

and Vernacular Anatomies," in Talvacchia, *Cultural History of Sexuality in the Renaissance*, 127.

153 **Indeed, Vesalius himself was responsible for:** Ibid., figure 6:3, 124.

155 **Descartes in France and Hobbes and Locke in England:** Fay Bound Alberti, "The Emotional Heart: Mind, Body and Soul," in Peto, *The Heart*, 125–142.

156 **Classical authorities, like Plato and Galen, had placed:** Jager, *The Book of the Heart*, 152.

156 **It is rather the innermost part of the brain:** *Stanford Encyclopedia of Philosophy*, 2.3 *The Passions of the Soul*, https//plato.stanford .edu/entries/pineal-gland.

156 **As for love, Descartes wrote that when one sees a love object:** René Descartes, *The Passions of the Soul*, trans. Stephen Voss (Indianapolis and Cambridge: Hackett Publishing Company, 1989), article 102, p. 74.

157 **The rivalry between heart and head only quickened:** Geraldine Caps, "Diffusions, enjeux et portées de la représentation mécaniste du corps dans la médecine du second XVIIe siècle." In *Europe XVI/ XVII: Réalités et Représentations du Corps* (I) (Nancy: Université de Nancy, 2011), 142–157.

158 **Hobbes, in his groundbreaking *Leviathan*:** Thomas Hobbes, *Leviathan*, ed. A. R. Waller (Cambridge: Cambridge University Press, 1904), xviii, emphasis original.

158 **Eric Jager, in his fine *Book of the Heart*, concludes:** Jager, *The Book of the Heart*, 155.

Chapter Fifteen: Exposing the Female Heart

160 **In so doing, novelists placed women center stage:** G. B. Hill, ed., *Boswell's Life of Johnson* (Oxford: Clarendon Press, 1950), ii, 49.

161 ***Pamela* was a media sensation unlike anything:** Samuel Richardson, *Pamela: or Virtue Rewarded*, eds. Thomas Keymer and

Alice Wakely (Oxford and New York: Oxford University Press, 2001), xxii–xxiii.

161 **She invokes it more than two hundred times:** This and the following quotations are from ibid., 31, 14, 22, 244, 245, 249, and 251.

163 **She, too, is the victim of "assaults to her heart":** Erickson, *The Language of the Heart*, 207. I am indebted to Robert Erickson for his careful reading of *Clarissa*, something I could not tolerate for the entire fifteen hundred pages.

164 **The urgency of her refusal comes from something:** This and the following quotations are cited by Erickson, *The Language of the Heart*, 208, 211, and 225.

165 **As he states to his friend Belford, "I think":** Samuel Richardson, *Clarissa: or the History of a Young Lady* (Harmondsworth, Middlesex: Penguin Books, 1985), 1383–1384.

169 **His philosophical essay *L'art de jouir*:** These comments on La Mettrie were inspired by Natalie Meeker, "French: Eighteenth Century," *Encyclopedia of Erotic Literature*, vol. I, eds. Gaëtan Brulotte and John Phillips (New York and London: Routledge, 2006), 484; and "La Mettrie, Julien Offray de," vol. II, 745–746.

170 **Determined research turned up Boucher's *Amours des Dieux*:** These are from Boucher's 1758 series "Les amours des Dieux," *La Cible d'Amour* [The Target of Love], Collection Louis XV, Louvre.

Chapter Sixteen: The Heart in Popular Culture

171 **Swiss maidens embroidered hearts on textiles:** H. J. Hansen, ed., *European Folk Art in Europe and the Americas* (New York and Toronto: McGraw Hill, 1967), 179 and 217.

172 **These were written in Fraktur, a distinctive artistic:** Donald Shelley, *The Fraktur Writings or Illuminated Manuscripts of the Pennsylvania Germans* (Allentown: Pennsylvania German Folklore Society), 1961.

173 **In the private registers kept by families in New England:** Laurel Ulrich, *A House Full of Females: Plural Marriage and Women's*

Rights in Early Mormonism, 1835–1870 (New York: Alfred A. Knopf, 2017), 109.

175 **For example, the outline of a heart on a "spirit drawing":** Edward Deming Andrews and Faith Andrews, *Visions of the Heavenly Sphere: A Study in Shaker Religious Art* (Charlottesville: University Press of Virginia, 1969), plate XII.

175 **Though the practice came to an end in the 1850s:** France Morin, *Heavenly Visions: Shaker Gift Drawings and Gift Songs* (New York: Drawing Center, 2001).

175 **Mormon drawings coupled the heart:** Ulrich, *A House Full of Females*, 110 and 133.

176 **They also were and remain popular:** See the wonderful examples in Mary Emmerling, *American Country Hearts* (New York: Clarkson N. Potter, 1988).

176 **Many hearts were expressions of friendship:** Marilyn Yalom with Theresa Donovan Brown, *The Social Sex: A History of Female Friendship* (New York: Harper Perennial, 2015), chs. 7 and 8.

176 **Hearts that spoke for one's loving feelings:** Robert Shaw, "United as This Heart You See: Memories of Friendship and Family," in *Expressions of Innocence and Eloquence: Selections from the Jane Katcher Collection of Americana*, vol. I, ed. Jane Katcher, David A. Schorsch, and Ruth Wolfe (New Haven, CT: Yale University Press, 2006), 89.

177 **A few years back, when my photographer son Reid and I:** Marilyn Yalom, with photographs by Reid S. Yalom, *The American Resting Place: Four Hundred Years of Cemeteries and Burial Grounds* (Boston: Houghton Mifflin, 2008).

Chapter Seventeen: Hearts and Hands

179 **These words were written by a young American woman:** Eliza Chaplin, Nelson Letters, 1819–1869, Essex Institute Library, Salem, Massachusetts.

180 **A proper church wedding usually took place:** Merry E. Wiesner, *Women and Gender in Early Modern Europe* (Cambridge: Cambridge University Press, 1993), 49.

182 **Petitions for annulment began with the formula:** Ann Rosalind Jones, "Heterosexuality: A Beast with Many Backs," in *A Cultural History of Sexuality in the Renaissance*, ed. Bette Talvacchia (Oxford and New York: Berg, 2011), 46.

183 **This trend can be seen in the history of "Lonely Hearts" ads:** Francesca Beauman, *Shapely Ankle Preferred: A History of the Lonely Hearts Ads, 1695–2010* (London: Chatto and Windus, 2011), citations from 26–29.

186 **Intelligence, wit, kindness, compassion, and mutual respect:** Helena Kelly, *Jane Austen: The Secret Radical* (New York: Knopf, 2017), ch. 4.

187 **Insofar as children were concerned, their legal custody:** Yalom, *A History of the Wife*, 185–191.

188 **"Man for the field and woman for the hearth":** See discussion in Erna Olafson Hellerstein, Leslie Parker Hume, and Karen M. Offen, eds., *Victorian Women: A Documentary Account of Women's Lives in Nineteenth-Century England, France, and the United States* (Stanford, CA: Stanford University Press, 1981), 118.

Chapter Eighteen: Romanticism, or the Reign of the Heart

194 **Sir Walter Scott maintained that its creator:** "Don Juan," Wikipedia, https://en.wikipedia.org/wiki/Don_Juan.

197 **In her fiction, as in her life, Sand sought:** For a more complete discussion of Sand and love, see Marilyn Yalom, *How the French Invented Love: Nine Hundred Years of Passion and Romance* (New York: Harper Perennial, 2012), 195–217.

197 **French stories of adultery have a very long history:** Didier Lett, "Marriage et amour au Moyen Age," *Le Monde: Histoire et Civilisations*, no. 15 (March 2016): 2.

198 **In a letter to Lewes dated November 6, 1847:** E. C. Gaskell, *The Life of Charlotte Brontë*, vol. II (London: Smith, Elder & Co., 1857), 43.

199 **In a subsequent letter to Lewes dated January 12, 1848:** This and the following quotations from Gaskell, *The Life of Charlotte Brontë*, vol. II, 54–55.

Chapter Nineteen: Valentines

207 **The French claim Oton de Grandson's:** Nathalie Koble, *Drôles de Valentines: La tradition poétique de la Saint-Valentin du Moyen Age à aujourd'hui* (Paris: Héros-Limite, 2016), 266; Jack B. Oruch, "St. Valentine, Chaucer, and Spring in February," *Speculum* 56, no. 3 (July 1981): 534–565.

208 **All of this was supposed to have taken place:** Charity Cannon Willard, *Christine de Pizan: Her Life and Works* (New York: Persea Books, 1984), 167–168.

209 **"This year the men and women who are":** Charles d'Orléans, *Poésies*, vol. I, ed. Pierre Champion (Paris: Honoré Champion Editeur, 2010), *Ballade* LXVI, 128–129 (my translations here and the following).

209 **"in the name of Love / They organized a big festival":** Ibid., *Complainte* IV, 281.

210 **Several of Charles's poems begin by invoking:** Charles d'Orléans, *Ballades et Rondeaux*, ed. Jean-Claude Mühlethaler (Paris: Livre de Poche, 1992), *Rondeau* 50, 430.

210 **There are even pictures of this Saint Valentine's Day event:** Koble, *Drôles de Valentines*, 273.

210 **In a priggish novel that mixed fact and fiction:** Jean-Pierre Camus, *Diotrephe, or An historie of valentines*, trans. Susan du Verger (1641).

211 **Elizabeth's letter to John on February 10, 1477:** The relevant letters from Elizabeth Brews and Margery Brews to John Paston

III are found in Norman Davis, ed., *The Paston Letters: A Selection in Modern Spelling* (Oxford: Oxford University Press, 1963), 233–235.

213 **Valentine's Day was not a one-day affair:** Samuel Pepys, *The Diary of Samuel Pepys*, vol. II, ed. Robert Latham and William Matthews (Berkeley and Los Angeles: University of California Press, 1970), 36 and 38.

213 **Some contained complicated puzzles, acrostics, and rebuses:** Several fine American examples are reproduced in Ruth Webb Lee, *A History of Valentines* (New York and London: Studio Publications, 1952), 8–38.

214 **Even if the valentine was only a copy of his text:** Barry Shank, *A Token of My Affection: Greeting Cards and American Business Culture* (New York: Columbia University Press, 2004), 34–35.

215 **Emily remarked that one instructor:** Emily Dickinson, *The Letters of Emily Dickinson*, vol. I (Cambridge, MA: Belknap Press of Harvard University, 1965), 63, emphasis original.

215 **They sold for no less than $5 each:** Webb Lee, *A History of Valentines*, 51–75.

215 **One titled "Cupid in Ambush" pictured Cupid:** Debra N. Mancoff, *Love's Messenger: Tokens of Affection in the Victorian Age* (Chicago: Art Institute of Chicago, 1997), 20–21.

216 **There were specialized cards for different trades and professions:** Webb Lee, *A History of Valentines*, 124.

217 **The directive specifically targeted "boxes and cards":** "Valentine's Day," Wikipedia, https://en.wikipedia.org/wiki/Valentine %27s_Day.

Chapter Twenty: I 🖤 U

221 **When queried in a 2010 interview:** Ilka Skobie, "Lone Wolf: An Interview with Jim Dine," ArtNet, www.artnet.com/maga zineus/features/scobie/jim-dine6-28-10.asp.

222 **For a 2015 retrospective of his work in Los Angeles:** Jonathan Novak, "A Retrospective Delves into Jim Dine's Hearts and Other Iconic Symbols," *Artsy Editorial*, February 4, 2015, www.artsy.net /article/editorial-a-retrospective-delves-into-jim-dines-hearts.

222 **In 1999 the Japanese provider NTT DoCoMo released:** Amanda Hess, "Look Who's Smiley Now," *New York Times*, October 27, 2016, C1.

224 **Discovering the heart shape in nature has prompted:** *The Power of the Heart* (movie), www.thepoweroftheheart.com, and Steve Casimiro, "25 Awesome Hearts Found in Nature," *Adventure Journal*, February 4, 2011, www.adventure-journal.com /2011/02/25-awesome-hearts-found-in-nature.

224 **A site founded by Ellen Huerta that specializes:** Sophia Kercher, "Modern Help for the Brokenhearted? It's Online," *New York Times*, February 2, 2017, D3.

Bibliography

Amidon, Stephen, and Thomas Amidon. *The Sublime Engine: A Biography of the Human Heart.* New York: Rodale, 2011.

Andrews, Edward Deming, and Faith Andrews. *Visions of the Heavenly Sphere: A Study in Shaker Religious Art.* Charlottesville, VA: Winterthur Museum and the University Press of Virginia, 1969.

Barberino, Francesco da. *I Documenti d'Amore.* Milan: Archè, 2006.

Beauman, Francesca. *Shapely Ankle Preferred: A History of the Lonely Hearts Ads, 1695–2010.* London: Chatto and Windus, 2011.

Bietenholz, Doris. *How Come This Means Love? A Study of the Origin of the Symbol of Love.* Saskatoon, Canada: D. Bietenholz, 1995.

Bushrui, Suheil, and James M. Malarkey, eds. *Desert Songs of the Night: 1500 Years of Arabic Literature.* London: SAWI, 2015.

Camille, Michael. *The Medieval Art of Love.* New York: Harry N. Abrams, 1998.

Campbell, Marian. *Medieval Jewelry in Europe 1100–1500.* London: Victoria and Albert Publishing, 2009.

Canteins, Jean. *Francesco da Barberino. L'Homme et l'Oeuvre au regard du soi-disant "Fidèle d'Amour."* Milan: Archè, 2007.

Capellanus, Andreas. *On Love.* Translated by P. G. Walsh. London: Duckworth, 1982.

Le "Cuer" au Moyen Age, Sénéfiance, Aix: Centre Universitaire d'Études et de Recherches Médiévales d'Aix, No. 30, 1991.

d'Anjou, René. *The Book of the Love-Smitten Heart.* Translated by Stephanie Viereck Gibbs and Kathryn Karczewska. New York and London: Routledge, 2001.

_____. *Le Livre du Cœur d'amour épris.* Edited and translated by Florence Bouchet. Paris: Livre de Poche, 2003.

de Champagne, Thibaud. *Recueil de Chansons.* Translated by Alexandre Micha. Paris: Klincksieck: Paris, 1991.

de la Croix, Arnaud. *L'érotisme au Moyen Age: Le corps, le désir et l'amour.* Paris: Editions Tallandier, 1999.

de Lorris, Guillaume, and Jean de Meun. *The Romance of the Rose.* Trans. Frances Horgan. Oxford and New York: Oxford University Press, 1994.

de Troyes, Chrétien. *Cligès.* Translated by Burton Raffel. New Haven, CT, and London: Yale University Press, 1997.

d'Helfta, Gertrude. *Œuvres Spirituelles. Tome I. Les Exercices.* Translated by Jacques Hourlier and Albert Schmitt. Paris: Les Editions du Cerf, 1967.

_____. *Œuvres Spirituelles.* Tome II, *Le Héraut* (Livres I et II). Translated by Pierre Doyère. Paris: Les Editions du Cerf, 1968.

d'Orléans, Charles. *Poésies.* Edited by Pierre Champion. Paris: Honoré Champion Editeur, 2010.

Doueihi, Milad. *A Perverse History of the Human Heart.* Cambridge, MA: Harvard University Press, 1997.

Emmerling, Mary. *American Country Hearts.* New York: Clarkson N. Potter, 1988.

Erickson, Robert A. *The Language of the Heart, 1600–1750.* Philadelphia: University of Pennsylvania Press, 1997.

Evans, Ruth, ed. *A Cultural History of Sexuality in the Middle Ages.* Oxford and New York: Berg, 2011.

Farrin, Raymond. *Abundance from the Desert: Classical Arabic Poetry.* Syracuse, NY: Syracuse University Press, 2011.

Gertrude the Great of Helfta. *Spiritual Exercises.* Translated by Gertrud Jaron Lewis and Jack Lewis. Kalamazoo, MI: Cistercian Publications, 1989.

Hansen, H. J., ed. *European Folk Art in Europe and the Americas*. New York and Toronto: McGraw Hill, 1967.

Harrison, Robert Pogue. *The Body of Beatrice*. Baltimore, MD: Johns Hopkins University Press, 1988.

Herbert, J. A. *Illuminated Manuscripts*. Bath, UK: Cedric Chivers Ltd. [1911], 1972.

Hillman, David, and Carla Mazzio. *The Body in Parts: Fantasies of Corporeality in Early Modern Europe*. New York and London: Routledge, 1997.

Høystad, Ole M. *A History of the Heart*. London: Reaktion Books, 2007.

Jager, Eric. *The Book of the Heart*. Chicago and London: University of Chicago Press, 2000.

Kemp, Martin. *Christ to Coke: How Image Becomes Icon*. Oxford: Oxford University Press, 2012.

Kish, George. "The Cosmographic Heart: Cordiform Maps of the Sixteenth Century." *Imago mundi* 19 (1965): 13–21.

Koechlin, Raymond. *Les Ivoires gothiques français*, 3 vols. Paris, 1924.

Mancoff, Debra N. *Love's Messenger: Tokens of Affection in the Victorian Age*. Chicago: Art Institute of Chicago, 1997.

Micrologus. *Micrologus: Natura, Scienze e Societa Medievali* [Nature, Sciences and Medieval Societies]. XI, *Il cuore* [*The Heart*]. Lausanne: Sismel, Edizioni del Galluzzo, 2003.

Nelli, René. *Troubadours et trouvères*. Paris: Hachette, 1979.

Ovid. *The Love Poems*. Translated by A. D. Melville. Oxford and New York: Oxford University Press, 1990.

Panofsky, E. "Blind Cupid." In *Studies in Iconology: Humanistic Themes in the Art of the Renaissance*, 95–128. New York: Harper and Row, 1962.

Pastoureau, Michel. *Une histoire symbolique du Moyen Age occidental*. Paris: Editions du Seuil, 2004.

Peakman, Julie, ed. *A Cultural History of Sexuality*. Vols. 1–6. Oxford and New York: Berg, 2011.

Peto, James, ed. *The Heart*. New Haven, CT, and London: Yale University Press, Wellcome Collection, 2007.

Picaud, Gérard, and Jean Foisselon. *A tout coeur: L'art pour le Sacré Coeur à la Visitation*. Paris: Somogy éditions d'art, 2013.

Praz, Mario. "Sacred and Profane Love." *Studies in Seventeenth Century Imagery*. Rome: Edizioni di Storia e Letteratura, 1964.

Randall Jr., Richard H. *The Golden Age of Ivory: Gothic Carvings in North American Collections*. New York: Hudson Hills Press, 1993.

Richardson, Samuel. *Pamela: or Virtue Rewarded*. Edited by Thomas Keymer and Alice Wakely. Oxford and New York: Oxford University Press, 2001.

Robinson, James. *Masterpieces: Medieval Art*. London: British Museum Press, 2008.

Shaw, Robert. "United as This Heart You See: Memories of Friendship and Family." In *Expressions of Innocence and Eloquence: Selections from the Jane Katcher Collection of Americana*, Vol. I, edited by Jane Katcher, David A. Schorsch, and Ruth Wolfe, 85–103. New Haven, CT: Yale University Press, 2006.

Slights, William W. E. *The Heart in the Age of Shakespeare*. New York: Cambridge University Press, 2008.

St. Teresa of Avila. *The Collected Works*. Translated by Kieran Kavanaugh and Otilio Rodriguez. Washington, DC: ICS Publications, 1987.

Talvacchia, Bette, ed. *A Cultural History of Sexuality in the Renaissance*. Oxford and New York: Berg, 2011.

Thomas, Antoine. *Francesco da Barberino et la Littérature Provençale en Italie au Moyen Age*. Paris: Ernest Thorin, 1883.

Tibaud. *Roman de la poire*. Edited by Christiane Marchello-Nizia. Paris: Société des Anciens Textes Français, 1984.

Vaenius, Otto. *Amorum Emblemata*. Edited by Karel Porteman. Aldershot Hants, England, and Brookfield, VT: Scolar Press, 1996.

Vinken, Pierre. *The Shape of the Heart*. Amsterdam: Elsevier/Colophon, 2000.

von Strassburg, Gottfried. *Tristan*. Translated by A. T. Hatto. Harmondsworth, UK: Penguin Books, 1967.

Webb, Heather. *The Medieval Heart*. New Haven, CT: Yale University Press, 2010.

Webb Lee, Ruth. *A History of Valentines*. New York and London: Studio Publications, 1952.

Wiet, Gaston. *Introduction à la Littérature Arabe*. Paris: Editions G. P. Maisonneuve et Larose, 1966.

Williams, John. *The Illustrated Beatus*. Vols. I–V. London: Harvey Miller Publishers, 1998.

Index

Marilyn Yalom is a senior scholar at the Clayman Institute for Gender Research at Stanford University and the author of *A History of the Wife* and *How the French Invented Love*, among other books. She lives in Palo Alto, California, with her husband, the psychiatrist and writer Irvin Yalom.

Photograph by Reid Yalom